D1394063

PRE-RAPHAELITES
DRAWINGS & WATERCOLOURS

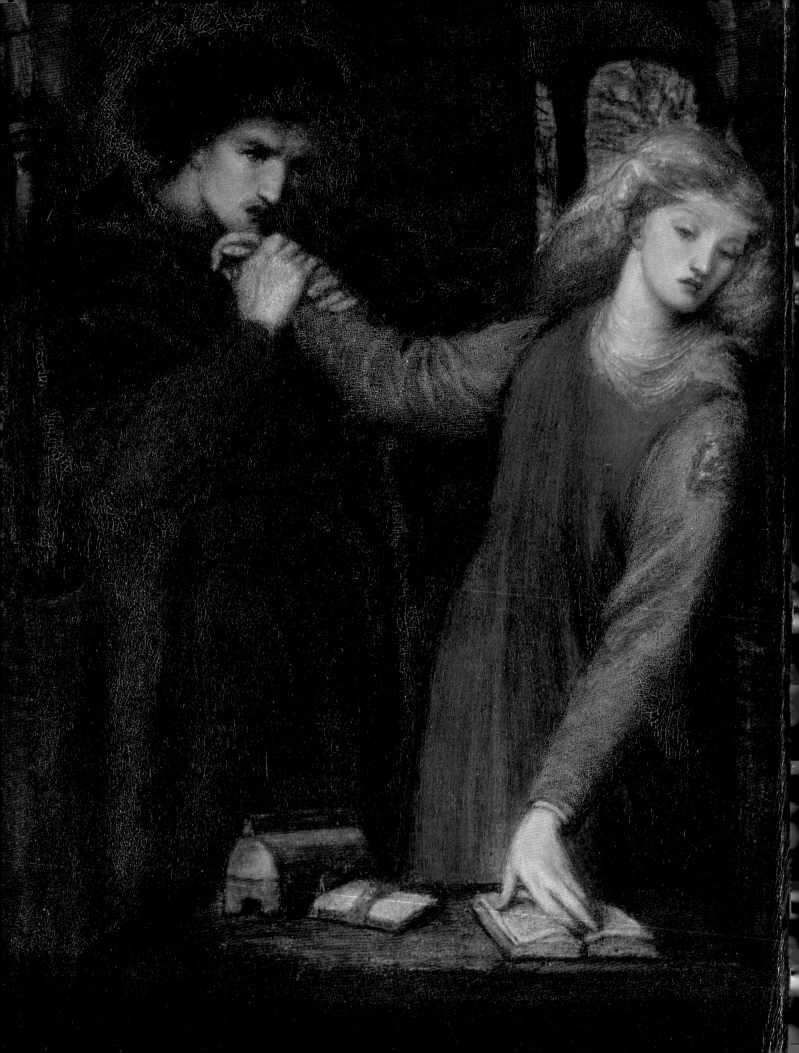

PRE-RAPHAELITES

DRAWINGS & WATERCOLOURS

Christiana Payne

with essays by

Fiona Mann and Robert Wilkes

ASHMOLEAN
MUSEUM
OXFORD

PRE-RAPHAELITES: DRAWINGS & WATERCOLOURS
4 February to 31 May 2021

Copyright © Ashmolean Museum, University of Oxford, 2021
Christiana Payne, Fiona Mann and Robert Wilkes have asserted their moral
rights to be identified as the authors of this work.
All images ©Ashmolean Museum, University of Oxford, except where stated.

British Library Cataloguing in Publications Data
A catalogue record for this book is available from the British Library

ISBN: 978-1-910807-43-9

All rights reserved. No part of this publication may be transmitted in any
form or by any means, electronic or mechanical, including photocopy,
recording or any storage and retrieval system, without the prior permission
in writing of the publisher.

Catalogue designed by Stephen Hebron

Printed and bound in Great Britain by Gomer Press

Frontispiece: detail of cat.52

For further details of Ashmolean titles please visit:
www.ashmolean.org/shop

Exhibition Supported by:

The Roger and Ingrid Pilkington Charitable Trust
The Anson Charitable Trust

Contents

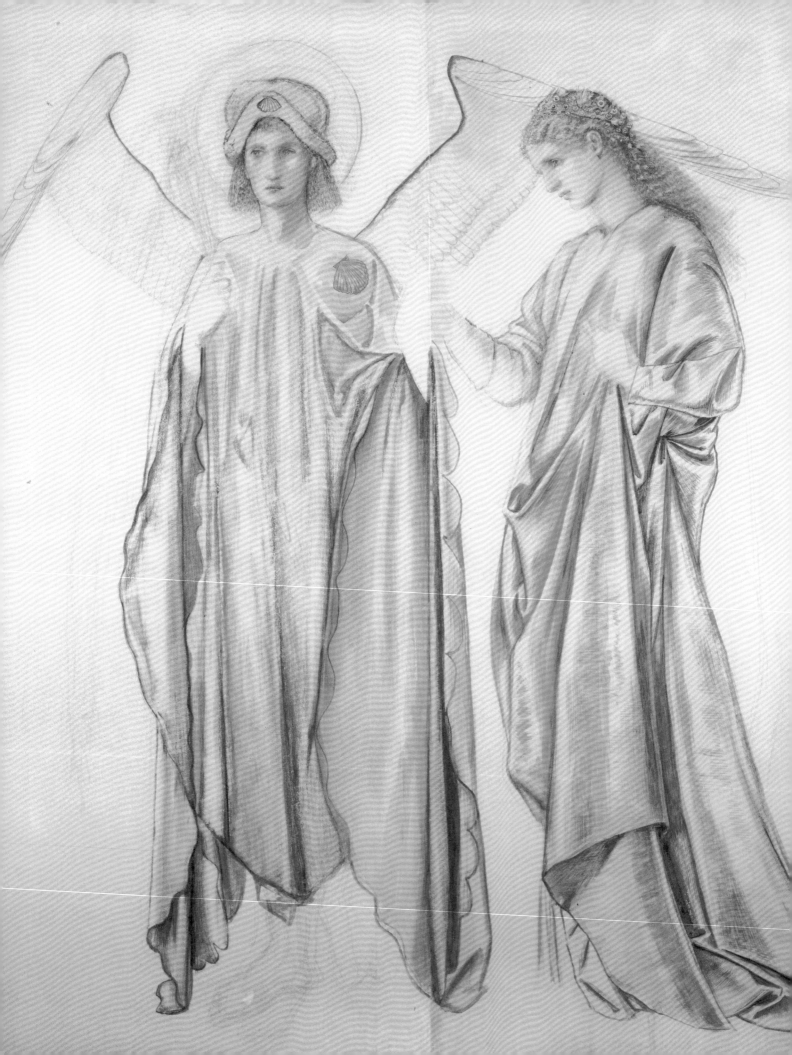

Foreword

Many visitors to the Ashmolean have been seduced by the bright colours and details in the Museum's impressive collection of Pre-Raphaelite paintings. Fewer, however, have been able to examine the large collection of works on paper, held in the Western Art Print Room. Although these are usually available to see by appointment, even enthusiasts and scholars have rarely looked at more than a selection. This exhibition, for the first time, makes it possible to see a wide range of these drawings together. It includes a variety of works of all kinds and different purposes, from William Holman Hunt's first drawing on the back of a tiny envelope for *The Light of the World* (Keble College) to large, elaborate chalk drawings of Jane Morris by Dante Gabriel Rossetti. Portraits throw an intimate light on the friendships and love affairs of the artists, and landscape watercolours reflect John Ruskin's advice to 'go to nature'. The exhibition demonstrates the enormous range of Pre-Raphaelite drawing techniques and media, including pencil, pen and ink, chalk, watercolour, bodycolour and gold paint.

Some key events in the history of Pre-Raphaelitism took place in the city of Oxford. In 1850, soon after the Pre-Raphaelite Brotherhood was founded, the avuncular Thomas Combe hosted the young artists in his house at the Clarendon Press; his widow Martha left their collection to the Ashmolean in 1893. William Morris and Edward Burne-Jones became converts to the movement when they studied here as undergraduates. It was in an Oxford theatre that the fateful meeting took place between Jane Burden, the stunningly beautiful stableman's daughter, and the two men who were to become her husband and her lover: Morris and Rossetti. Oxford, too, played an important role in Ruskin's life, and he began donating many of his own exquisite drawings to the University in the 1870s.

Thanks to all these connections, the Ashmolean Museum has been a magnet for Pre-Raphaelite bequests and donations, augmented by purchases, up to the present day, from Thomas and Martha Combe's foundational bequest to the recent acquisition of Burne-Jones's wonderfully illustrated letters to May Gaskell.

We are delighted to have recruited Christiana Payne, Professor Emerita of History of Art at Oxford Brookes University, as guest curator and main author of the catalogue. Two scholars whose doctoral research she supervised, Fiona Mann and Robert Wilkes, have contributed essays to the catalogue, bringing new insights in the important areas of painting techniques and literary inspiration. Within the Museum, Christiana has been ably assisted by Colin Harrison, Senior Curator of European Art, and Caroline Palmer, Western Art Print Room Manager. As ever we are enormously grateful to those who have made this work possible through their vital financial support including The Roger and Ingrid Pilkington Charitable Trust, The Anson Charitable Trust and others who wish to remain anonymous. Much of the preparation and research for the exhibition and catalogue has taken place during the conditions of lockdown, when libraries, and the Museum itself, were closed which has presented its challenges but also been a source of solace and optimism. We hope that visitors will enjoy seeing the drawings as much as we do.

Alexander Sturgis
Director, Ashmolean Museum

Opposite: detail of cat.70.

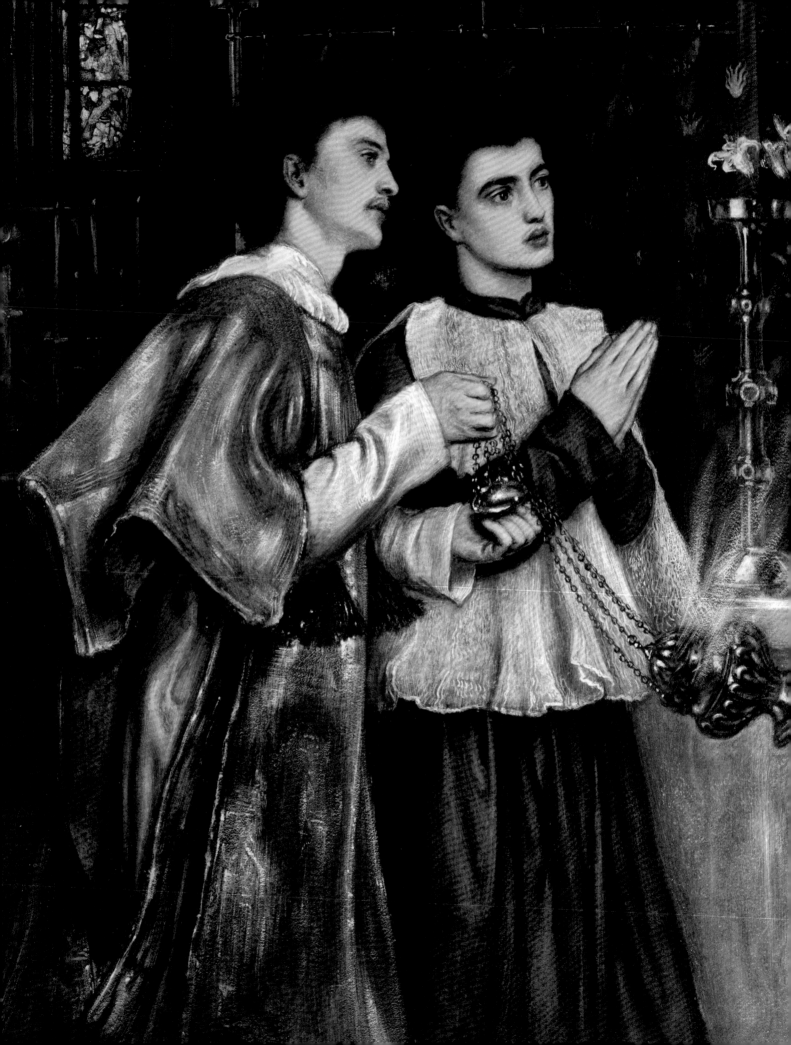

Acknowledgements

It has been a great pleasure working on this catalogue and exhibition, even under the stresses and restrictions caused by the global pandemic. Colin Harrison, Caroline Palmer and Katherine Wodehouse showed me drawings and followed up my queries with efficiency and courtesy. All the team at the Ashmolean, but especially Alexandra Greathead, Declan McCarthy, Catriona Pearson and Natasha Podro worked hard, often under very difficult conditions, to get everything ready in time.

I am grateful to the Pre-Raphaelite scholars who responded promptly to my questions and helped me out with their own special areas of expertise: Colin Cruise, Carol Jacobi, Pamela Gerrish Nunn, Elizabeth Prettejohn, Jason Rosenfeld, Malcolm Warner and Stephen Wildman. In addition, I have learned much over the years from conversations with Barbara Bryant, Nancy Langham Hooper and Dinah Roe.

Finally, I must thank my fellow authors Fiona Mann and Robert Wilkes, who made many useful comments on the text as well as contributing essays of their own.

Christiana Payne

Opposite: detail of cat.21.

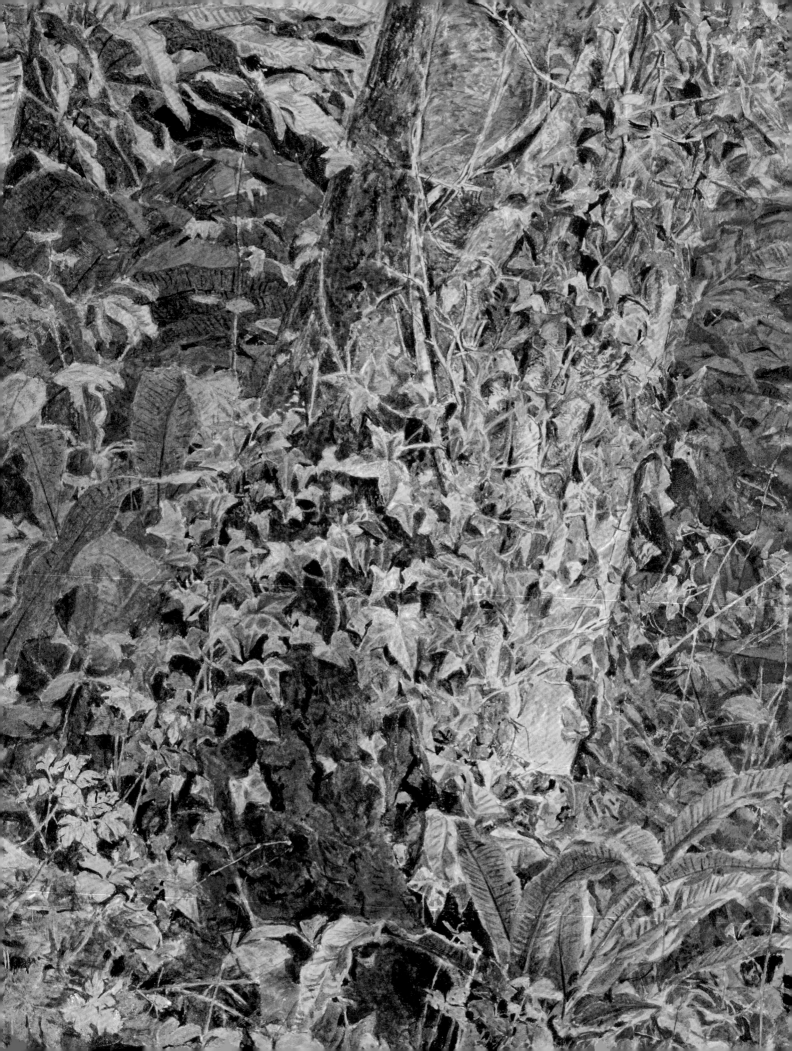

Introduction: Pre-Raphaelites on Paper

THE MOVEMENT WE now know as Pre-Raphaelitism began in the autumn of 1848. Seven young men – John Everett Millais, William Holman Hunt, Dante Gabriel Rossetti, Frederic George Stephens, William Michael Rossetti, Thomas Woolner and James Collinson – got together and founded the Pre-Raphaelite Brotherhood: the PRB. This name reflected their admiration for artists who had worked prior to the death of Raphael in 1520. Poetry, study from nature, social criticism and a desire to be original were all important elements in their work.

Their initial meetings took place in London. However, Oxford was to play a key role in the Pre-Raphaelite movement as it developed to encompass a wide range of artists, including Elizabeth Siddal, Ford Madox Brown, Arthur Hughes, Edward Burne-Jones and William Morris. Some of the painters gathered at the house of Thomas Combe in Oxford in the early 1850s; another group decorated the Oxford Union with murals in 1857. In the 1870s their champion, the art critic John Ruskin, gave a teaching collection of drawings to the University of Oxford. Ruskin, Burne-Jones, Morris and the landscape painter Alfred William Hunt studied as undergraduates at Oxford University. As a result of all these connections, the Ashmolean Museum's collection of Pre-Raphaelite works is one of the most significant in the world. The PRB itself came to an end by 1853, but the movement it began had a dramatic effect on British, and indeed European and American art, that lasted into the early years of the twentieth century.

The Pre-Raphaelites are best known today for brightly coloured oil paintings, for example Millais's *Spring (Apple Blossoms)* (fig.1) or Rossetti's *'Astarte Syriaca'* (fig.2). Yet it is less widely appreciated that the Pre-Raphaelites were also keen

Opposite: detail of cat.94.

Below left: fig.1 Sir John Everett Millais (1829–1896), *Spring (Apple Blossoms)*, 1856–9. Oil on canvas. Lady Lever Art Gallery, Port Sunlight. WGL82984. Bridgeman Images.

Below right: fig.2 Dante Gabriel Rossetti (1828–1882), *'Astarte Syriaca'*, 1877. Oil on canvas. Manchester Art Gallery. MAN62973. Bridgeman Images.

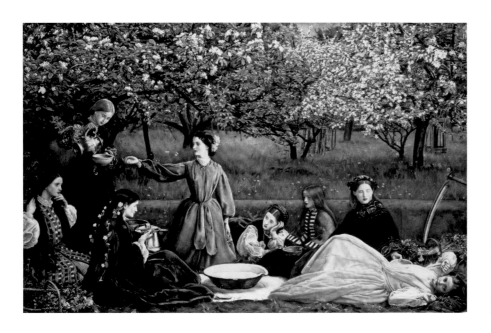

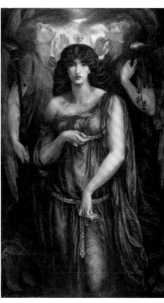

draughtsmen and draughtswomen. Their drawings and watercolours tend to be overlooked, since due to the risk of damage by light they cannot be permanently displayed. Yet, as Colin Cruise has shown, drawing is 'key to an understanding of Pre-Raphaelitism ... it was in the setting up of a new way of drawing that they built the foundations of a new movement in painting'.[1] Members of the group drew constantly in a variety of graphic media, trying out their ideas, studying from life, producing rough sketches or elaborate finished drawings in pen and ink, graphite pencil, coloured chalks, pastel or wash. Burne-Jones was especially inventive in his drawing media, working in silverpoint and even gold paint.

Watercolour, too, was an important medium for them. Pre-Raphaelite water-colours have a jewel-like strength and intensity of colour, thanks partly to their use of bodycolour (gouache). Indeed, some watercolours by the Pre-Raphaelites are so densely worked and opaque that they have been mistaken for oil paint-ings. Rossetti and Burne-Jones worked exclusively in watercolour for sustained periods of their careers; Ruskin only used watercolour, never oils. Watercolour might be preferred for reasons of health, cost and practicality, but it was also closer than oil to some of the works from the past that the artists admired, such as tempera paintings and manuscript illuminations from the Middle Ages and the Early Renaissance. In addition, watercolour was the medium favoured by William Blake. His writings, and his status as a poet painter, were important inspirations for the Pre-Raphaelites, especially for Dante Gabriel Rossetti and William Morris, both of whom were also poets.

Artists of the Pre-Raphaelite movement came from a wide variety of artistic backgrounds, and individual artists developed very different drawing styles and techniques over the course of their careers. As a result, Pre-Raphaelite works on paper display a wide range of different types of drawing. All the original mem-bers of the PRB, apart from William Michael Rossetti, underwent the standard training in drawing at the Royal Academy Schools, but some absorbed it more deeply than others. This training involved a long apprenticeship in drawing from antique sculpture, in order to master form and light and shade, before going on to draw from the living (nude) model. Artists were set exercises in composition and perspective so that they could invent multi-figure designs, involving some kind of heroic action or narrative. Holman Hunt's design for his never-executed painting of the biblical subject *Ruth and Boaz* (cat.20), with its nude or lightly draped figures in contrasting poses, is the kind of production for which the Academy training was meant to prepare artists. Millais had a particularly thorough academic training: a child prodigy, he began attending the Schools in 1840, aged just eleven. Rossetti, Hunt and Stephens joined him there in 1844.

All four artists were to rebel against the competent but rather bland and uniform kind of art that the Royal Academy training produced. Endless drawing from plaster casts of sculpture did not inspire them and Rossetti, in particular, quickly became impatient with its methods. As a poet, he was keen to use his imagination to illustrate literary themes rather than following repetitive exercises. Along with his protégés Elizabeth Siddal and Edward Burne-Jones, Rossetti introduced a distinctive element to the Pre-Raphaelite movement which valued originality and feeling over artistic skills progressed through training. Siddal

first came into the Pre-Raphaelite circle as a model, but developed her innate talent as a poet and artist under Rossetti's tutelage. Burne-Jones also received instruction from Rossetti when he moved from Oxford to London in 1856.

Poetry was vitally important to the Pre-Raphaelites. In 1849 William Michael Rossetti began keeping a diary of the PRB, offering us a crucial record of their early years. In the very first meeting he describes Millais is writing a poem, while Dante Gabriel Rossetti reads out one of his own poems and another by Coventry Patmore, which the brothers then 'minutely analyzed'.[2] They produced a magazine, *The Germ* (January–April 1850), subtitled 'Thoughts towards Nature in Poetry, Literature, and Art' which published poems by both Rossetti brothers and their sister Christina, as well as poems by Woolner, Collinson and Hunt. As Robert Wilkes has recently discovered, Stephens also wrote poetry, although he never published it.[3] The poets the artists admired included not only the classic figures of Chaucer and Shakespeare, but also their own contemporaries: Robert and Elizabeth Barrett Browning, Alfred Tennyson and, from an earlier generation, John Keats, William Wordsworth and Sir Walter Scott.

Dante Gabriel Rossetti, who was half-Italian, identified especially with the fourteenth-century poet Dante Alighieri, after whom he was named. His father, Gabriele Rossetti, was a poet, Dante scholar and political exile; he had been obliged to leave Italy in 1821 because of his support for the country's revolutionary nationalist movement. In many of Rossetti's drawings and watercolours his theme is the unrequited love of Dante for Beatrice, who died young. *Beatrice, meeting Dante at a Wedding Feast, Denies him her Salutation* (fig.3) illustrates one of the few, unsatisfactory, encounters that the poet had with Beatrice in life,

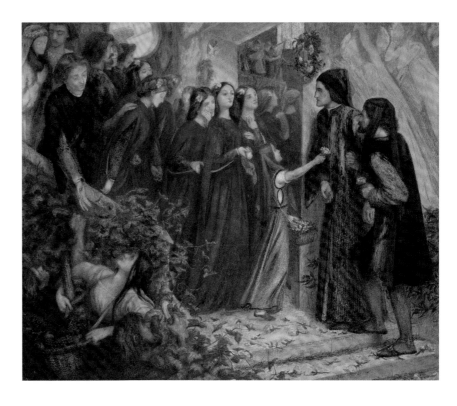

Fig.3 Dante Gabriel Rossetti (1828–1882), *Beatrice, meeting Dante at a Marriage Feast, Denies him her Salutation*, 1855. Watercolour and bodycolour on paper. Ashmolean Museum. WA1942.156.

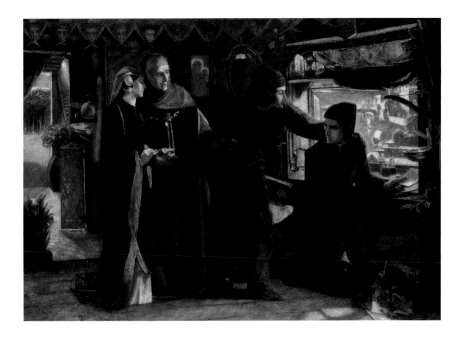

Fig.4 Dante Gabriel Rossetti (1828–1882), *Dante Drawing an Angel on the Anniversary of Beatrice's Death*, 1853. Watercolour and bodycolour on paper. Ashmolean Museum. WA1894.16.

while in *Dante Drawing an Angel on the Anniversary of Beatrice's Death* (fig.4) Rossetti imagines the effect on the poet of her untimely death. Rossetti's own poetry often dealt with love or lovers, and this became an important theme in his art, and indeed in Pre-Raphaelite art generally. They are generally illicit or doomed lovers, whose passion is intense but does not turn out well – a state of affairs echoed in Rossetti's own relationships with Elizabeth Siddal, whom he married in 1860, and Jane Burden, who married his friend William Morris in 1859.

Inspired by a desire to reform art, and by what they had read and seen of the so-called 'Primitives' – the fifteenth- and early sixteenth-century artists of Flanders and Italy – the Pre-Raphaelites began drawing in a deliberately awkward and 'spiky' style. Instead of studying the revered 'Old Masters' from the High Renaissance and the seventeenth century – Raphael, Michelangelo, Rubens – they looked at engravings by Carlo Lasinio of fifteenth-century Italian frescoes, original prints by Albrecht Dürer and illustrations to Shakespeare in the 'outline style' by the contemporary German artist Moritz Retzsch. These sources of inspiration were all in black and white, rather than colour, and they all relied on an emphatic use of line.

Millais's lunette designs of 1847–8 (cat.60) date from just before the formation of the PRB. They show the influence of the outline style, combined with an ease in figure drawing based on a sustained period of study. A year or two later, however, the figures in his drawing for *Christ in the House of his Parents* (fig.5) are stiffly posed and lacking in anatomical definition. It is as if Millais has self-consciously 'unlearned' some of the academic stratagems he had absorbed, trying rather to imagine himself as a fifteenth-century artist who had never seen classical sculpture, drawn from the life model or fully understood the rules of perspective. A similar kind of awkwardness is evident in Rossetti's drawing *Dante Drawing an Angel on the First Anniversary of the Death of Beatrice* (fig.6),

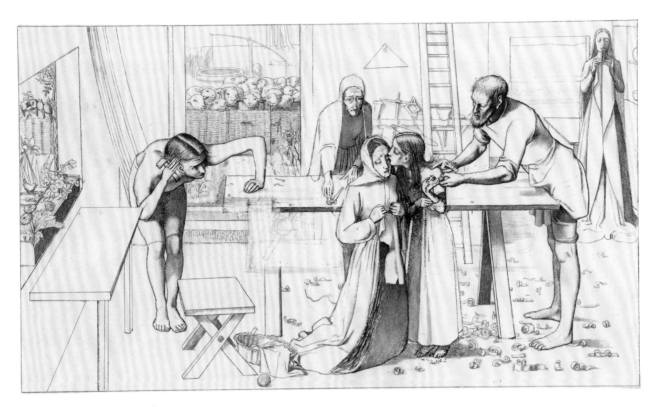

Fig.5 Sir John Everett Millais (1829–1896), *Study for 'Christ in the House of his Parents'*, c.1849. Graphite, pen, ink and wash on paper. Tate, London. N04623. Photo © Tate.

Fig.6 Dante Gabriel Rossetti (1828–1882), *Dante Drawing an Angel on the First Anniversary of the Death of Beatrice*, 1849. Pen and brown ink on paper. Birmingham Museums and Art Gallery. 1904P485. Photo by Birmingham Museums Trust, licensed under CC0.

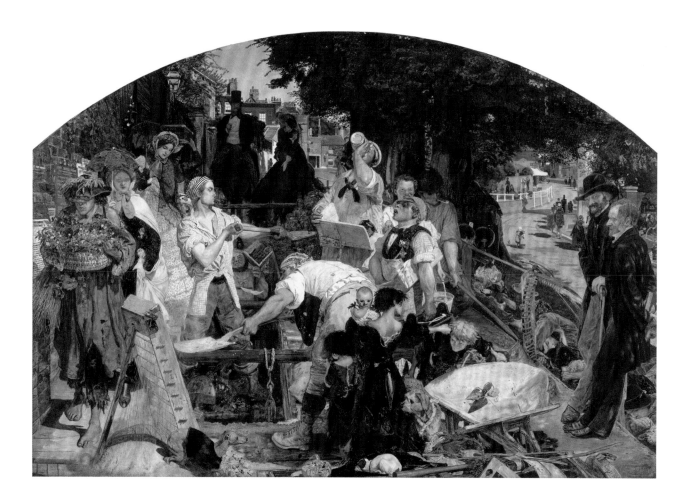

Fig.7 Ford Madox Brown (1821–1893), *Work*, 1852–65. Oil on canvas. Manchester Art Gallery. MAN3927271. Manchester Art Gallery / Bridgeman Images.

but in this case Rossetti's relative lack of training explains some of its character-istics. Both drawings date from 1849. The artists were using drawing, therefore, as a way of trying out new ideas and declaring a revolutionary approach to art – one even more radical than in their exhibited works.

The first works exhibited by the Pre-Raphaelites took their themes from the past, from sources such as the Bible and Shakespeare. However, the Brotherhood was formed in the revolutionary year of 1848. In later years Hunt recalled that he had said to Millais's mother 'our talk is the deepest treason against our betters'. He and Millais joined the massive Chartist demonstration held on Kennington Common in April 1848, which called for the shockingly radical measures of universal male suffrage and secret ballots in elections.[4] The artists' choice of name, and their initial resolution to keep it a secret, were a deliberate challenge to the authority of the Royal Academy. The letters 'PRB' were a calculated affront to an institution in which the greatest honour was to be able to add 'PRA' (President of the Royal Academy) to an artist's signature, and it is hardly surprising that their paintings were at first harshly received. Their critical approach to the social questions of the day encouraged the Pre-Raphaelites to take up modern life sub-jects. The most important of these was *Work* (1852–65) by Ford Madox Brown (fig.7). Brown was not a member of the Brotherhood – he was of a slightly older generation – but he was an important early influence and gave lessons to both

Hunt and Rossetti. *Work* surveys the different social classes, contrasting the idle rich with the hard-working labourers, the destitute poor with the intellectuals whose writings aimed to help them. Its underlying theme was determined by Brown's Christian Socialist beliefs. Despite the modernity of its subject matter, Brown's drawings for *Work* show that he prepared the painting in the traditional manner, making cartoons for transferring his designs to the canvas (cat.18). In a similar vein, Millais made drawings that satirise the boredom and depravity of the upper classes. Gentler social criticism is evident in paintings and book illustrations by Arthur Hughes, appealing to the viewer's sympathy for virtuous cottage families (cats 16 and 17).

Drawing was a strategy that the members of the Brotherhood used to cement their association. Rossetti's drawing of the first anniversary of Beatrice's death is inscribed 'to his P.R. Brother John E. Millais', Stephens' *Dethe and the Riotours* (cat.47) was given as a gift to Rossetti, and the group inscribed the portraits they drew of one another in a similar way. Portraits of the artists were also given as gifts to patrons. The pencil portraits of Charles Allston Collins and Holman Hunt by Millais, and of Millais himself by Collins (cats 1, 2 and 3) all belonged to Thomas Combe, superintendent of Oxford University Press. Collins was not himself a member of the Brotherhood, but he was a close friend of Millais and Hunt. Poignantly, he signed his portrait of Millais with the initials 'P. R. B.'; however, when Millais proposed Collins for membership, he was rebuffed by his colleagues. Millais, Hunt and Collins worked together in Oxford, thanks to the patronage of Combe and his wife Martha. The Combes had no children and they became surrogate parents to the young artists, especially Hunt and Millais. The artists spent Christmases with them and Thomas Combe even considered accompanying Hunt to Egypt and Palestine.[5] Collins's drawing of an evening at the Combes' house (cat.7) gives a vivid impression of the household's homely atmosphere. When Martha Combe died she left the couple's considerable collection of Pre-Raphaelite drawings and oil paintings to the Ashmolean.

Thomas Combe was known as 'the Early Christian' for his support of the Tractarian or Oxford movement, which set out to reform the Anglican Church. The PRB's early paintings were often of religious subjects. The artists deliberately avoided traditional modes, either taking new subjects that had not been painted before or rethinking old subjects in new ways – as Millais did in his drawing, and then his painting, of *Christ in the House of his Parents* (1849–50).[6] The subject was apparently inspired by a sermon he heard in Oxford.[7] Rossetti liked the idea of a Brotherhood because it reminded him of secret, revolutionary societies; Hunt, Millais and Collins, however, were thinking more in terms of a religious community, such as a monastery. In 1854 Hunt's desire for authenticity in his biblical paintings led him to plan a trip to Palestine, so that he could paint them in their correct geographical setting. His example was followed by the landscape painter Thomas Seddon, whose view of Jerusalem, the Mount of Olives and the Garden of Gethsemane is one of the most thoroughgoing examples of the Pre-Raphaelite approach to landscape (fig.8).

The Combes bought several oil paintings by Hunt, Millais and Collins which are now in the Ashmolean. One of these was Collins's *Convent Thoughts*

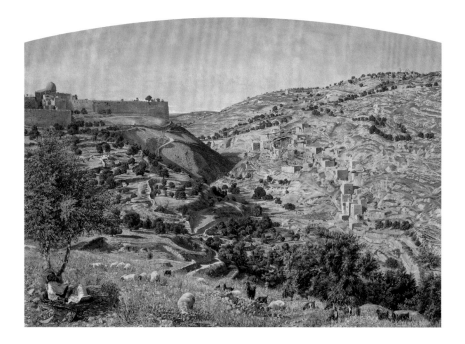

Fig.8 Thomas Seddon (1821–1856), *Jerusalem and the Valley of Jehoshaphat from the Hill of Evil Counsel*, 1854–5. Oil on canvas. Tate, London. N00563. Photo © Tate.

(fig.9), with its detailed depiction of several different types of lilies. The work was painted in the garden of the Combes' house at the University Press; it followed the new practice, initiated by the PRB, of painting everything from nature in the open air. The drawing for *Convent Thoughts* is also in the collection (cat.61). This painting brought about the first favourable comment on the group by John Ruskin, who came to their defence in a letter to *The Times* in May 1851. He had made his name as the writer of *Modern Painters*, which praised J. M. W. Turner as the greatest artist of modern times: Volume I was published in 1843, Volume II in 1846. By 1851 Turner was ailing (he died later that year) and Ruskin was looking for a new artistic hero. The Pre-Raphaelites, meanwhile, had been subjected to savage criticism in the press reviews of the Royal Academy exhibitions of 1850 and 1851. Ruskin was somewhat suspicious of what he saw as 'Romanist' tendencies in their work – this was a time when feelings were running high about the threat to the Anglican church posed by the Tractarians – but he praised Collins's treatment of the lilies and the waterlilies. He tried to define the artists' aims, saying that they were not simply seeking to imitate earlier art, but to adopt the methods that fifteenth-century painters had used: 'They intend to return to early days in this point only ... they will draw either what they see, or what they suppose might have been the actual facts of the scene they desire to represent, irrespective of any conventional rules of picture-making', as artists had done before the time of Raphael.[8] Ruskin followed up his first letter to *The Times* with a second one, then with a pamphlet, *Pre-Raphaelitism*. In the pamphlet he claimed that the group had followed his advice in the first volume of *Modern Painters* to 'go to Nature in all singleness of heart, ... rejecting nothing, selecting nothing, and scorning nothing'.[9] He thus claimed, in effect, to be the progenitor of the movement, although, ironically, most of his pamphlet was about Turner. Ruskin argued that the Pre-Raphaelites and Turner were doing essentially the

same thing – an argument that its readers have found difficult to accept, both at the time and since.

Ruskin was an accomplished draughtsman himself. His father, a prosperous sherry merchant and collector, gave him a gentleman's education: a degree course at Christ Church, Oxford and drawing lessons from the best teachers of the day, including James Duffield Harding. Ruskin later served as Slade Professor at Oxford, established the Ruskin School of Drawing and donated a substantial collection of drawings by himself and others to the University to be used for teaching. Some of Ruskin's watercolours are miracles of acute observation; they have been compared to the famous nature studies by Albrecht Dürer (cats 82 and 83). He declared, however, that he could not draw anything unless it was in front of him: as he wrote in a letter of 1846, 'I can do nothing that I haven't before me; I cannot change, or arrange, or modify in the least, and that amounts to a veto on producing a great picture'.[10] Under the influence of the Pre-Raphaelites,

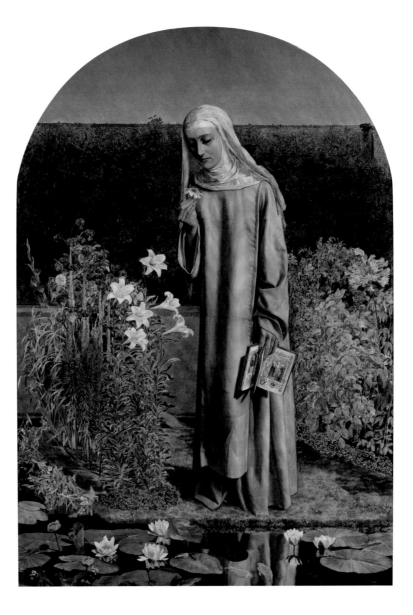

Fig.9 Charles Allston Collins (1828–1873), *Convent Thoughts*, 1850–1. Oil on canvas. Ashmolean Museum. WA1894.10.

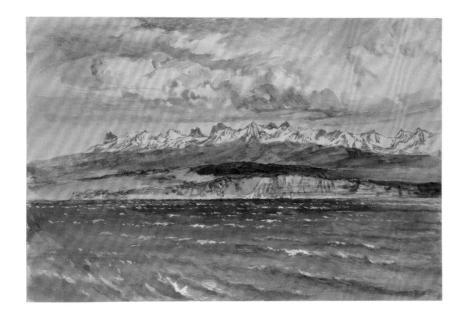

Fig.10 John Ruskin (1819–1900), *Afternoon in Spring, with South Wind, at Lausanne*, 1869. Watercolour and bodycolour over graphite on pale grey wove paper. Ashmolean Museum. WA.RS.ED.298.

Ruskin's drawings of architecture were to become more colourful, his studies of natural history more sharply focused. His landscape paintings, however, remained faithful to the very different legacy of Turner. Even when Ruskin is at his most Pre-Raphaelite, in the brightly coloured watercolour *Afternoon in Spring, with South Wind, at Neuchatel* (fig.10), the evanescent clouds in the sky and the sketchy treatment of the foreground reveal his deep knowledge and appreciation of Turner.

Ruskin kept his love of Turner to the end of his life. In the teaching collection he gave to the University of Oxford, there are 57 drawings by Turner, 415 by Ruskin himself. The Pre-Raphaelite drawings consist of only 55 drawings by Burne-Jones; there is nothing by Millais, nothing by Holman Hunt, nothing by Rossetti and nothing by Siddal, although Ruskin had admired, praised and bought works by all of them in his earlier years. Even the substantial collection of drawings by Burne-Jones shows little variety. It is made up mainly of his series of illustrations to the story of Cupid and Psyche, along with a few copies of Italian works and two large studies for wall hangings (cats 70 and 71).

Ruskin's relationship with the Pre-Raphaelites was not always a happy or an easy one. His own artistic training was that of an amateur. He had learned to draw buildings and landscapes, but he only worked in watercolour and rarely drew the human figure. When he produced his own drawing manual, *The Elements of Drawing* (1857), he stated explicitly that amateurs should not draw the figure.[11] He was, however, very useful to the artists as a critic, and also as a patron. Initially he became friendly with Hunt and Millais, praising the former's painting of Christ, *The Light of the World* (fig.11), as 'one of the very noblest works of sacred art of this or any other age'.[12] This was another purchase by the Combes, which Mrs Combe gave to Keble College, Oxford in 1873 (in memory of her husband). Hunt's preliminary sketches (cats 62–4) include a tiny first sketch, literally on the back of an envelope, and a careful drawing for the lantern with its symbolic openings, which Hunt had made up specially by

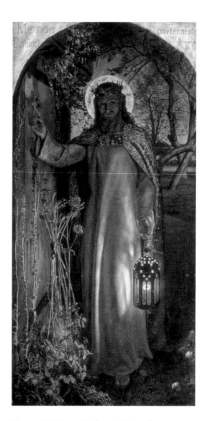

Fig.11 William Holman Hunt (1827–1910), *The Light of the World* (1851–2). Oil on canvas over panel. Keble College, Oxford. KOX701861. By Kind Permission of the Warden, Fellows, and Scholars of Keble College, Oxford / Bridgeman Images.

a metalworker. In Millais, Ruskin recognised a worthy successor to Turner. He commissioned a full-length portrait of himself (fig.12), standing in front of an outcrop of gneiss rock at Glenfinlas, in the Trossachs. In 1853, while Millais was painting the portrait, Ruskin himself made a superb drawing of the rock (cat.79) – possibly to help the artist, or perhaps to try out Millais's very detailed method of studying nature for himself. However, the association between Ruskin and Millais was cut short when Millais fell in love with Ruskin's wife Effie (née Gray). After a scandalous divorce Effie and Millais were married in 1855. Ruskin then transferred his attentions to other artists in the group.

Ruskin's patronage after this point was centred on Rossetti and Siddal, and then on Burne-Jones. All were artists whose work was imaginative and poetic, rather than pursuing the 'going to nature' which Ruskin made the theme of *Modern Painters* and subsequently claimed as the original inspiration for the Pre-Raphaelite movement. Presumably Ruskin admired their art so much because it was work that he could not do himself, both because they drew figures and because they invented compositions from their own imagination, a skill that Ruskin felt he lacked. He bought several drawings by Rossetti, including

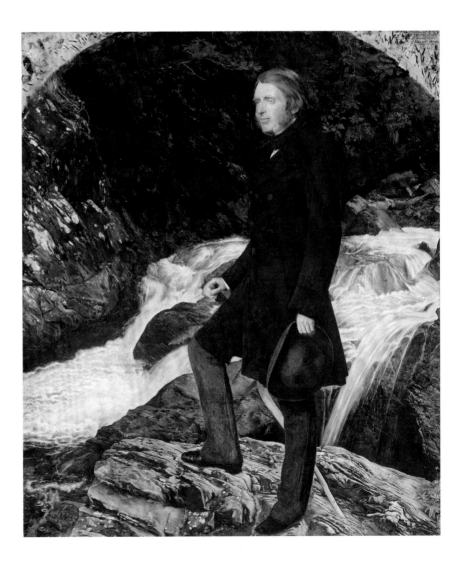

Fig.12 Sir John Everett Millais (1829–1896), *John Ruskin*, 1853–4. Oil on canvas. Ashmolean Museum. WA2013.67.

Rossetti's watercolour *Beatrice, meeting Dante at a Wedding Feast, Denies him her Salutation* (1855, fig.3). Ruskin had seen an earlier version of this watercolour at the Winter Exhibition of the Old Watercolour Society in 1852 and described it to Holman Hunt as 'a most glorious piece of colour'.[13] Being a poet as well as a painter, Rossetti took naturally to drawing, as well as writing, with pen and ink.

Elizabeth Siddal was also a poet and was admired for her skill in 'invention' (cats 48 and 49). She has a good claim to be one of the founders of an informal 'Pre-Raphaelite Sisterhood' which paralleled the activities of the men. In her watercolour *Clerk Saunders* (fig.13) she produced a chilling illustration to one of the Border ballads in a collection edited by Sir Walter Scott; it portrays a woman whose murdered lover comes back as a ghost, asking her to renew her vows.

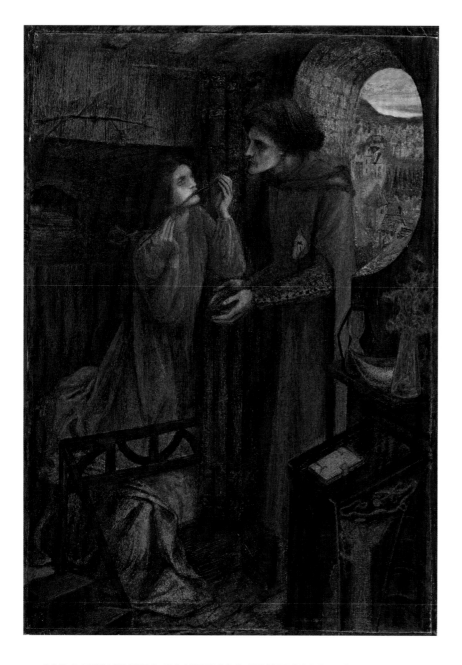

Fig.13 Elizabeth Eleanor Siddal (1829–1862), *Clerk Saunders*, 1857. Watercolour, bodycolour and coloured chalks on paper. Fitzwilliam Museum, Cambridge. 680. © Fitzwilliam Museum, University of Cambridge.

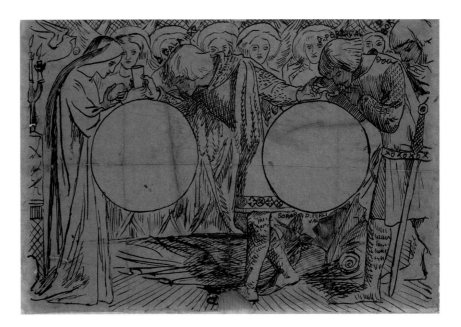

Fig.14 Dante Gabriel Rossetti (1828–1882), *Sir Galahad, Sir Bors and Sir Percival receiving the Sanc Grael*, 1857. Pen and brown ink on fine tracing paper. Ashmolean Museum. Bequeathed by John N. Bryson, 1977; WA 1977.85.

The insubstantial anatomy of Clerk Saunders is perfectly suited to the theme. Despite its origins in a Brotherhood, Rossetti's version of Pre-Raphaelitism was actually quite favourable to female artists; it did not demand the long training in the study of the nude, for instance, from which women were generally excluded. Like Rossetti, Siddal had limited formal training. Ruskin undertook to pay her a salary in return for all the work she produced, but her health was poor. By the time Rossetti married her in 1860 she had almost ceased to work as an artist, and in 1862 she died of an overdose of laudanum. After Siddal's death Ruskin fell out with Rossetti. He became instead an enthusiastic patron of Burne-Jones who, together with his great friend William Morris, took the movement in new directions.

Morris and Burne-Jones had met at Exeter College, Oxford, where they arrived as undergraduates in 1853. They shared a passion for the Middle Ages, and especially for the legends of King Arthur and the Knights of the Round Table. Once again there was talk of a brotherhood, but this time it was to be a spiritual one: in May 1853 Burne-Jones wrote that Sir Galahad (famous for his chastity) was to be the patron of their Order.[14] Morris and Burne-Jones looked at illuminated manuscripts together in the Bodleian Library and they visited Thomas Combe. By 1855 they had become fervent admirers of Rossetti, whose watercolour of *Dante Drawing an Angel on the Anniversary of Beatrice's Death* (1853, fig.4) they saw in the Combe collection.[15] The idea of a religious order was abandoned, and both decided to become artists.

In 1857 Morris and Burne-Jones were back in Oxford again, with Rossetti, working on Arthurian paintings for the Debating Chamber of the Oxford Union (now the Library). Rossetti assembled a team of seven artists, a kind of second-generation Brotherhood. The murals, now sadly darkened, can best be appreciated from surviving watercolours, such as those in the Ashmolean by Rossetti and Arthur Hughes (cats 45 and 46), which still have the glowing

colours praised by contemporary observers. Rossetti produced two designs for the murals. One showed Sir Lancelot being prevented from entering the chapel of the Holy Grail by his illicit love affair with Guinevere, Arthur's queen (cat.45). The other, which was not used, depicted the chaste Sir Galahad and his companions receiving the Grail; a fragile drawing of it on tissue paper survives, a gift from Rossetti to Thomas Deane, partner to Benjamin Woodward, the architect of the Chamber (fig.14).[16]

It was in this year at Oxford, too, that Rossetti, Burne-Jones and Morris began looking out for 'stunners' – by which they meant women of remarkable beauty. The actress Ruth Herbert (cats 33 and 34) was Rossetti's 'Stunner No 1', and Burne-Jones described his wife Georgiana as 'my stunner'.[17] Georgiana commented in later years that 'human beauty ... was in a way sacred to them'.[18] This mainly meant female beauty, although it could be argued that the artists developed androgynous ideals of beauty. The women in Rossetti's later drawings and paintings often have male characteristics such as strong features and thick necks, while Burne-Jones's male figures can look very similar to his female figures. Indeed, this disturbed the more conservative critics: Harry Quilter complained in 1892 that Burne-Jones was 'apt to reduce both men and women to a type which, while partaking of the character of both is a perfect representation of neither'.[19] Simeon Solomon, an artist of great promise whose career ended in 1873 when he was sentenced to imprisonment for homosexual offences, developed his own variation on the 'stunner' in the form of paintings and drawings of beautiful young men (cat.21). 'Stunners' also appeared in the guise of allegorical, mythological or historical paintings – thinly disguised excuses for portrayals of the female form, concentrating on the head and shoulders, and sometimes the hands. Paintings of this kind were produced, very successfully, by Frederick Sandys (cats 43 and 44), as well as by a female artist, Marie Spartali Stillman. She trained with Ford Madox Brown and was herself a 'stunner'; noted for her beauty, she occasionally modelled for other artists (cat.53).

Rossetti used drawing as a form of worship of the women he admired. Ford Madox Brown commented in his diary in 1854 that Rossetti's studio was full of drawings of 'Guggums' – his pet name for Elizabeth Siddal.[20] He drew close-up portraits of her and full-length studies; a few of them had a practical function as the basis for pictures, but mainly he simply seems to have loved drawing her. Some of these drawings are in pen and ink, but the majority are in pencil, with soft shading used to express her delicate features. Rossetti adopted a bolder treatment for drawings of Fanny Cornforth, who became his housekeeper, and later his lover, and also for drawings of the actress Ruth Herbert (cats 33–5). His most frequent model, however, was Jane Burden, the stableman's daughter who was spotted by the artists at a theatre in Oxford and married Morris in 1859. She may already have been in love with Rossetti. In any case, their relationship became increasingly close in the mid-1860s, to the extent that Morris felt he had to leave the two of them alone together at his house near Oxford, Kelmscott Manor, while he explored Iceland in 1871. Neither Elizabeth Siddal nor Jane Morris conformed to contemporary standards of beauty, and they were very different in their appearance. Siddal's red hair was regarded as extreme and figures in

Fig.15 Sir Edward Coley Burne-Jones (1833–1898), *Gualdrada Donati Presenting her Daughter to Buondelmente*, c.1860. Pen and black ink with graphite on white paper. Ashmolean Museum. WA1951.156.

paintings for which she had modelled were condemned as 'plain'. Jane Morris, on the other hand, was quite the opposite with her dark eyes, large features and abundant wavy hair.

Burne-Jones's somewhat androgynous ideal of beauty was different again. It was based either on the regular features of his wife Georgiana and his daughter Margaret or on the dark, Mediterranean looks of his lover, the sculptor Maria Zambaco. Burne-Jones is the Pre-Raphaelite artist whose drawings show the most variety and development. When he met Rossetti in January 1856 he had been drawing since his childhood, but had received little formal instruction. Rossetti became his teacher and encouraged him to make elaborately detailed pen and ink drawings, in a self-consciously medievalising style modelled on Albrecht Dürer's engravings. Several of these, including *The Knight's Farewell* (cat.25) are executed on vellum, the material used for medieval manuscripts. Rossetti described Burne-Jones's early drawings as 'marvels of finish and imaginative detail, unequalled by anything except perhaps Albert Dürer's finest works'.[21] However, Ruskin began to find the works of this period by Rossetti and Burne-Jones excessive in their fine detail, cramped perspectives and awkward figures. The drawing in the Ashmolean collection entitled *Gualdrada Donati Presenting her Daughter to Buondelmonte* (fig.15) shows Burne-Jones, around 1860, already starting to move away from medievalism under the influence of Ruskin. Ruskin enabled Burne-Jones to make visits to Italy in 1859 and 1862, accompanying him for some of the second trip. In return, Burne-Jones made copies for Ruskin of fifteenth- and sixteenth-century Venetian pictures. One of the results was a series

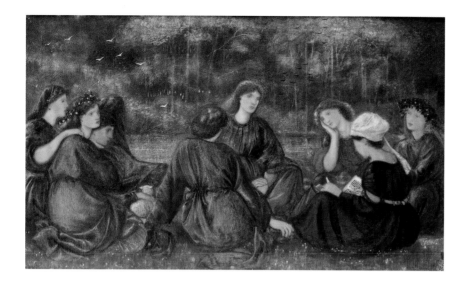

Fig.16 Sir Edward Coley Burne-Jones (1833–1898), *Green Summer*, 1864. Watercolour. Private collection. MFA167775. Bridgeman Images.

of drawings in soft red chalk (cat.67) for a painting, *Green Summer* (fig.16): both the subject and the drawing media imitate Venetian models.

The normal course of study for artists in this period introduced life drawing, from the nude model, once the student was proficient in drawing from antique sculpture. Burne-Jones's artistic education took a very different trajectory. Having already become skilled in pen and ink drawing, and also in the use of watercolour, he went back to the beginning, making numerous studies from life and from the Parthenon marbles. He experimented with different media, using chalk on coloured paper (cat.68), thickly textured paper (cat.26), pencil (cat.27), silverpoint (cat.69) and gold paint (cat.28). The artist has been described as a 'compulsive draughtsman'.[22] His wife Georgiana wrote that in his spare time he was always drawing:

> he must have covered reams of paper with drawings that came as easily to him as his breath ... They filled up moments of waiting, moments of silence or uncomfortable moments, bringing everyone together again in wonder at the swiftness of their creation, and laughter at their endless fun.[23]

Drawing was for Burne-Jones both a leisure activity and a medium of friendship. At home in the evenings he would make drawings for stained glass while Georgie read aloud to him; on Sunday mornings he and William Morris drew together, or Burne-Jones would draw while Morris read aloud.[24] Letters to favourite correspondents were adorned with delightful caricatures (cat.14). In 1869 the American scholar and collector Charles Eliot Norton visited The Grange, Burne-Jones's house, and saw 'literally hundreds' of drawings lying about or pasted into 'three or four enormous volumes filled with studies of every sort'.[25]

In 1861 drawing took on a new role in the preparatory works made for William Morris's 'Firm'. This was Morris, Marshall, Faulkner and Co., the firm

of 'Fine Art Workmen in Painting, Carving, Furniture and the Metals', founded in that year. It set out to transform domestic interior design and church decoration, bringing together artists and craftsmen in a collective enterprise. Its prime founder William Morris, Dante Gabriel Rossetti, Edward Burne-Jones and Ford Madox Brown all produced designs for the Firm. The Ashmolean has several drawings made by Burne-Jones, and by other artists, for translation into media other than painting: book illustration, embroideries, furniture and stained glass (cats 59, 70–7). Through Morris's activities the Pre-Raphaelite movement gained a wide international influence, giving birth to the Arts and Crafts movement. Morris was particularly proud of the books printed by his Kelmscott Press, which included many of the medieval and early Renaissance texts that he and Burne-Jones had read together in their student days. Book illustration had been an important feature of Pre-Raphaelite drawing since its inception and here, again, the variety of styles and methods is striking. The precise, assured technique of Millais's drawings for the Moxon edition of Tennyson (cat.50), for example, has almost nothing in common with Burne-Jones's drawings for *The Golden Legend* (cat.59). Millais's broken lines, hatching and cross-hatching – derived from the work of contemporary illustrators such as John Leech, who worked for *Punch* – are totally different from the graceful, simplified lines of Burne-Jones's illustrations.

Pre-Raphaelitism also had a profound influence on landscape painting. In the summer of 1851 Millais and Holman Hunt travelled together to Ewell, Surrey to paint the landscape backgrounds to their paintings *Ophelia* (1851–2) and *The Hireling Shepherd* (1851–2).[26] This was a radical new departure in the history of art: they took their canvases out into the open air, so that they could paint in oils, directly from nature. Until this time artists had made oil sketches out of doors and a few, such as John Constable, had painted complete, finished pictures on the spot, but it only became possible to make this a sustained practice after the invention of collapsible metal paint tubes in the 1840s. The amount of closely observed detail in these paintings is remarkable. The works owe much to the example of contemporary landscape photography which, for technical reasons, often confined itself to foregrounds: tree trunks, grasses and wild flowers, delineated with microscopic precision. Albert Moore's watercolour of a tree trunk entwined with ivy (cat.94) is like a detail from one of these paintings. Ruskin's writings provided further encouragement for landscape painters to look closely at nature, and to transcribe what they could see with the exactitude of a botanist or a geologist.

It was easier, of course, to paint out of doors with watercolours, rather than oil paints; several Pre-Raphaelite landscape painters, including Ruskin, confined themselves mainly or entirely to this medium. Instead of the transparent washes of an earlier generation, however, they generally strengthened their watercolours with bodycolour, producing a greater intensity of colour. Ruskin loved the dramatic mountain scenes painted by Turner, his first artistic hero, and did his best to persuade Pre-Raphaelite artists, starting (unsuccessfully) with Millais, to go to Switzerland and paint grand landscapes. Yet there was a strong tendency among Pre-Raphaelite landscape painters to find beauties in the homely and

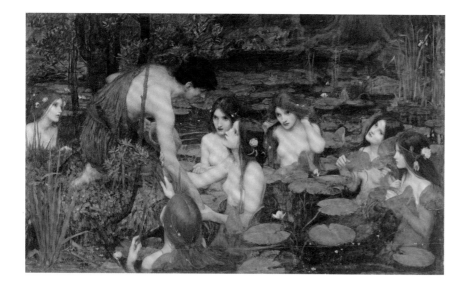

Fig.17 John William Waterhouse (1849–1917), *Hylas and the Nymphs*, 1896. Oil on canvas. Manchester Art Gallery. MAN62987. Manchester Art Gallery / Bridgeman Images.

everyday scenes of southern England. This characteristic is most fully expressed in the watercolours of George Price Boyce, whose subjects of old barns and farm buildings will be familiar to those who know the countryside around Oxford.

Pre-Raphaelitism lasted until the early years of the twentieth century. Burne-Jones continued to paint, draw and make designs until his death in 1898; his work was widely exhibited, both in Britain and abroad. Holman Hunt completed his third and final version of *The Light of the World*, the painting that now hangs in St Paul's Cathedral, London, in 1904. In the following year he published his autobiographical account of the movement, *Pre-Raphaelitism and the Pre-Raphaelite Brotherhood*, claiming that Pre-Raphaelitism was fundamentally about imitating nature, rather than imitating the qualities of medieval or early Renaissance art, and downplaying the importance of Rossetti.

Ironically, however, it was the followers of the Rossettian, imaginative strand of the movement who had the greatest longevity. Marie Spartali Stillman was born in 1843, so she was only a child when the PRB was formed, but she trained with Brown, became a friend to Burne-Jones and modelled for Rossetti; she lived until 1927. John William Waterhouse was born in 1849, after the formation of the PRB, yet his *Hylas and the Nymphs* of 1896 (fig.17) is now one of the most famous of all Pre-Raphaelite paintings; he continued to paint in a Pre-Raphaelite style up until his death in 1917. Eleanor Fortescue-Brickdale, 'the last Pre-Raphaelite', was born in 1872 and continued painting until the 1930s. Arthur Hughes, whose work combined both naturalist and revivalist tendencies, lived long enough to visit the Pre-Raphaelite room in the Ashmolean in 1909. He was proud to see his painting *Home from Sea* (fig.62) hanging close to Rossetti's watercolour, *Dante Drawing an Angel on the Anniversary of Beatrice's Death* (fig.4).[27]

Navigating the 'many botherations of a picture': the Techniques and Materials of George Price Boyce, Dante Gabriel Rossetti and Edward Burne-Jones

Fiona Mann

New developments in chemistry, manufacturing and distribution dramatically expanded the range and availability of artists' materials in England during the second half of the nineteenth century. A tempting array of brilliant new pigments and innovative types of brush, pencil and paper encouraged artists to experiment, break conventions and challenge hierarchical boundaries. The lure of these mass-produced advances of the industrial age was tempered by a longing for the past, however – especially for the Middle Ages, which represented an idyllic vision of moral purity, truth and artistic collaboration. Historical methods were eagerly revived and recreated especially in the decorative arts, often employing a unique combination of traditional and modern materials.

When the Society of Painters in Water Colours opened their summer exhibition in 1864, the *Art Journal* proclaimed it the 'best exhibition ever known', reflecting that:

> as the colours at command multiplied, as the papers manufactured became of every variety of substance and surface, from the smoothness of an ivory tablet to the roughness of a brick and plaster wall, and as the modes of manipulation magnified the power of the skilful master ambitious to push his art to the utmost pitch of elaboration, so did water-colour painting...enhance its glory.[1]

Two young artists, George Price Boyce and Edward Burne-Jones, had been elected associate members of the society that year. Boyce's contributions, seen as conventional representations of 'simple nature', contrasted strongly with Burne-Jones's daringly 'mediaeval and archaic' creations. Both men had become close friends with Dante Gabriel Rossetti, forming a mutually supportive network, with Rossetti providing instruction in painting techniques and Boyce giving vital financial support by purchasing Rossetti's and Burne-Jones's early work. All three artists were strongly influenced by the writings of John Ruskin, who also became an important patron in their early years, while often doling out harsh criticisms of their work.

Boyce, Rossetti and Burne-Jones all obtained artists' materials from the colourman Charles Roberson, of Long Acre in London. Roberson had opened

his first shop in 54 Long Acre in 1819, and by the second half of the nineteenth century he was supplying many of the major artists and art institutions of the day with ready-prepared pigments, canvases and brushes. He also provided services such as renting out lay figures, repairing damaged works, delivering paintings to exhibitions and studios and custom-making materials to an artist's specific requirements.[2] With the exception of William Bell Scott and Eleanor Fortescue-Brickdale, all of the artists represented in this exhibition had accounts with Roberson, whose impressive handwritten ledgers are now housed in the archive of the Hamilton Kerr Institute near Cambridge.

The Roberson archive is currently closed to scholars, but I was fortunate some years ago to access the ledgers for Burne-Jones and some early ledgers for Rossetti. These offered valuable details about the materials that Rossetti and Burne-Jones employed, in particular their experimentation with many new nineteenth-century products.[3] Boyce's ledgers remain unexplored, although his diaries and family letters, recently published in their entirety for the first time, reveal much about his working methods. This essay will highlight the impressive variety of media and techniques the three artists adopted as they explored the possibilities of artists' materials, old and new.

George Price Boyce initially trained as an architect, but by 1849 he had settled on becoming an artist. He spent periods of time in Betws-y-Coed, where he met and received some watercolour instruction from the artist David Cox (fig.18). Inspired by Cox's use of coarse 'Scotch' wrapping papers – full of specks and imperfections, but varied in tone and suited to a looser application of paint – in August 1851 Boyce eagerly attempted 'an evening sketch on grey wrapping-up paper, which Cox saw and approved'.[4] It was from Cox that Boyce also learnt about pigment combinations, carefully noting in his diary that:

> Mr Cox uses cobalt for blue sky, French blue and black for shadows of distant ones [mountains]... Cobalt and light red for distance, indigo, gamboge and purple for lake middle distance. Brown pink is merged into foregrounds. He uses Prussian blue in bright greens.[5]

These colours are included in Cox's influential manual, *A Treatise on Landscape Painting and Effect in Water Colours*, first published in 1813–14 and reissued in 1840. Without recourse to Boyce's Roberson ledgers, we cannot know whether he followed Cox's example of using mainly hard cakes of watercolour for outdoor sketching.

David Cox's particular interest in atmospheric and lighting effects produced at different times of the day must have especially appealed to Boyce, who admitted to Ruskin in 1854 his own 'liking for after sunset and twilight effects'. Ruskin's response was predictably critical: 'He said I must not be led away by them, as on account of the little light requisite for them, they were easier of realization than sunlight effects.'[6] Boyce's taste for moonlit scenes, particularly of the Thames, anticipated the work of Whistler, whom he met in 1860 and who began working on an etching of the river from Boyce's Blackfriars rooms in February 1863. Two of the watercolours in this exhibition provide examples of Boyce's fascination

Fig.18 David Cox (1783–1859), *The Challenge*, 1853. Watercolour on paper. Ashmolean Museum, WA 1967.52.8.

with twilight effects: *The Nile Valley, Mottaham, and the Citadel of Cairo, from the Neighbourhood of the Pyramids of Gizeh* (cat.91), painted in 1861–2, and *Pangbourne, Berks, After Sunset* (cat.93), dating from 1865. Boyce had travelled to Egypt in October 1861, exploring Cairo and the Nile Valley before returning home the following spring. The tiny Nile scene must have been painted in a small travelling sketchbook and was probably intended to be worked up into a larger version on his return home. His friend Rossetti was unimpressed with Boyce's Eastern subjects, however, complaining that 'all the things that artists brought from the east were always all alike and equally uninteresting'.[7]

During 1859 and the 1860s Boyce spent long periods of time working directly from nature along the Thames between Streatley and Pangbourne. He is known to have rowed up and down the river in a boat to discover suitable locations, possibly inspired by J. M. W. Turner's practice earlier in the century. *Pangbourne, Berks, After Sunset*, with its beautiful mirroring of purple clouds in the waters of the river below, was one of many atmospheric scenes Boyce painted in this rural area. It must have been challenging to transport his painting equipment by boat. On one occasion at Wargrave he returned to collect some things he had left behind, only to find 'a cow had been devouring my sketching umbrella and had eaten ¾ of it'.[8] The folding 'Sketching Umbrella' was one of many new items of portable sketching equipment being offered by suppliers of artists' materials after 1850, as the fashion for outdoor sketching increased (fig.19). Burne-Jones also purchased one of these from Roberson in 1857, although he soon abandoned attempts to work out of doors.

Old Barn at Whitchurch (cat.92) is another sketch Boyce made near Pangbourne, lovingly completed with his eye for architectural detail. Centre stage is given to a magnificent old farm building complete with red tiled roof, large porches to what are possibly two threshing bays and a lean-to chicken shed. By

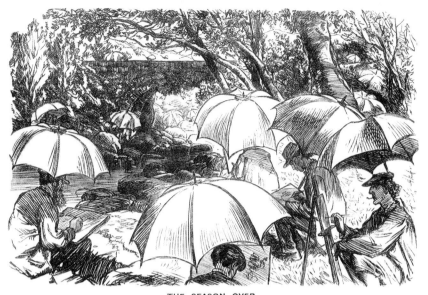

THE SEASON OVER,

OUR ARTISTS GO TO NATURE, AND THIS IS THE CHEERFUL STATE OF THINGS AT THAT SECLUDED AND DELIGHTFUL PLACE
BETTWS-Y-COED, NORTH WALES.

Fig.19 Illustration in *Punch*, 19 August 1865, p. 72: *The Season over, our artists go to nature, and this is the cheerful state of things at that secluded and delightful place, Bettws-y-Coed, North Wales.* PCL114990. Punch Cartoon Library / TopFoto.

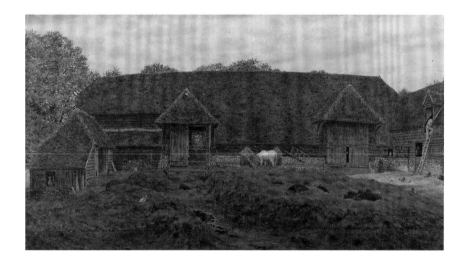

Fig.20 George Price Boyce (1826–1897), *Old Barn at Whitchurch*. Watercolour and bodycolour on paper. Christie's sale, 4 November 1999, lot 22. Photo © Christie's Images / Bridgeman Images.

adding the black Berkshire pigs 'snoozling in the straw in the foreground',[9] Boyce was perhaps heeding Ruskin's advice, given in April 1856, to include 'a faithful bit of foreground Preraffaelite work'.[10] A larger version of this composition was submitted to Boyce's first summer exhibition as an associate of the Society of Painters in Water Colours in 1864 (fig.20). In this version he has raised the horizon to accentuate the structure of the barn, the details of the tiles on the red roof and the straw. However, to Boyce's intense dismay, the work was badly hung. He was advised that 'the Barn drawing was tried in many places, but would not harmonise with its neighbours, so was put on the floor'.[11] Boyce felt he had been very unfairly treated. At least he could commiserate with Burne-Jones, whose radical watercolour *The Merciful Knight*[12] was hung 'high up out of sight behind the door' in 'what they call the naughty boy's corner'.[13]

In October 1851 Boyce began to attend life-drawing sessions at the Artists' Society in Clipstone Street, which had been started by Thomas Seddon and his architect brother John Pollard Seddon. In 1858 Boyce also sketched at the Philographic Society in Savile Row and at meetings of the Hogarth Club. During the winter months in the 1860s, when outdoor working was not practical, his diaries record that he was sketching in his studio from a number of different young women, many of whom also modelled for Rossetti. Described by both artists as 'stunners', they included Miss Cooke, Miss Varley, Agnes Manetti, Lizzie Gresham, Annie Miller, Ellen Smith and Alexa Wilding. Boyce's small female portraits may have been inspired by Rossetti's move away from his small-scale medieval subjects to painting beautiful women in 'a rather Venetian aspect',[14] such as *Bocca Baciata*,[15] commissioned by Boyce himself in 1859 (fig.21).

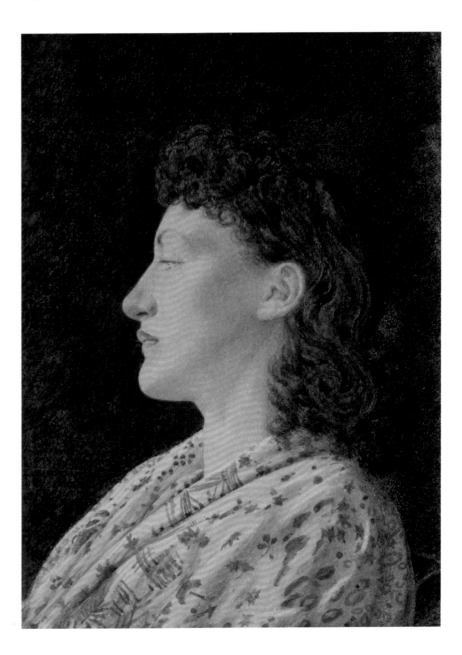

Fig.21 George Price Boyce (1826–1897), *A Girl's Portrait, c.*1868. Watercolour on paper. Tate, London. T05018. Photo © Tate.

Boyce was curious about the effects produced by different pigments and papers. He tried out a new type of 'straw paper', given to him in 1854 by the illustrator Charles Keene, creator of the *Punch* illustration shown in fig.19, which was said to be good for receiving washes, and questioned Henry Tanworth Wells about his use of Antwerp Blue, a pale variety of Prussian Blue. According to Wells, the blue pigment 'had turned the grey greens etc. into purples (by destroying the yellow I suppose) and committed other kinds of devilry'. 'Why cannot he be satisfied with indigo?' Wells asked Joanna, George's sister, before continuing 'but of course George can't use what the common herd do.'[16]

Together with Burne-Jones, Boyce gazed admiringly at medieval illuminated manuscripts in the British Museum, from the *Roman de la Rose* to works by Froissart and Christine de Pizan. Boyce commissioned the jewel-like *Girl and Goldfish*[17] watercolour from Burne-Jones in 1861. The two men shared an interest in piano design, and Boyce in fact purchased the pen and ink design of *Ladies and Death*[18] that Burne-Jones made as a decorative panel for his own instrument in 1860. Boyce submitted drawings to W. G. Eavestaff for a new piano of his own the following year.

Boyce's love for painting *en plein air* contrasted strongly with both Burne-Jones's and Rossetti's intense dislike of painting outdoors. Rossetti shrewdly capitalised on Boyce's expertise in capturing geographical detail in 1858 by borrowing two sketches the artist had made at Babbacombe Bay to use as inspiration for the background in his watercolour *Writing on the Sand* (fig.22). Boyce also obliged him by sending a tracing of a windmill in 1856 to be incorporated into the background of his early watercolour version of *Dante's Dream at the Time of the Death of Beatrice*.[19] Rossetti similarly had recourse to Boyce's collection of china, materials and costumes, in 1863 borrowing a piece of jewellery and a 'green Japanese lady's dress' from Boyce for his oil painting of *The Beloved*.[20]

In 1862 Boyce moved into Rossetti's former Blackfriars studio when Rossetti relocated to Chelsea. Rossetti's charming pen and ink drawing shows his friend painting at an easel in the Blackfriars studio, with Fanny Cornforth leaning affectionately on his shoulder (fig.23). Boyce is sitting with the window to his left – the working position also adopted by Rossetti, who specified to his patrons that his pictures should 'be hung with the light from the left – i.e. of the spectator – that being the light in which they were painted'.[21] Rossetti's palette can be seen on the wall behind, hanging like an artwork, next to a portrait of the beautiful actress Ruth Herbert, 'a model whom I have been longing to paint for years'.[22] Rossetti made a number of delicate drawings and watercolours of her during the same year (cats 33 and 34). Many of these works remained in Ruth Herbert's possession. Fanny Cornforth also modelled for many drawings and paintings, including the portrait of her in pen and brown ink made around 1860 (cat.35), which also shows her fine profile.

Whereas George Price Boyce's subjects mainly centred around his natural interest in architecture and landscape, Rossetti's passion for poetry and literature was the main driving force behind his early artistic endeavours. As Robert Wilkes's essay in this catalogue explains, Rossetti drew inspiration from a diverse range of literary sources. An impatient scholar, he tolerated brief spells of

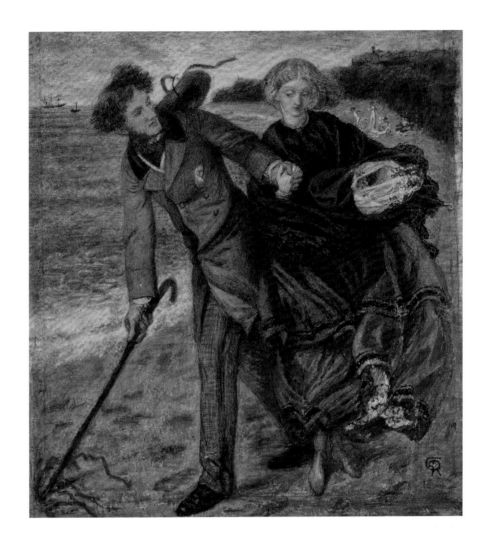

Fig.22 Dante Gabriel Rossetti (1828–
1882), *Writing on the Sand,* 1858–9.
Watercolour on paper. British Museum.
1886.0607.14. © The Trustees of the
British Museum.

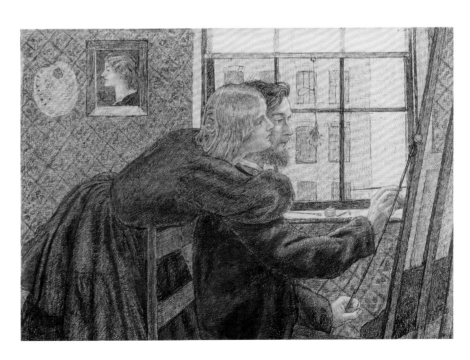

Fig.23 Dante Gabriel Rossetti (1828–
1882), *Fanny Cornforth and George Price
Boyce,* 1858. Pen and ink on paper. Tullie
House Museum and Art Gallery, Carlisle.
From the collections at Tullie House
Museum, Carlisle.

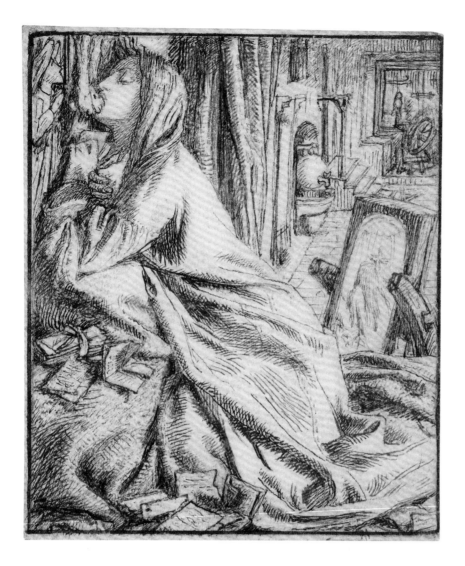

Fig.24 Dante Gabriel Rossetti (1828–1882), Design for Moxon's Tennyson – *Mariana in the South*, 1856–7. Pen and black ink with framed edge on paper. Birmingham Museums and Art Gallery. 1904P237. Photo by Birmingham Museums Trust, licensed under CCO.

training at Sass's School of Art followed by the Royal Academy, but soon set off on his own path. In 1848 he turned to Ford Madox Brown for some instruction in colour. Madox Brown's training at academies in Bruges, Ghent and Antwerp, as well as his time spent with the Nazarenes in Rome, provided a distinct contrast to the stifling limitations imposed by the Royal Academy Schools. In addition to providing Rossetti with advice on how to set a palette and on methods of painting, Madox Brown's highly methodical approach clearly also encompassed skills such as 'drawing in French chalk, and pen and ink, painting in oil and watercolour from life, still life and casts from nature'.[23] Rossetti continued to seek advice from the artist throughout his career.

During the late 1850s Rossetti created intricately detailed Düreresque pen and ink designs for the Moxon edition of Tennyson's poems. He used painstaking techniques commonly employed in woodblock illustration and medieval illumination, such as hatching and cross-hatching, to convey shading on the draperies and flesh (fig.24). 'You ask me whether I sketch my pen-and-ink drawings first in pencil,' Rossetti wrote in a letter to his aunt Charlotte in 1859, 'I always do so,

as far as indicating the composition goes, but little more.' He acknowledged that a complex larger pen and ink drawing, *Mary Magdalene at the Door of Simon the Pharisee* (fig.25), commissioned by Thomas Plint, contained 'when finished, fully as much work as, if not more than, a watercolour of the same size, for which I should ask considerably more'.[24] Ruth Herbert, said to be the model for Mary in the finished composition, first came to sit for Rossetti in June 1858: cat.34 is one of many studies he made of her at that time, possibly for use in the *Mary Magdalene* drawing.[25]

Rossetti's early watercolours adopted many of the methods used in his pen and ink drawings, stippling and hatching using fine brushes. His application of colour, however, was radical. Rejecting traditional transparent washes, he worked in what one of his students at the Working Men's College called the 'dry brush style', a method favoured by Ford Madox Brown, 'rubbing with an almost dry brush on hard chips' of watercolour to achieve a 'strange iridescence'.[26] Traditional hard cakes of watercolour required laborious grating or grinding with water each day and were advocated by Ruskin in his 1857 manual, *The Elements of Drawing* (fig.26). By August 1852 Rossetti was buying tubes of watercolour

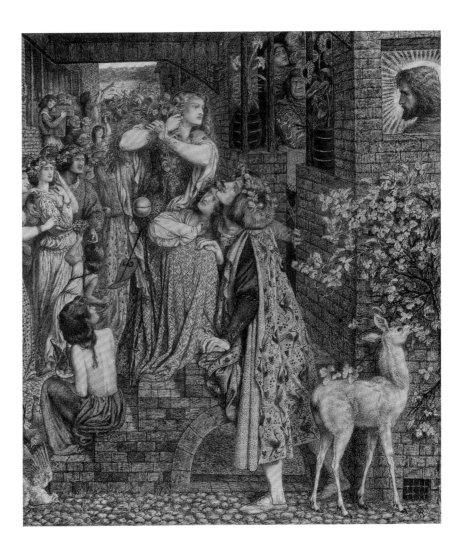

Fig.25 Dante Gabriel Rossetti (1828–1882), *Mary Madgalene at the Door of Simon the Pharisee*, 1858. Pen and Indian ink on paper. Fitzwilliam Museum, Cambridge. 2151. © Fitzwilliam Museum, University of Cambridge.

paint, an innovation first introduced by Winsor & Newton in 1842. These enabled a large volume of paint to be squeezed out directly onto the palette, 'affording facilities for power of touch and vigour of effect'.[27]

Carlisle Wall (The Lovers) (cat.24), said to have been painted 'in two evenings at W. B. Scott's in Newcastle',[28] was acquired by Madox Brown in settlement of a debt in 1853. The luminous sky streaked with orange and blue recalls the 'prismatic system of colour' that Rossetti so admired in William Blake's work, 'in which tints laid on side by side ... are made to produce a startling and novel effect'.[29] The picture's dimensions suggest it might have been carried out in an octavo Imperial sketchbook (10 × 7 in / 25.4 × 17.8 cm). In *St George slaying the Dragon* (cat.77) Rossetti superimposed layers of thick dry colour to create the textures of St George's shining suit of armour, the patterned dress of Princess Sabra and the scaly skin of the dragon; the flesh tones were achieved by means of tiny, cross-hatched strokes of different colours (fig.27). The main figures are outlined in purple. Burne-Jones described Rossetti's early method of painting, in which he began with a rough pencil outline, then painted it over 'clearly and rather sharply in a colour called violet carmine'.[30] In 1859 Rossetti wrote to Ford Madox Brown inquiring about a similar colour: 'Have you any *Burnt Lake* among those colours of Tom Seddon's. I have been using some which I had from the same source for the laying in of my large picture ... no *Laque Brulée* even at Barbe's is anything like the same tint'.[31] The colourman Lechertier Barbe was by 1849 established in Regent Street and counted Ford Madox Brown among their clients.

The watercolour pigments Rossetti used in 1854 when teaching at the Working Men's College included traditional colours such as vermilion and

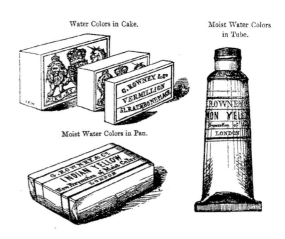

Fig.26 Watercolour cakes, moist cakes and tube colours by George Rowney and Co. (from catalogue of artists' materials attached to George Rosenberg, *The Guide to Flower Painting in Water Colors*, London, 1852, p. 3). Image courtesy of Fiona Mann.

Fig.27 Dante Gabriel Rossetti (1828–1882), *St George slaying the Dragon*, 1863 (detail showing cross-hatching). Watercolour and bodycolour on off-white paper. Ashmolean Museum. Presented by Miss H.M. Virtue-Tebbs, 1944; WA1944.27.

CONTÉ CRAYONS.

Black Square Conté Crayons, No. 1, 2, and 3,			per doz.			
Ditto Round, glazed	,,		
Velours, very soft and black	,,			
Red, Square, Conté Crayons	,,			
Bistre	,,

Fig.28 Conté crayons, from Winsor & Newton, *Catalogue of Materials for Water-Colour Painting, and Sketching, Pencil, and Chalk Drawing,* London, 1849, p. 31. Image courtesy of Fiona Mann.

red lead, in addition to more recently introduced colours such as purple carmine, cobalt, chrome yellow and emerald green.[32] Many were unstable and either faded or darkened on exposure to the atmosphere, causing some early watercolours to deteriorate. Burne-Jones was dismayed by Rossetti's careless attitude towards pigments, including his early use of red lead for flesh; he noted that: 'Heads that had once been so beautiful are now seamed and haggard, with dark marks where the red lead he used for flesh colour is turning black.'[33] Other colours purchased by Rossetti from Roberson between 1852 and 1866 include indigo, scarlet madder, yellow madder, lemon yellow, ultramarine ash, Chinese white, gold shell and three greens: malachite, cobalt green and hooker's green (a combination of Prussian blue and gamboge).[34]

In December 1852 Rossetti purchased 'conté crayon pencils' at a cost of one shilling and 8 pence from Roberson.[35] Conté crayons, invented in 1795 by Nicolas-Jacques Conté, initially aimed to emulate English graphite pencils. They comprised pulverised French graphite mixed with clay, which was heated and then formed into thin sticks encased in wood to form a pencil that could be sharpened. A later variation available by 1849 (fig.28) came as small fat square or round blocks in a range of colours (black, white, bistre and sanguine),[36] without the wooden casing. They permitted a range of effects, from thin lines produced by the tip to broad shading using the sides of the stick.[37] During the 1860s and 1870s, as he began to move away from small, intimate pen and ink drawings and watercolours, Rossetti increasingly used coloured chalks and pastels to create preparatory sketches for much larger compositions – following the tradition of Renaissance masters such as Michelangelo.

Head of a Woman (attendant for 'Astarte Syriaca') (cat.39) is a study he made in 1875 for his oil painting of the Syrian goddess of love, Astarte, which was completed in 1877 (fig.2). The study is on pale green paper, using mainly brown and red chalk heightened with white. Another study of the same dimensions, showing the head of Astarte, based on Jane Morris, can be found in the Victoria and Albert Museum. Other similarly sized chalk sketches were made, also on a pale green paper, for the heads of Dante and Love in another monumental oil painting of 1871, *Dante's Dream at the time of the Death of Beatrice.*[38] Toned or coloured grounds had been used for drawings in natural red and black chalks by Leonardo da Vinci (one of the Pre-Raphaelite's 'Immortals') during the early 1490s; they were also advocated in the *Libro dell'Arte* of Cennini, who noted that a green tinted paper for drawing was popular 'both for shading down and for putting lights on'.[39]

By 1856 contemporary manuals, such as *The Art of Painting and Drawing in Coloured Crayons* by Henry Murray, recommended using a 'soft machine-made drawing paper' of a 'middle tint' which will most successfully 'bear out the colours of the crayons', using the fingers to blend colours together on the sheet.[40] In a letter written to his friend Frederic Shields in early 1871, Rossetti reveals that previous attempts to draw in chalk on a dark blue grey paper had been unsuccessful, requiring 'endless work to keep the ground down', but that

he now found 'the greenish paper (from Winsor & Newton specimen enclosed) is much the best for the purpose which the English makers afford – I have tried several', despite its having 'a tendency to fade and turn yellow in parts'.[41] In their 1878 catalogue Winsor & Newton offered 'tinted crayon papers (machine made). A great variety of Tints' in three sizes: Royal (24 × 19 ½ in / 61 × 49.5 cm), Imperial (30 ¾ × 22 ¼ in / 78 × 56.5 cm) and Double Elephant (40 × 27 in / 101.6 × 68.6 cm).[42] A more expensive handmade sheet was also available. The studies for *Astarte* would have been made on sheets of tinted paper of Royal size. One of the sources of chalks, including a particular grey shade recommended by Shields for use on tinted paper, was Brodie and Middleton of 69 Long Acre, not far from Roberson's shop.[43]

Completed quickly, many preparatory works in chalk were eagerly purchased by patrons such as Frederick Leyland and William Graham. The latter feverishly collected different versions of Rossetti's pictures, including both the oil replica of *Beata Beatrix* commissioned in 1871[44] and the similarly sized version executed in red, black and white chalks in 1869.[45] Replication would become a regular part of Rossetti's process. Almost invariably short of money, the artist soon recognised the financial value of these chalk sketches. As he shamelessly commented to Shields following the sale of two chalk drawings to the dealer Agnew at this time (for 80 guineas each), 'If he will go on this will furnish some profitable pot-boiling'.[46] In fact Rossetti made an enlarged replica of his 1875 *Head of a Woman (attendant for 'Astarte Syriaca')* in 1879, also in chalks on green paper, which he is said to have given to the Sunderland art gallery in the year of its opening.

Apart from chalk studies for oil paintings, Rossetti also completed larger compositions in chalk and crayon, as finished works in their own right. *Reverie* (cat.38) is one of two versions, identical in size, completed by Rossetti in 1868. More subdued in colouring and employing mainly grey and red chalks, with some alterations to the neckline of the dress and the inscription in the top left of the picture, the Ashmolean version is a replica of the original drawing, which was sold to Rossetti's friend, the poet and critic Theodore Watts-Dunton, and was later owned for a time by the artist L. S. Lowry.[47] Both works have been drawn on two conjoined pieces of Imperial paper, rather than on one piece of the larger Double Elephant paper, which is surprising. Perhaps Rossetti found it more convenient to work separately on the smaller sheets. The Ashmolean version, inscribed with the initials 'J.M.', was bequeathed by Rossetti to Jane Morris.

The Day Dream (cat.40) is another preparatory study in pastel and black chalk for an oil painting, commissioned by Constantine Ionides in 1879 and completed the following year (fig.29). Initially intended to be on the subject of spring, it shows Jane Morris sitting in the branches of a willow tree

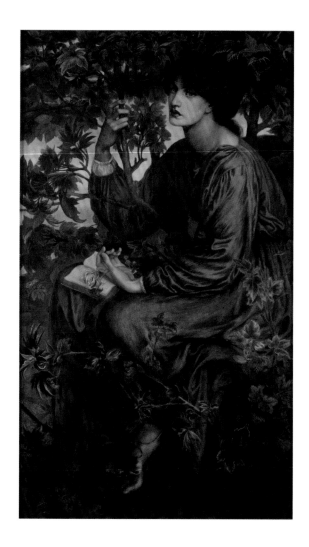

Fig.29 Dante Gabriel Rossetti (1828–1882), *The Day Dream*, 1880. Oil on canvas. Victoria and Albert Museum. 2006AP8073. © Victoria and Albert Museum, London.

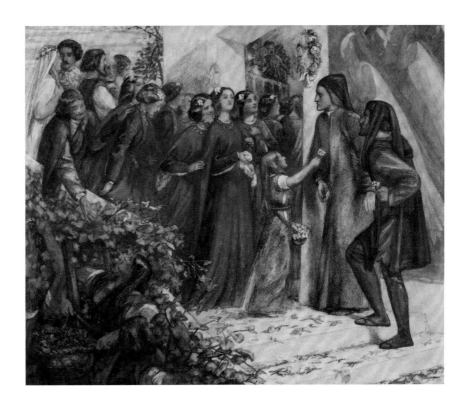

Fig.30 Dante Gabriel Rossetti (1828–1882), *Beatrice, meeting Dante at a Marriage Feast, Denies him her Salutation*, 1851–2. Watercolour and bodycolour with scraping out over traces of graphite on paper. Art Gallery of New South Wales. 431.2003. Photo: AGNSW.

holding a flower in her left hand, which rests on an open book. In the Ashmolean chalk drawing the flower shown is a white convolvulus or bindweed which, in the Victorian language of flowers, represented devoted affection – but in the final painting it was replaced with honeysuckle, also denoting bonds of affection, with the tree now a sycamore. Marillier notes that Rossetti encountered additional technical problems with the oil version, which had been extended to include the figure's legs; at the last minute he was seen to 'deliberately set to and paint out all the lower portion because he thought on consideration that the limbs were made too short'. This revision entailed copying on to a separate canvas

> the sycamore shoots which were painted on top of the drapery, because the season of the year had passed for obtaining fresh specimens. The head of *The Day Dream* was also entirely repainted once if not more times because Rossetti felt dissatisfied with the result.[48]

Rossetti regularly struggled with proportions and perspective. He sought guidance on these matters from both Ford Madox Brown and F. G. Stephens over a period of years. 'Proportions always bother me more than anything else,' he confided to Brown in 1870.[49]

Rossetti's constant desire to rework and alter his designs proved extremely challenging to his patrons, who were often kept waiting for their commissions. Ruskin found this habit particularly irritating. In *Beatrice, Meeting Dante at a Marriage Feast, Denies him her Salutation* of 1855 (fig.3), a replica of an earlier watercolour (fig.30), Rossetti responded to Ruskin's criticism by physically

removing the head of one of the bridesmaids and replacing it with a patch. Ruskin's fury at the artist's action did not prevent him from purchasing the replica, however, before giving it to his friend Charles Eliot Norton at Harvard College.

This radical and clumsy technique of cutting out and repatching was not one recommended in any contemporary watercolour manual. However, it was one that Rossetti also adopted in other small works during the 1850s, including *The Passover in the Holy Family: Gathering Bitter Herbs*[50] and in the intricately worked pen and ink drawing of *Hamlet and Ophelia* of 1858 (fig.31). In this work a new piece of paper was inserted for Hamlet's head and the whole area of arches behind it.[51] Perhaps Rossetti took his cue from medieval manuscripts, in which natural holes or 'lacunae' in the expensive vellum support were sometimes considered acceptable; they were either stitched up or were left visible with the calligraphy written around them. Or it may have been simply impatience on the artist's part and a reflection of what Ruskin called Rossetti's 'slovenly' procedures.[52]

Fig.31 Dante Gabriel Rossetti (1828–1882), *Hamlet and Ophelia*, c.1854–9. Pen and black ink on paper. British Museum. 1910,1210.8 . © The Trustees of the British Museum.

Fig.32 Materials for Illuminating and Missal Painting: Prepared Vellum and Vellum Paper from Winsor & Newton catalogue attached to G. W. Bradley, *A Manual of Illumination on Paper and Vellum*, London, 1860, p. 13. Image courtesy of Fiona Mann.

A small pen and ink sketch of the same incident in *Hamlet and Ophelia*, dated 1865, shows how Rossetti had by this time refined and simplified this composition; he removed much of the fine detail from the background and from Ophelia's dress and focused instead on the two figures, both of whom are now standing.[53] The watercolour version in the exhibition (cat.52), completed in 1866, places the emphasis on blocks of bright colour, the shadows deepened by the use of gum arabic. Rossetti has reintroduced into the foreground the devotional book Ophelia was reading, together with the letters and casket of jewellery that she wished to return to Hamlet.

Under his apprenticeship to Rossetti, Burne-Jones quickly became immersed in creating medieval subjects. Unlike Rossetti, who preferred paper, many of Burne-Jones's small early watercolour and pen and ink drawings were produced on vellum, the material traditionally used for medieval manuscripts. Vellum was made from calfskin, in contrast to parchment, made from sheepskin. Both sides of the skin were used, the hair side providing more 'tooth' for writing on while the flesh side was whiter, smoother and more suitable for painting.[54] J. W. Bradley's *Manual of Illumination*, published in 1860 to cater to the growing Victorian thirst for revivalism, noted that vellum could be 'obtained ready prepared for the Illuminator, in pieces, whole skins, or ready made up into block books'. He noted that it was expensive and delicate, however, and 'the marks upon it cannot easily be erased'.[55] Vellum sheets were available from Winsor & Newton by 1860 (fig.32). The architect William Burges, who was passionate about the decorative arts of the Middle Ages, experimented with Theophilus's ancient recipe for dyeing vellum and ivory with madder.[56] Boyce observed in 1858 that Burges bullied Rossetti into

using vellum when he wished simply for paper. Consequently he didn't make so good a sketch as he would have done had he been left to his own bent. It was in pen and ink, and he gave it to me before leaving.[57]

Burne-Jones had already created his tiny *St John the Baptist*[58] on vellum two years earlier. He went on to produce at least ten small, minutely detailed pen and ink drawings and a few watercolours on vellum, mainly between 1858 and 1861. Other medieval subjects on vellum and dating from 1858 include *Alice, la Belle Pèlerine*,[59] *Sir Galahad*[60] and *Going to Battle*.[61] *The Knight's Farewell* (cat.25), also on vellum, is intricately patterned and finely drawn in pen over graphite,[62] but it does not fill the whole sheet (fig.33). The empty margin to the right of the drawing reveals not only various rough experimental squiggles in pencil and ink, but also a scattering of tiny black dots along the very edge, suggesting that this is the hair side of the vellum sheet. The black dots are the remains of the hair follicles. They suggest this was a skin prepared in winter, when it was more difficult to remove the hair (fig.34).[63]

Burne-Jones did not obtain his vellum from Roberson. He may have bought it from another colourman, such as Winsor & Newton, or from Burges.

Another source may have been William Morris who was sourcing quality vellum for making books from Rome, via Charles Fairfax Murray, during the 1870s.[64] Morris disapproved of the white lead used to prepare the skins sold in England, as it reacted adversely with the gold and the colours.[65] The only two references to vellum in Burne-Jones's ledgers, both for 1869, indicate that Roberson was mounting Burne-Jones's own vellum over stretchers or wooden boards. The first, dated 3 August, notes an order for a small stretcher of 13½ × 9½ inches (34.3 × 23.1 cm) and for 'mounting own vellum on do. [*ditto*]'. This may have been for the watercolour of *The King's Wedding*, which was completed the following year. The second order, for '11 Panel'd Boards covered with linen and own vellum strained over do', is dated 11 August.[66] 'Japanese vellum paper' was a cheaper alternative to the original product, which Burne-Jones bought from Roberson in later years.[67] Winsor & Newton offered sheets of this highly finished and toned paper, resembling vellum, in their 1860 catalogue.[68]

During 1858 and 1861 Burne-Jones ordered other drawing materials from Roberson: Indian Ink, scrapers and erasers.[69] Metal scrapers were 'small, double-edged, triangular points set in handles', designed for removing fine areas of bright white highlights in a painting or drawing.[70] They probably derived from the curved-bladed quill knife of medieval times; held in the left hand, it enabled scribes to remove errors as they worked on manuscripts with their right.[71] Nineteenth-century scrapers came in a variety of shapes and sizes, some designed for watercolour, others for illuminating and oil painting (fig.35). Burne-Jones not only used such tools for corrective measures, but also adopted Rossetti's method of vigorous scratching into the surface of his supports, thus achieving both texture and contrast. These techniques are evident in the softened facial contours of *The Knight's Farewell*, as well as in *Ezekiel and the Burning Pot*[72] of 1861, also on vellum. Here the flames of the fire are indicated by areas of strenuous scratching out.

Above left: fig.33 Sir Edward Coley Burne-Jones (1833–1898), *The Knight's Farewell*, 1858. Whole sheet showing border to the right of the drawing. Ashmolean Museum. Bequeathed by John N. Bryson, 1977; WA1977.34.

Above right: fig.34 Sir Edward Coley Burne-Jones (1833–1898), *The Knight's Farewell*, 1858. Detail of black dots on vellum margin (illustration of hair follicles on hair-side of the sheet). Ashmolean Museum. Bequeathed by John N. Bryson, 1977; WA1977.34.

SCRAPERS AND ERASERS.

1	3	4	5 and 6	7		

	Each s. d.		Each s. d.
Plain Steel Scrapers No 1.	0 6	Cocoa handled Erasers No 5	1 3
Illuminating Erasers No 3.	1 0	Ebony handled Erasers No 6	1 6
Cocoa handled Erasers No 4	1 0	Ivory handled Erasers No 7	2 0

Fig.35 Erasers and scrapers, from *Winsor & Newton's List of Water Colours, Drawing Papers, Water Colour Brushes, and Materials for Water Colour Painting,* attached to Henry Murray, *The Art of Painting and Drawing in Coloured Crayons,* London, 1871, p. 43. Image courtesy of Fiona Mann.

During the 1860s Burne-Jones met with a wide circle of artists, stained-glass makers and architects, all of whom shared a common passion for the revival of ancient decorative arts. William Burges and George Bodley provided the young Burne-Jones with important commissions, Burges inviting him to paint a panel on a highly decorated bookcase[73] and Bodley commissioning him to produce an altarpiece for the church of St Paul's in Brighton. Through such commissions and his stained-glass designs for the burgeoning business of Morris, Marshall, Faulkner & Co., Burne-Jones quickly developed a detailed understanding of the materials and processes involved in a wide range of highly skilled decorative arts, from metalworking, illuminating, mosaics and stained glass to tapestry weaving and carving, using gemstones, special pigments, plaster, leather and wood, as well as metals in foil, leaf and powder. Burne-Jones adopted similar effects into his paintings, blurring the boundaries between decorative and fine art.

Burne-Jones's love for the brilliant colouring of illuminated manuscripts provided the inspiration for one avant-garde technique he adopted not traditionally employed in transparent watercolour painting: the application of metallic paints, which contained powdered metals and sometimes also coloured pigments. In 1861 the artist began ordering gold shells from Roberson (powdered gold mixed with gum arabic, which had historically been sold in mussel shells), followed in 1870 by paints including silver and more recently introduced metals such as aluminium and platina. These other metals have a more silvery appearance than gold powder, making cooler and whiter metallic paints. These were used to embellish his beautiful large watercolours such as the *Days of Creation*.[74] Between 1893 and 1896 Burne-Jones purchased cakes of gold metallic paints in shades of red, lemon and green; he used them alongside cakes of silver, red copper and aluminium in order to create experimental 'drawings in tints of gold on coloured grounds'.[75] *Hope* (cat.28), painted in metallic gold paint on prepared paper, illustrates Burne-Jones's skill at reworking earlier designs in alternative

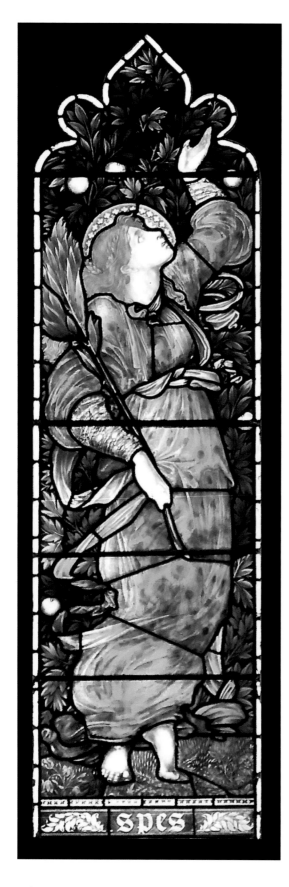

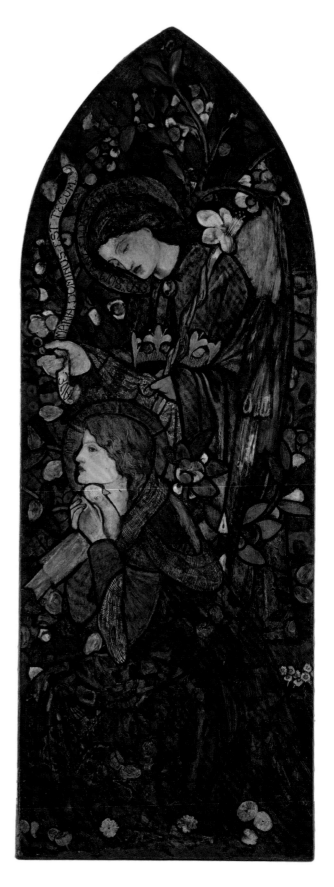

media; it refers back to a design made in 1871 for a stained-glass window depicting the figures of Faith, Hope and Charity, for Christ Church in Oxford (fig.36). A large watercolour version of *Hope* had been completed in 1871[76] and an oil replica would be commissioned in 1896.[77] Works such as *Study of a Woman with a Musical Instrument*,[78] *Nymphs of the Stars* and *Nymphs of the Moon*[79] all display Burne-Jones's experimental use of metallic preparations during the 1890s. This was a challenging process, as he explained to his assistant Thomas Rooke:

> This gold work must be done very directly – it's an art of itself. I forget how to do it between one time and another, and it's always an experiment.[80]

Following the formation of Morris, Marshall, Faulkner & Co. in 1861, Burne-Jones's attention turned increasingly to designs for decorated furniture and for stained glass. In 1862 he provided designs for the East Window of St Michael and All Angels Church in Lyndhurst, Hampshire, a new church then being constructed in the Gothic revival style. Cats 75 and 76 represent two of the lights which he also designed for the church. The angel figures playing their instruments have been expertly compressed into the contorted space of the trefoil; the dark outlines of the Angel Harpist indicate the leading lines for the stained glass, while lead-lines of the more complex Angel Organist are absent. Morris's insistence on dictating the colours for stained-glass windows himself meant that Burne-Jones could only provide the palest indications in these cartoons. Other commissions, such as the one from Lavers and Barraud in 1859 for the church of St Columba in Topcliffe, had allowed him to choose his own colours. The result was a brilliantly painted cartoon which was carefully reproduced in the final Annunciation window (fig.37).[81]

Patience, a steady hand and attention to detail were all qualities particularly required for working in metalpoint, a delicate Renaissance medium which underwent a revival in Victorian England. Silverpoint required the use of a sharp metal stylus on a specially prepared surface, often green, pink, grey or yellow in colour, with tones built up by means of fine parallel lines and intricate hatching. Valued for its permanence, it was almost impossible to erase. Burne-Jones produced some preparatory studies for decorative projects and paintings in silverpoint during the 1870s, among them his sketch of *Antonia* (cat.69), a study for his important oil painting *The Golden Stairs*.[82] Combining silverpoint with graphite and bodycolour for the highlights, the sketch was considered by Burne-Jones to be 'the finest drawing I have ever done'.[83] During the second half of the nineteenth century suppliers such as Henry Penny and T. J. & J. Smith began to offer special 'metallic books' of commercially prepared paper, complete with their metal pencils. In 1879–80 Burne-Jones created designs for a piano for his patron William Graham in one of Smith's small metallic books (figs 38 and 39). His passion for piano decoration had already started as early as 1860. Burne-Jones's continuing dedication to the medium of silverpoint is also evident. He went on to exhibit eighteen studies in 'colours, silver-point and chalk' at the Society of Painters in Water Colours in the winter of 1891[84] and purchased a book of metalpoint papers and two silverpoints from Charles Roberson in 1892.

Opposite left: fig.36 Sir Edward Coley Burne-Jones (1833–1898), (designed), Morris, Marshall & Faulkner (manufactured), *Hope*, 1871. Stained-glass window. Christ Church Cathedral, Oxford. By kind permission of the Dean & Canons of Christ Church.

Opposite right: fig.37 Sir Edward Coley Burne-Jones (1833–1898), *The Annunciation*, 1859 (stained-glass design). Oil on canvas. Birmingham Museums and Art Gallery. 1927P406. Photo by Birmingham Museums Trust, licensed under CCO.

Fig.38 Sir Edward Coley Burne-Jones (1833–1898), *Preliminary design for the Graham Piano,* 1878–9. Metalpoint (probably silverpoint) on paper (in a sketchbook). Victoria and Albert Museum. 2013GA2819. © Victoria and Albert Museum, London.

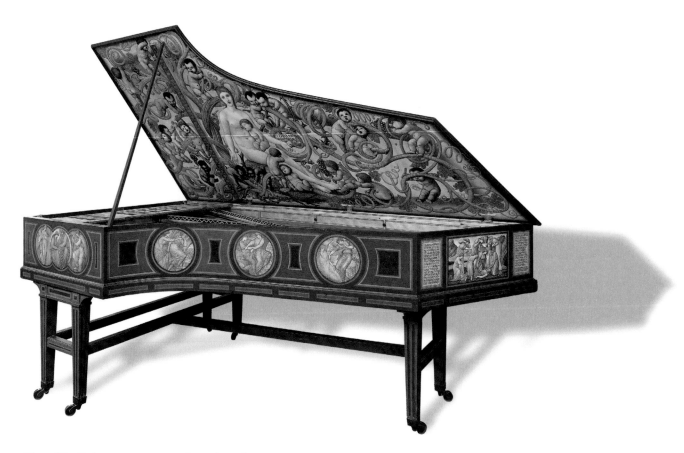

Fig.39 The Graham piano, 1879–80. Painted wood, 98 x 142 x 260 cm. Private collection. Tate, London. M04927. Photo © Tate.

Fig.40 Sir Edward Coley Burne-Jones (1833–1898), *Cerberus* (1872–5) (detail highlighting black specks of graphite). Graphite on paper. Ashmolean Museum. Bequeathed by Sir Philip Burne-Jones, 1926; WA1926.22.

Not all Burne-Jones's designs for the Graham piano were created in silverpoint, however. In 1875 he translated a series of earlier illustrations to Morris's poem, *The Story of Orpheus and Eurydice*, into eleven intricately detailed roundels for his design (cats 56 and 57) using the more correctible medium of pencil. In light of the growing scarcity of high-quality Cumberland graphite ('black gold')[85] at this time, European manufacturers such as A. W. Faber began producing leads from pulverised graphite baked with clay and formed into rods, varying the proportions to create different grades of hardness. However, these often contained grit or were considered too flaky or 'friable',[86] as Burne-Jones himself later acknowledged.

> Sometimes knots will come into it, and I can never get them out, I mean little black specks. There's no drawing I consider perfect ... I look on a perfectly successful drawing as one built up on a groundwork of clear lines till it's finished.[87]

Between 1873 and 1875 Burne-Jones regularly ordered Faber's mechanical pencils and boxes of leads, mainly BB (soft black) or 6B (extra soft and black with a broad lead), from Roberson. Tiny black specks are clearly visible in his beautiful design for *Cerberus* (cat.57), the three-headed dog of Greek mythology who guarded the entrance to the underworld (fig.40).

Whether working in pencil, chalks, metalpoint, pen and ink or watercolour, media which all presented their own challenges, Burne-Jones, Rossetti and Boyce were united by a passion for their art. Sharing resources and working together to overcome the technical difficulties and 'many botherations of a picture',[88] they dismantled the boundaries between high and decorative art, forging ahead with the latest new drawing and painting materials while preserving a deep understanding of ancient techniques.

Reading and Drawing: Pre-Raphaelite Sources in English Literature

Robert Wilkes

LITERATURE WAS IMPORTANT for the Pre-Raphaelites as both a means of expression and a source of inspiration for their artworks. The critic Walter Hamilton declared that 'the union of art and letters in one harmonious whole' was the 'chief raison d'être' of the Pre-Raphaelite Brotherhood (PRB).[1] All seven members of the PRB experimented with writing poetry and prose – some more successfully than others – and they all read voraciously: their list of 50 'Immortals' included 29 writers, ranging from historical authors such as Chaucer, Boccaccio and Shakespeare to more contemporary writers like Tennyson and the Brownings.[2] In 1850 the Brotherhood published a literary magazine, *The Germ: Thoughts Towards Nature in Literature, Poetry, and Art*, which contained poems, essays, reviews and dialogues written by the artists and their friends. The Pre-Raphaelites' paintings and drawings responded to literary texts.

Drawing as a medium was well suited to making illustrations. They could be produced more rapidly than oil paintings and they enabled the artists to experiment freely with their designs without the pressure of exhibiting them – although plenty of these designs were developed into paintings that appeared at the Royal Academy and other public exhibition venues. The artists could also share works on paper more easily among themselves, and drawing clubs such as the Cyclographic Society in 1848 (a precursor to the PRB) and the Folio in 1854 were set up with this principle in mind.[3] Drawings and watercolours offer a different viewing experience to large oil paintings, owing to their small scale and more delicate treatment.

The Ashmolean's 2010 exhibition *The Pre-Raphaelites and Italy* demonstrated how the artists were inspired by subjects from Italian literature.[4] This essay will shift the focus to the Pre-Raphaelites' visual responses to English literary sources, ranging from studies for paintings to designs for book illustrations. It will draw from the Museum's exceptional collection of Pre-Raphaelite works on paper which began with the 1893 Combe bequest. Many of these are by well-known artists such as Holman Hunt, Millais and Rossetti. However, this essay will also highlight works in the Ashmolean collection by members of the Pre-Raphaelite circle who are less familiar today, either because the works are rarely seen or because the artists themselves have often been overlooked.

Opposite: detail of cat.46.

Drawing from the past

Medieval literature was a frequent source of inspiration for the young Pre-Raphaelites. One notable but overlooked example in the Ashmolean is Frederic George Stephens' pen and ink drawing *Dethe and the Riotours* (cat.47), which was begun in 1848 and probably completed in 1853.[5] The subject comes from a strange, violent episode in 'The Pardoner's Tale' from Geoffrey Chaucer's fourteenth-century magnum opus *The Canterbury Tales*. The story, set in medieval Flanders, begins with the conceit of three young men vowing to avenge a friend's death by setting out to find and kill Death. It ends with the men murdering one another by dagger and poison out of jealousy for possession of some gold coins. Given its macabre subject matter, the tale was not very popular with artists who preferred the livelier, more picturesque incidents from Chaucer's *Tales*. Stephens has depicted the moment in 'The Pardoner's Tale' when the three rioters meet a mysterious old man who tells them that they can find Death at the

Fig.41 Frederic George Stephens (1827–1907), *Studies for 'Dethe and the Riotours'*, *c*.1848. Pen on paper. Collection of Robert Wilkes. Courtesy of Robert Wilkes.

Fig.42 John Hamilton Mortimer (1740–1779), *Three Gamblers and Time*, 1787. Engraving. The Wellcome Collection. Wellcome Library no. 38996i. Wellcome Collection. Attribution 4.0 International (CC BY 4.0).

foot of a nearby oak tree. When the rioters reach the tree, they find only the gold coins, thereby setting in motion the grisly events that finish the tale.

Stephens' preliminary sketches for his Chaucer drawing have recently come to light and are reproduced here for the first time (fig.41).[6] Like Hunt's initial idea for *The Light of the World* sketched on the back of an envelope (cat.62), Stephens used whatever materials came to hand in order to jot down his ideas quickly – in this case, a blank order form for arranging the transportation of goods. These early sketches demonstrate that Stephens had worked out the general composition, and even the title 'Dethe and the Riotours', before he started the main drawing in 1848. The general arrangement of the figures may have been inspired by one of the few illustrations of 'The Pardoner's Tale' in circulation, a 1787 engraving by John Hamilton Mortimer (fig.42). The finished Ashmolean drawing is inscribed with a dedication to 'Dante G. Rossetti from his P-R.Br[other] F.G.S.', indicating that Stephens eventually gifted the picture to Rossetti – a common practice among the Pre-Raphaelite Brothers.[7] On the reverse of the sheet Stephens copied out a lengthy extract from 'The Pardoner's Tale' in the original Middle English, as if to prove his faithfulness to Chaucer's text. This extract is signed with the date 'July 1st 1853'. The following year Stephens submitted his drawing to the Folio, a drawing club set up by Rossetti which involved circulating a portfolio of members' drawings among themselves for critical feedback.

Stephens' *Dethe and the Riotours* is a typical example of the early Pre-Raphaelite style of drawing, with its angular human figures and emphasised linearity of forms. It is comparable with other works from this period such as Millais's *The Death of Romeo and Juliet* from 1848 (fig.43) – indeed, the group of figures on the far left of Millais's drawing is echoed in the three rioters in Stephens' picture. Colin Cruise has suggested that Stephens would also have

Fig.43 Sir John Everett Millais (1829–1896), *The Death of Romeo and Juliet – Compositional Study*, 1848. Graphite. Birmingham Museums and Art Gallery. 1906P646. Photo by Birmingham Museums Trust, licensed under CC0.

been mindful of the engravings of early Italian frescoes which he and his fellow PRBs had admired at their early meetings in 1848.[8] Stephens' drawing is the first depiction of a subject from Chaucer by a member of the PRB. He evidently admired *The Canterbury Tales*, using 'The Clerk's Tale' as the basis for his oil painting *The Proposal* (1850–1).[9] Edward Burne-Jones was the next Pre-Raphaelite artist to develop a passion for Chaucer's work, later in the 1850s: the large wardrobe which he painted with scenes from 'The Prioress's Tale' as a wedding present for William and Jane Morris in 1859 is now a highlight of the Ashmolean's collection.

Burne-Jones's enigmatic and finely worked pen and ink drawing *The Knight's Farewell* of 1858 (cat.25) encapsulates the Pre-Raphaelites' engagement with medieval literary sources. Not only is it constructed in a medieval fashion – drawn on a piece of vellum on a small scale, like an image from an illuminated manuscript – but it also depicts a scene inspired by the courtly love tradition popular in medieval literature: a knight taking leave of his lady-love within an enclosed garden (*hortus conclusus*). This apparently simple subject is rendered more complex by the surrounding pictorial details: the crowd of knights sparring among the trees just over the garden wall, and the presence of the male figure (probably a pilgrim) seated on the right, who holds a book entitled 'Roman du Quete du Sangrail' (Romance of the Quest of the Holy Grail). Grail quest narratives were highly popular in the Middle Ages. The presence of this book in Burne-Jones's drawing raises questions about the knight's endeavour: is he leaving to join the battle outside or is he undertaking a grail quest of his own? A possible clue can be found in the pennon hanging from a pole at the centre of the composition, decorated with a saintly female figure – this may allude to the 'Damsel of the Sanct Grael', a character from Thomas Malory's *Le Morte d'Arthur* who was depicted in a watercolour by D. G. Rossetti the previous year.[10]

Burne-Jones's drawing can be read in a different way. The young pilgrim's dreamy expression implies that the other figures in the scene have been imagined by him – they may be a visionary response to the chivalric text in which he is absorbed. Burne-Jones himself was prone to such waking dreams. In 1854, while a student at Oxford, he wrote a letter home to his family describing a walk across Port Meadow from Godstow Priory during which he experienced vivid hallucinations of 'knights and ladies' along the river bank.[11] At the time, Burne-Jones was discovering medieval literature for the first time: Malory's *Morte d'Arthur*, Chaucer and Boccaccio. *The Knight's Farewell* therefore reflects Burne-Jones's newfound interest in reading historical literary texts.

Shakespeare was another giant of English literature whom the Pre-Raphaelites admired – he was one of their named 'Immortals'. Of course, their admiration for Shakespeare was far from unusual; British artists had been illustrating his plays long before 1848. However, the Pre-Raphaelites depicted Shakespeare's historical settings with a radical realism. Paintings such as Millais's *Mariana* (1851) and Hunt's *Claudio and Isabella* (1850–3) and *Valentine Rescuing Sylvia from Proteus* (1850–1) were painted under stringent Pre-Raphaelite principles of 'truth to nature'.[12] For example, Hunt took his large canvas for *Valentine Rescuing Sylvia* down to Knole Park in Kent in October 1850, so that he could paint en

Fig.44 Walter Howell Deverell (1827–1854), *The Banishment of Hamlet, c.*1850. Pen and black ink with grey washes on paper. Ashmolean Museum. WA1977.41.

plein air and thereby locate the human drama within a convincing outdoor setting. Previous artists working under the standard Academy rules would likely have painted a generic woodland background either from memory or their imagination, without going to such physical efforts. Viewers who were accustomed to seeing Shakespeare's plays performed on a stage were now seeing the works 'reperformed' in startling new settings, in the open air or in a real prison cell (as in Hunt's *Claudio and Isabella*, which was partly painted in the prison at Lambeth Palace). They were therefore, in the artists' opinion, more faithful to the original texts.

A Pre-Raphaelite artist particularly drawn to Shakespeare's work was Walter Howell Deverell. He was a close associate of the PRB and was elected to replace James Collinson after Collinson left the Brotherhood in May 1850 (although Deverell never became an official member). Besides being a painter, Deverell was also a part-time actor, which may explain his fascination with Shakespeare; several of his surviving paintings depict Shakespearean subjects.[13] *The Banishment of Hamlet* in the Ashmolean (fig.44) is a preparatory study for the painting of the same title which Deverell exhibited at the National Institution in London in 1851, and which has since been lost.[14] William Michael Rossetti noted in his diary in October 1850 that Deverell was working on the painting depicting 'the ordering of Hamlet's departure for England, of which [D. G. Rossetti] has seen an uncompleted design'.[15] As with Stephens' *Dethe and the Riotours*, Deverell presented his drawing as a gift to D. G. Rossetti at a later date.[16]

The subject of the drawing is apparently from Act 3, Scene 4 of Shakespeare's *Hamlet*, although, as Rebecca A. Jeffrey notes, Deverell has compressed several different details from the narrative into one image, so that it is difficult to read clearly.[17] In the foreground sits Hamlet and on the right looms his villainous uncle

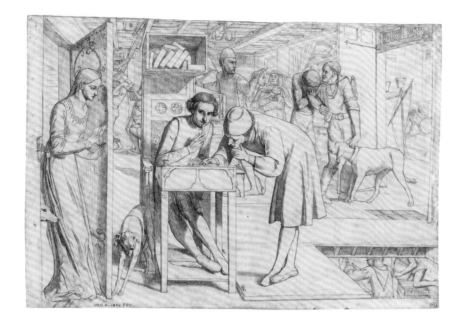

Fig.45 William Holman Hunt (1827–1910), *Lorenzo at his Desk in the Workhouse*, 1848–50. Graphite. Musée du Louvre, Paris. RF 39617. Photo © RMN-Grand Palais (musée d'Orsay) / Thierry Le Mage.

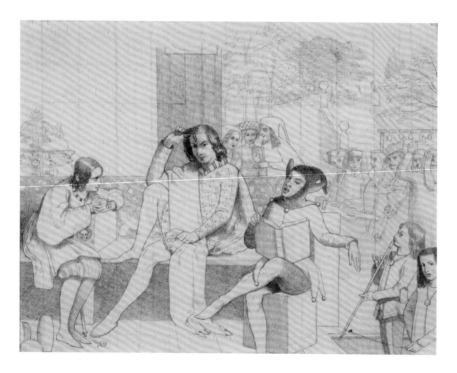

Fig.46 Walter Howell Deverell (1827–1854), *Study for 'Twelfth Night'*, c.1850. Ink and graphite on paper. Tate, London. N03429. Photo © Tate.

and stepfather Claudius. Behind them the lifeless body of Polonius, accidentally stabbed by Hamlet in an earlier scene, is being carried downstairs. Polonius's daughter Ophelia can be seen weeping through the aperture on the left. Other characters include Rosencrantz and Guildenstern, whispering to each other behind Claudius's back, while the woman comforting Ophelia with a hand on her shoulder may be Hamlet's mother Gertrude. Many Pre-Raphaelite pictures focus on intense psychological interactions or emotional exchanges between two central figures and Deverell's drawing continues this motif: Claudius's anger

is contrasted with Hamlet's nervous expression as the prince bites his fingernails (a similar gesture appears in Millais's painting *Isabella* of 1848–9).[18]

The contrast between the highlighted drama in the foreground and the hustle and bustle in the background may have been influenced by Hunt's drawing *Lorenzo at His Desk in the Workhouse*, a subject from John Keats's poem 'Isabella; or, The Pot of Basil' begun in 1848 and completed in 1850 (fig.45). Some idea of Deverell's lost *Banishment of Hamlet* painting can be gained by looking not only at the Ashmolean study, but also at the reviews of the picture when it was exhibited in 1851. One critic wondered if the figure of Claudius had been 'copied, perchance, from the Bayeux Tapestry' – an indication of the archaism of Deverell's style.[19] Deverell evidently liked to fill his subjects with peripheral details: his study for his other Shakespearean painting *Twelfth Night* (fig.46) shows, besides the central trio, two boys standing in the right margin, a group of music-making minstrels and people gossiping.

Elizabeth Siddal, the artist, poet and model, was also drawn to Shakespeare's work. She first entered the Pre-Raphaelite circle in about 1849, partly as a model and partly through her connection with Deverell. At his encouragement Siddal showed her drawings to his father, who was the assistant secretary of the Government School of Design in Somerset House.[20] In around 1853, with Madox Brown's assistance, she opened an account with Charles Roberson and Co., one of the major art suppliers in London.[21] Her drawing now entitled *The Macbeths*

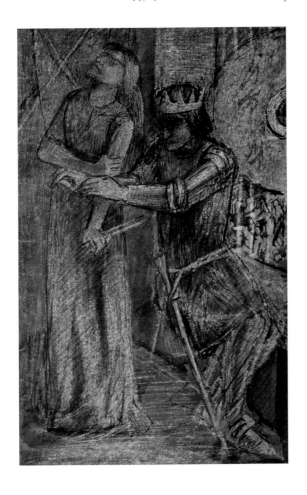

Fig.47 Elizabeth Siddal (1829–1862), *The Macbeths*, c.1855. Pen and brush, Indian ink with scratching out. Ashmolean Museum. WA1937.131.

(fig.47) depicts a tense moment from one of Shakespeare's most popular plays. Macbeth has murdered Duncan, the king of Scotland, in his sleep in an attempt to claim the throne. Macbeth emerges from Duncan's bedroom with the bloody daggers in hand, but Lady Macbeth chastises him for not having left the weapons with Duncan's sleeping servants and framing them for the murder. He is too afraid to return to the crime scene ('I'll go no more. / I am afraid to think what I have done; / Look on't again I dare not'). Lady Macbeth, declaring that her husband is 'infirm of purpose', seizes the daggers from him and goes to do the deed herself, declaring as she does so:

> Give me the daggers. The sleeping and the dead
> Are but as pictures; 'tis the eye of childhood
> That fears a painted devil. If he do bleed,
> I'll gild the faces of the grooms withal,
> For it must seem their guilt. (Act 2, Scene 2, ll. 51–6)

Siddal's small drawing conveys the psychological intensity of Shakespeare's scene through the figures' tense, angular poses: Lady Macbeth grips her left arm and her head is thrust back in defiant determination, while her husband sits uncomfortably in an alcove. Some elements of the composition are more awkwardly drawn – Macbeth's hands hover in mid-air and he is positioned too near to the edge of his seat. Yet this perceived

'naivety' is a quality for which Siddal's works were admired. The daggers themselves are communicated simply through sharp scratches in the paper. Siddal shared this experimental approach to watercolour, incorporating different techniques of scratching and scraping, with Rossetti, whose early watercolours in the 1850s exhibit similar textural effects.[22] Siddal's *Macbeth* is undated, but the grisaille technique recalls one of the studies she made for her 1857 watercolour *Clerk Saunders* (fig.48), so they could have been produced at the same time. *The Macbeths* uses a similar composition to *Clerk Saunders*, pairing a male and female figure within a claustrophobic interior.

Rossetti continued to explore the emotional tension between Shakespeare's men and women in his 1866 watercolour *Hamlet and Ophelia* (cat.52). He had been interested in the subject since the early 1850s, depicting it in an elaborate pen and ink drawing which is now in the British Museum (fig.31). The rich, jewel-like colour palette and dry-brush technique are typical of Rossetti's

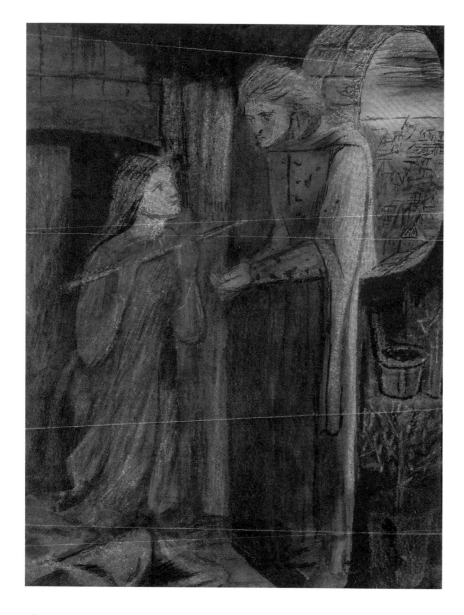

Fig.48 Elizabeth Siddal (1829–1862), *Study for 'Clerk Saunders'*, c.1857. Brush and pen and black and brown inks with scraping. Collection of Dennis T. Lanigan. CH6331492. Photo © Christie's Images / Bridgeman Images.

watercolours, which he often produced for additional income while he worked on his more time-consuming oil paintings.[23] *Hamlet and Ophelia* still has its original gilded frame, designed by Rossetti himself, which is inscribed with the line which Hamlet is speaking: 'What should such fellows as I do, crawling between earth and heaven?'[24] Like Siddal's *Macbeths*, Rossetti presents a claustrophobic interior in which the human figures are caught in a dramatic moment.

The Border ballads were another archaic literary source used by some of the Pre-Raphaelites. The Brotherhood's 'List of Immortals' included 'Early English Balladists', although the term 'English' is misleading as many of the poems were Anglo-Scottish, originating from both England and Scotland. They had inspired British authors long before the Pre-Raphaelites, including Sir Walter Scott: he edited an anthology of them, 'Minstrelsy of the Scottish Border' (1802), and wrote a long narrative poem inspired by them, *The Lay of the Last Minstrel* (1805). Scott's poetry inspired a watercolour by Rossetti, titled *Carlisle Wall* (also titled *The Lovers*), in the Ashmolean (cat.24). Rossetti evidently made the picture while he was staying with William Bell Scott in Newcastle in the summer of 1853, following a visit to Carlisle in Cumberland.[25] A surviving sketch made by Rossetti on the battlements of Wetheral Priory Gatehouse, within days of his visit to Carlisle, could have provided the setting for the watercolour.[26] William Sharp noted that the title comes 'from the motto line "The sun shines red on Carlisle Wall".'[27] Sharp was misquoting the line from Canto 6 of Scott's *Lay of the Last Minstrel*:

> It was an English ladye bright,
> (The sun shines fair on Carlisle wall,)
> And she would marry a Scottish knight,
> For Love will still be lord of all!

Rossetti conveys the couple's passion through their poses: their faces are turned introspectively towards each other, to the point where the woman's face is obscured. The motif of a man cradling and kissing his female lover recurs throughout Rossetti's watercolours in the 1850s: *Paolo and Francesca da Rimini* (1855), *The Wedding of St George and Princess Sabra* (1857), *Ruth and Boaz* (1855).[28] Besides responding to a literary text, *Carlisle Wall* is also an experiment in colour. The 'rising sun' mentioned in Scott's poem is visualised by the patches of chalky yellow pigment which Rossetti has applied to the sky. The dominant colour of the picture, however, is red: the brick wall and the woman's dress and hair, complemented by the man's reddish-purple tunic. The overall simplicity of Rossetti's design is a visual equivalent of the simplicity of the poem.

The Border ballads continued to influence Rossetti, as well as Siddal. In 1854 they worked together on a project to illustrate an edition of the ballads which would be edited by the poet William Allingham. Rossetti wrote to Ford Madox Brown: '[Siddal] has just done her first block (from "Clerk Saunders") and it is lovely'. Rossetti continued: 'Her powers of designing [...] increases greatly, and her fecundity of invention & facility are quite wonderful, much greater than mine'.[29]

Fig.49 William Holman Hunt (1827–1910), *Study for 'The Flight of Madeline and Porphyro', c.*1848. Graphite on paper. Ashmolean Museum. WA1977.62.

Drawing from the present

It was not only historical English literature that inspired the Pre-Raphaelites – they also read poetry and prose written during their own century. They greatly admired the Romantic poet John Keats, who had died in 1821, aged only 25. Richard Monckton Milnes's *Life, Letters, and Literary Remains [of Keats]* helped to revive interest in Keats's work; it was published in 1848, only a few months before the PRB was founded. Keats's poems were frequently illustrated by the PRB in their paintings and drawings; one example is Hunt's painting *The Flight of Madeline and Porphyro* after Keats's 'The Eve of St Agnes' (1848), an early study for which is in the Ashmolean (fig.49).[30] Among their living contemporaries, the Pre-Raphaelites admired poems by Alfred Tennyson, such as 'The Lady of Shalott', 'Morte d'Arthur', 'St Agnes' Eve' and 'The Palace of Art'.

Siddal was inspired to illustrate poems written by members of her own artistic circle. For example, she produced a striking pencil drawing in response to Rossetti's famous poem 'The Blessed Damozel' (fig.50). That it is linked to Rossetti's poem is suggested by an inscription on the back of the sheet in William Michael Rossetti's hand: 'By Lizzie R / Blessed Damozel' ('Lizzie R' because Siddal became D. G. Rossetti's wife in 1860).[31] Siddal was therefore the first person to illustrate 'The Blessed Damozel'. The poem was first published in *The Germ* in February 1850. Siddal has adhered to the basic description of the eponymous female figure in the poem's opening lines:

> The blessed Damozel leaned out
> From the gold bar of Heaven:
> Her blue grave eyes were deeper much
> Than a deeper water, even.
> She had three lilies in her hand,
> And the stars in her hair were seven.[32]

Yet Siddal has not interpreted the poem literally. Some of the spiritual details are absent: the lilies, the stars in the damozel's hair. The 'gold bar' has become a gridded trellis, evoking a medieval walled garden – the setting seems grounded in the real world, rather than the 'Heaven' and 'terrace of God's house' described in Rossetti's poem.

Siddal's drawing is characteristically spiky and severe. Her interpretation of 'The Blessed Damozel' is likely to have influenced Burne-Jones's own water-colour illustration of Rossetti's poem made several years later (fig.51).[33] Siddal's drawing may also have been in Rossetti's mind when he was planning his own painting inspired by his poem in the late 1860s; there is one early sketch from around 1869 which bears a striking resemblance to Siddal's design.[34] However, Rossetti's finished painting completed in 1878 adopts a different composition.[35]

In 1854 Siddal produced a pen and ink drawing inspired by Robert Browning's dramatic poem *Pippa Passes*, published in 1841 (cat.49). The poem, whose setting is a spring day in fourteenth-century Asolo, describes young Pippa's walk through the town and her encounters with its inhabitants. The scene depicted does not quite match the literary description. In Browning's poem the

Below left: fig.50 Elizabeth Siddal (1829–1862), *The Blessed Damozel*, c.1850. Graphite on paper. Ashmolean Museum. WA1977.100.

Below right: fig.51 Sir Edward Coley Burne-Jones (1833–1898), *The Blessed Damozel*, c.1856–61. Watercolour, gouache, and shell gold on paper mounted on canvas. Harvard Art Museums, USA. 1943.452. Harvard Art Museums/Fogg Museum, Bequest of Grenville L. Winthrop. Photo: © President and Fellows of Harvard College.

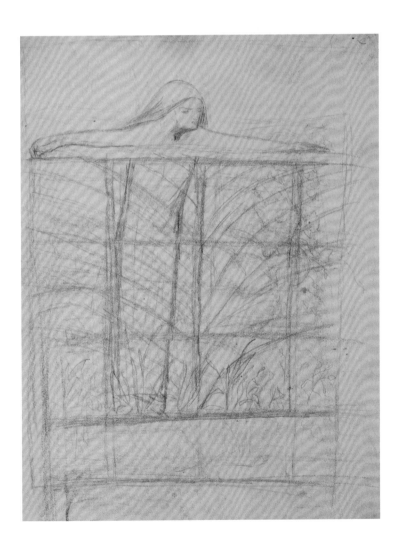

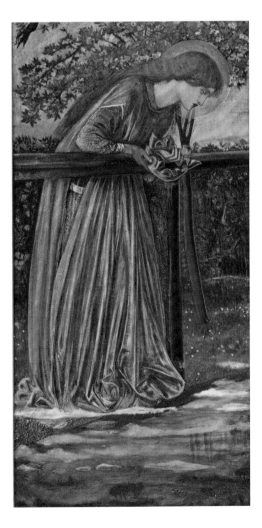

prostitutes call to Pippa from the steps of a church, which Siddal has changed to a park surrounded by railings, perhaps because she struggled with perspective and architectural drawing. Graphically, she was continuing the 'outline' style of early Pre-Raphaelite drawings from the late 1840s, relying on the distinct delineation of forms and minimal shading. The overall composition of *Pippa Passes* echoes Siddal's other drawing made in 1854, *Two Lovers Listening to Music* (cat.48): two groups of figures on the left and right, with an enclosed space receding along a diagonal into the background and a faint view in the distance on the left.

Siddal's *Pippa Passes* was eventually seen by Browning himself in January 1856, as Rossetti explained in a letter to a friend:

> In London I showed Browning Miss Siddal's drawing from *Pippa Passes*, with which he was delighted beyond measure, and wanted excessively to know her.[36]

Although Siddal's own thoughts about her work are not recorded, she was evidently pleased with her design, as she made two other versions of *Pippa Passes*. One of these three versions was purchased by John Ruskin in March 1855, together with all other designs that she had made so far.[37] According to Rossetti, Ruskin 'seemed quite wild with delight at getting them. [...] He is going to have them splendidly mounted and bound together in gold'.[38] Ruskin was an enthusiastic patron, agreeing to pay Siddal £50 per year in exchange for all the artworks she produced. For him, imagination and 'genius' took precedent over technical skill, although Siddal's work had already become visually sophisticated despite her apparent lack of formal art training – it is not as 'naive' as has often been claimed.

Fig.52 Elizabeth Siddal (1829–1862), *St Agnes' Eve*, undated. Pen on paper. Ashmolean Museum. WA 1977.96.

Fig.53 Elizabeth Siddal (1829–1862), *The Eve of St Agnes*, 1850. Gouache on paper. Wightwick Manor, West Midlands, National Trust. NT 688025. © National Trust / Sophia Farley and Claire Reeves.

While the above drawings were produced for private consumption, many other Pre-Raphaelite illustrations of modern literature had a public life in the realm of printed books.[39] The close relationship between words and images on the printed page was in keeping with Pre-Raphaelitism's dual nature as a movement in both literature and the visual arts. The best-known example of Pre-Raphaelite book illustration is the edition of Tennyson's poems published by Edward Moxon in 1857, the so-called 'Moxon Tennyson', with designs by Millais, Hunt and Rossetti. The Ashmolean holds several drawings related to this project, including Rossetti's initial idea for St Cecilia from 'The Palace of Art' (cat.51) and a set of five drawings by Millais which may have been later copies of the finished engravings rather than working drawings for them (cat.50).[40] Ultimately Tennyson disliked the Pre-Raphaelites' interpretations of his poems because they did not adhere closely enough to the texts; indeed, Rossetti deliberately chose those works 'where one can allegorize on one's own hook on the subject of the poem, [...] unless the poetry is so absolutely narrative as in the old ballads, for instance'.[41]

Siddal also produced illustrations of Tennyson's poems. There is an apocryphal story that she discovered Tennyson's work on a scrap of paper wrapped around a pat of butter, but this has never been confirmed.[42] The Ashmolean holds one of her sketches inspired by 'St Agnes' Eve' (fig.52), a poem about a young nun who yearns for a vision of her future husband – revealed to be 'the Heavenly Bridegroom', Jesus Christ – on St Agnes's Eve.[43] Comparing Siddal's sketch with Millais's illustration of the same poem (cat.50) shows two very different approaches: where Millais's drawing is serene and carefully composed, Siddal's rough sketch is fraught with dramatic tension, as the nun stretches herself across a windowsill. The outcome of Siddal's sketch was a watercolour version which is now in Wightwick Manor (fig.53).

Siddal also made several drawings of St Cecilia and an angel, from 'The Palace of Art' (fig.54). It has long been noted that her idea of depicting the saint swooning, perhaps in death, preceded, and may have directly inspired, Rossetti's illustration of the same subject for the Moxon Tennyson (cat.51).[44] Tennyson and his wife Emily were apparently so impressed by Siddal's various drawings that they 'wished her exceedingly to join' Moxon's project, although this never happened.[45] This did not prevent her from exhibiting her talents: in 1857, she showed several 'Sketches from Browning and Tennyson' at a semi-public exhibition of artworks by the Pre-Raphaelites and their friends in Russell Place – her designs of 'St Agnes's Eve', 'St Cecilia' and 'Pippa Passes' would certainly have been included.[46] Siddal's watercolour of *Clerk Saunders* (fig.13) was also included in the Exhibition of British Art which toured the East Coast of the United States in 1857–8.

Fig.54 Elizabeth Siddal (1829–1862), *St Cecilia and an Angel*, undated (*c*.1856–7). Pen and ink on paper. Wightwick Manor, West Midlands, National Trust. NT 688053. © National Trust / Sophia Farley and Claire Reeves

Collaborations between writers and artists continued among the later proponents of Pre-Raphaelitism. A notable example is Arthur Hughes's illustrations for Christina Rossetti's book of nursery rhymes, *Sing-Song* (1872), based upon Rossetti's own drawings from her original manuscript.[47] Thirty-eight of Hughes's drawings for *Sing-Song* are in the Ashmolean. In 1864 William Morris began writing *The Earthly Paradise*, an ambitious series of 24 narrative poems based on ancient myths and legends. The series was never finished, but Morris enlisted his close friend Burne-Jones to illustrate it. The first poem in the cycle was 'The Story of Cupid and Psyche', for which Burne-Jones 'designed 70 subjects' in 1865.[48] A set of 47 of these original drawings for the *Cupid and Psyche* illustrations was given to the University of Oxford by Ruskin, who thought they would be good for students to copy; they form part of the Ruskin Teaching Collection at the Ashmolean. The *Cupid and Psyche* series preoccupied Burne-Jones for the rest of his life. He continued to reuse designs from the original series for separate watercolours, oil paintings, and even a large cycle of wall paintings for the home of George Howard, No. 1 Palace Green, Kensington.[49] He was particularly fascinated with his composition of *Cupid's First Sight of Psyche* (fig.55),

repeating it in stand-alone paintings and watercolours produced for exhibitions and private patrons (fig.56).

The artistic partnership between Morris and Burne-Jones effectively continued until Morris's death in 1896. In the 1880s Morris wrote *A Dream of John Ball*, a historical novel about the Peasants' Revolt of 1381. The text was serialised in the socialist newspaper *The Commonweal* in 1886–7 and published in book form in 1888. The novel was the product of Morris's socialist ideals, as he sought to remind Victorian readers of social injustices and how historical figures brought about social and political change.[50] The Ashmolean holds one of Burne-Jones's preparatory studies for the frontispiece of the 1888 edition (fig.57). The design is a literal interpretation of a slogan from one of John Ball's sermons addressed to the rebels of the Revolt: 'When Adam delved and Eve span, / Who was then the gentleman?' This couplet is inscribed beneath the figures of Adam and Eve, who have been banished from Eden and are compelled to toil in the fields and make their own clothes as punishment for their sins. Their two infant sons, Cain and Abel, crawl at their feet. Here Burne-Jones's art communicates a political message: in John Ball's – and Morris's – view, when work ('delving' and 'spinning') was equally distributed among the workers (Adam and Eve, representing both sexes), society was fairer, without hierarchical oppression. The fourteenth-century working-class uprisings described in Morris's *John Ball*

Below left: fig.55 Sir Edward Coley Burne-Jones (1833–1898), *The Story of Cupid and Psyche: Cupid's First Sight of Psyche*, undated (*c*.1864). Graphite on tracing paper. Ashmolean Museum. WA.RS.ED.065.b.

Below right: fig.56 Sir Edward Coley Burne-Jones (1833–1898), *Cupid and Psyche*, *c*.1870. Watercolour, gouache and pastel on paper mounted on linen. Yale Center for British Art, USA. B1979.12.1038.

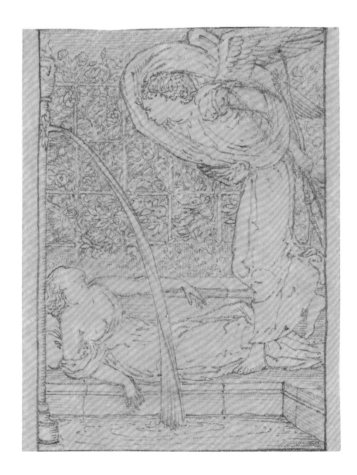

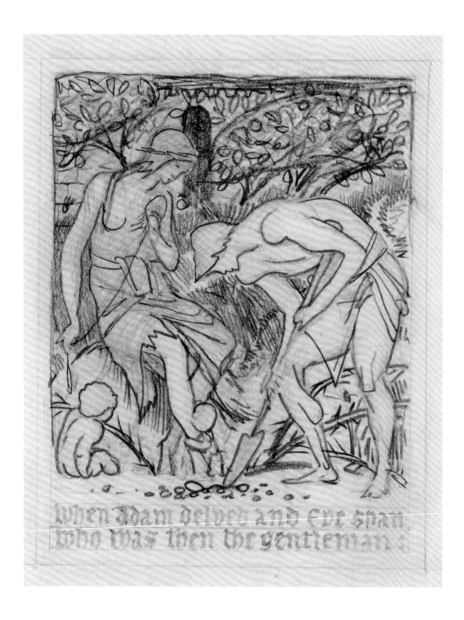

Fig.57 Sir Edward Coley Burne-Jones
(1833–1898), *Study for the frontispiece
of 'A Dream of John Ball'*, c.1888. Black
chalk over graphite on paper. Ashmolean
Museum. WA1941.108.5.

had their modern equivalent in the socialist demonstrations in London, with
which Morris was closely involved at this time. As Georgiana Burne-Jones later
observed, there was a 'divergence of opinion on the subject of Socialism' between
the two men in the 1880s, as Burne-Jones preferred solitary artistic creation over
public demonstrations and protests as a mode of political expression.[51] Still, his
John Ball drawing demonstrates that Pre-Raphaelite art always had a radical
purpose, whether artistic or political.

CATALOGUE

I

The Pre-Raphaelite Circle: Portraits, Formal and Informal

THE PRE-RAPHAELITES loved making intimate portraits of each other, and of their families, patrons and friends. Their early portraits are small, direct and in pencil, perhaps with the addition of a light wash or watercolour; later on they became proficient in the use of coloured chalks, giving their large portraits the strength and solidity of oil paintings.

The Ashmolean collection includes portraits of many of the important figures in the movement. John Everett Millais and Charles Allston Collins made pencil drawings of one another in 1850, looking extremely young and very serious. Both signed their drawings with the crucial initials PRB, even though Collins was never technically a member of the Brotherhood. Dante Gabriel Rossetti's profile watercolour portrait of Elizabeth Siddal, once owned by her brother, was made in 1854. William Holman Hunt and John Ruskin are also represented here, in each case depicted by Millais. The drawing of Ruskin is a rough preliminary sketch for the famous portrait of Ruskin at Glenfinlas (fig.12) – a work that Millais executed under conditions of extreme stress, as he was falling in love with Ruskin's unhappy wife Effie (née Gray).

A portrait by Millais of Ford Madox Brown settled comfortably in an armchair reading the paper, and informal sketches of groups by Collins and Siddal, offer us an insight into the lives of these artists and their friends in lighter moments. Collins's ink and wash study evokes the cosy intimacy of evenings in an Oxford household, with Thomas Combe, the superintendent of Oxford University Press, reading by candlelight to his wife, his wife's uncle and the two young artists Millais and Collins, whom he had adopted as his protégés.

William Holman Hunt's paired portraits of Thomas and Martha Combe commemorate these important early patrons, whose bequest formed the nucleus of the Museum's Pre-Raphaelite collection. Thomas sparkles with wit and good humour from behind his voluminous hair, eyebrows and beard, but the artist's refusal to flatter in his depiction of Martha is almost shocking. Hunt's proficiency in the use of coloured chalks is impressive. It is surpassed, however, by Frederick Sandys in his extraordinary portrait of Charles Augustus Howell, an art dealer who befriended several members of the Pre-Raphaelite group and helped to manage their financial affairs. Howell subsequently become notorious for persuading Rossetti to have his wife's body exhumed so that he could retrieve the poems he had buried with her. In Sandys's portrait he is the epitome of world-weariness.

Portraits of women by John Brett, Henry Wallis and William Bell Scott complete this section. They include sensitive portrayals of the artist Laura Alma-Tadema as a child and of the feminist campaigner Josephine Butler. It is noticeable that, with the exception of Wallis's portrait of Mary Meredith, the women look introspective and often have downcast eyes, reflecting socially acceptable behaviour for this period. In contrast men are more likely to look directly at the viewer, engaging our attention in a friendly, quizzical or challenging manner.

Opposite: detail of cat.10.

1

CHARLES ALLSTON COLLINS (1828–1873)
Portrait of John Everett Millais, 1850

Graphite and grey wash on discoloured cream paper, 16.6 × 12.6 cm
Signed and dated: *C. Collins P.R.B. / 1850*
Purchased, 1894; WA1894.58

John Everett Millais and Charles Allston Collins were close friends in the early 1850s.
From September to November 1850 they stayed with Thomas and Martha Combe
at their house in Oxford. Here Collins worked on two paintings, both of which are
now in the Ashmolean: *Convent Thoughts* (fig.9) and a portrait of William Bennett,
Martha's uncle. These two pencil portraits, cats 1 and 2, were made as gifts for the
Combes. Millais was noted for his regular good looks. Collins has drawn him with
Pre-Raphaelite exactness, not seeking to disguise the early indications that Millais, then
aged just 21, would become prematurely bald. He has added the letters 'P. R. B.' to his
signature, even though Collins never became an official member of the group.

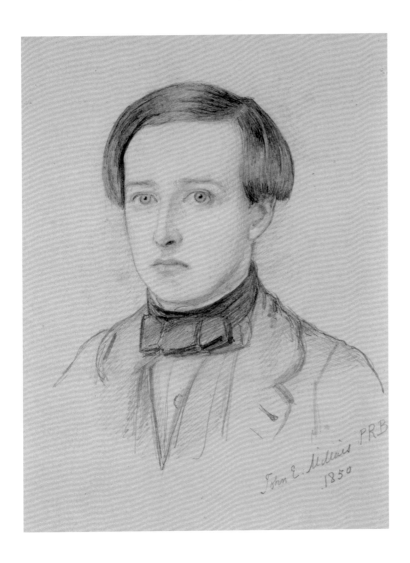

2

SIR JOHN EVERETT MILLAIS (1829–1896)
Portrait of Charles Allston Collins, 1850

Graphite on discoloured cream paper, 16.6 × 12.5 cm
Signed and dated: *John E. Millais P.R.B. / 1850*
Purchased, 1894; WA1894.57
LITERATURE: Funnell (1999) no.8; Rosenfeld and Smith (2007) no.33

Like Collins's portrait of Millais (cat.1), Millais's portrait of Collins adopts a severe, full-frontal format, implying the clear-sighted honesty on which the PRB prided themselves. Millais proposed Collins – whom he affectionately called 'Charley', 'Carlo' or 'Fra Carlo' – for membership of the Brotherhood, but his candidacy was opposed by Thomas Woolner and William Michael Rossetti.[1] Millais had a high opinion of Collins: in a letter to Martha Combe of 1899 he wrote: 'there are few so devotedly directed to the one thought of some day (through the medium of his art) turning the minds of men to good reflections and so heightening the profession as one of unworldly usefulness to mankind.'[2] Hunt recalled that Collins had striking looks, with strong blue eyes and brilliant red bushy hair.[3]

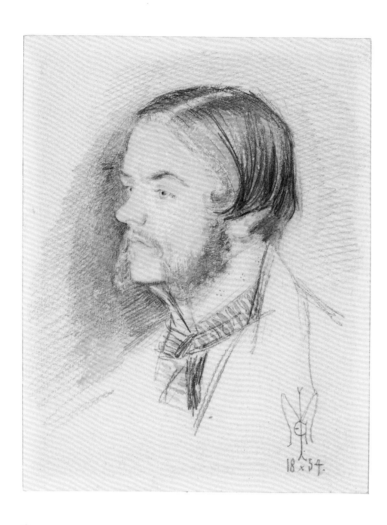

3

SIR JOHN EVERETT MILLAIS (1829–1896)
Portrait of William Holman Hunt, 1854

Black chalk with brown wash on cream paper, 22 × 17.5 cm
Signed in monogram and dated: *JEM / 18 × 54*
Bequeathed by Mrs Thomas Combe, 1893; WA1893.8
LITERATURE: Funnell (1999) no.27; Rosenfeld and Smith (2007) no.36; Harrison (2015) no.63

William Holman Hunt was another young artist virtually adopted by the Combes.
When he announced his intention of going to Palestine to paint scenes from the
Bible, Thomas Combe even considered accompanying him. Before Hunt departed, the
Combes asked Millais to make a portrait of him; this drawing was the result. Millais
had made a drawing of Hunt in December 1853, but wrote to Combe that he was so
pleased with it that he had decided to keep the original for himself, and would make a
copy. In January 1854 he wrote again with another offer.

> I have made a drawing of Hunt, which I think you will find very like. It is not a
> copy of the one I have, but another I drew on Sunday evening.[4]

Millais was distressed by Hunt's departure, the more so as their mutual friend, the artist
Walter Deverell, was very ill. He was to die in early February 1854, aged just 26.

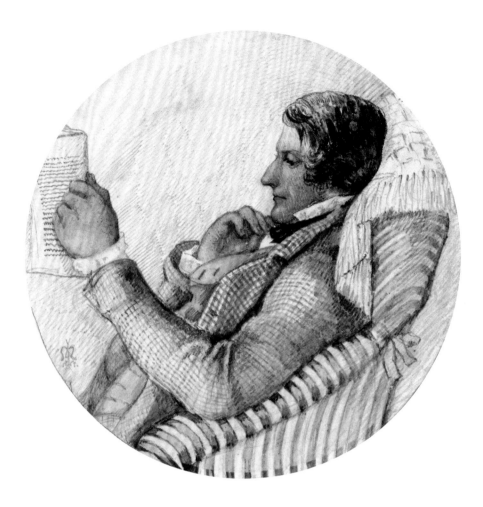

4

SIR JOHN EVERETT MILLAIS (1829–1896)
Portrait of Ford Madox Brown, 1853

Watercolour over graphite with pen and blue ink on off-white paper, 11.4 cm diameter
Signed in monogram and dated 1853
Purchased (Hope Fund), 1940; WA1940.102
LITERATURE: Rose (1981) p. 73

Ford Madox Brown (1821–1893) was born in Calais. He trained in Belgium, spending
three years at the Antwerp Academy where he studied under the historical painter
Gustave, Baron Wappers. He settled in London in 1844 and got to know the Pre-
Raphaelites in 1848, when Dante Gabriel Rossetti asked him for painting lessons.
Madox Brown was thus already an experienced artist when the Brotherhood was
formed in the autumn of 1848; he never became a member, although his work had
affinities with the Pre-Raphaelites and had in some respects anticipated it.

 The round format and profile view of this drawing are unusual in Millais's
portraiture. The shape of the drawing may be connected with the use of the same
format for Brown's *The Last of England*, begun in 1852;[5] the profile view may reflect a
certain coolness in the relationship between the two artists. In 1854 Brown complained
that Millais had given him dangerous advice on technique.[6]

5

DANTE GABRIEL ROSSETTI (1828–1882)
Portrait of Elizabeth Siddal facing left, 1854

Watercolour on paper, 28.3 × 24 cm
Dated 1854
Presented by Virginia Surtees, 2011; WA2011.57
LITERATURE: Surtees (1971) no.462

Elizabeth Siddal (1829–1862) first joined the Pre-Raphaelite circle as a model in 1849 or 1850, but soon began to develop her talents as a poet and an artist. The daughter of a cutler, she was working in a milliner's shop when the artist Walter Deverell met her. He invited her to model for the figure of Viola, disguised as the page Cesario, in his painting *Twelfth Night* (1849–50, private collection). Siddal subsequently modelled for two further Shakespearian characters: Sylvia in Holman Hunt's *Valentine Rescuing Sylvia from Proteus* (1850–1)[7] and Ophelia in Millais's *Ophelia* (1851–2).[8] Surprisingly she was not initially seen as beautiful – her striking copper-coloured hair did not conform to early Victorian notions of beauty. John Ruskin, in his letters to *The Times* defending the Pre-Raphaelites in 1851, complained about 'the unfortunate type chosen for the face of Sylvia'.[9]

Georgiana Burne-Jones, however, recalling a visit from Siddal (now Mrs Rossetti) and Jane Morris in 1861, observed that

> The difference between the two women may be typified broadly as that between sculpture and painting, Mrs Morris being the statue and Mrs Rossetti the picture.

She noted the 'grave nobility and colourless perfection' of Jane, while appreciating in Siddal 'a wistfulness that often accompanied the brilliant loveliness and grace', which brought 'an unearthly character to her beauty'.[10]

From 1851 Siddal sat exclusively for Rossetti and began to take art lessons from him. In a letter of May 1854 Rossetti remarked on her talent to Ford Madox Brown:

> Her power of designing ... increases greatly, and her fecundity of invention & facility are quite wonderful, much greater than mine.[11]

In 1855 Siddal's drawings were shown to Ruskin, who offered her a quarterly allowance of £150 per annum in exchange for all that she produced. The Ashmolean holds the original manuscripts of Siddal's poems, unpublished in her lifetime, as well as a photographic archive of her work made by Dante Gabriel Rossetti after her death.

This portrait was bought in 1899, from her brother James Siddal, by William Michael Rossetti: he recorded that it was 'very sweet and like her, but faded as to glow or bloom of colour'.[12] The work dates from 1854, the year in which Siddal was introduced to Rossetti's sister, the poet Christina Rossetti, and also to a group of his female friends: Anna Mary Howitt, Barbara Leigh Smith (later Bodichon) and Bessie Parkes. Barbara wrote to Bessie that Siddal 'is a genius and will, if she lives, be a great artist', adding that she was Rossetti's 'love and pupil' but he could not marry her because 'she is of course under a ban having been a model'.[13] The couple were eventually married in 1860.

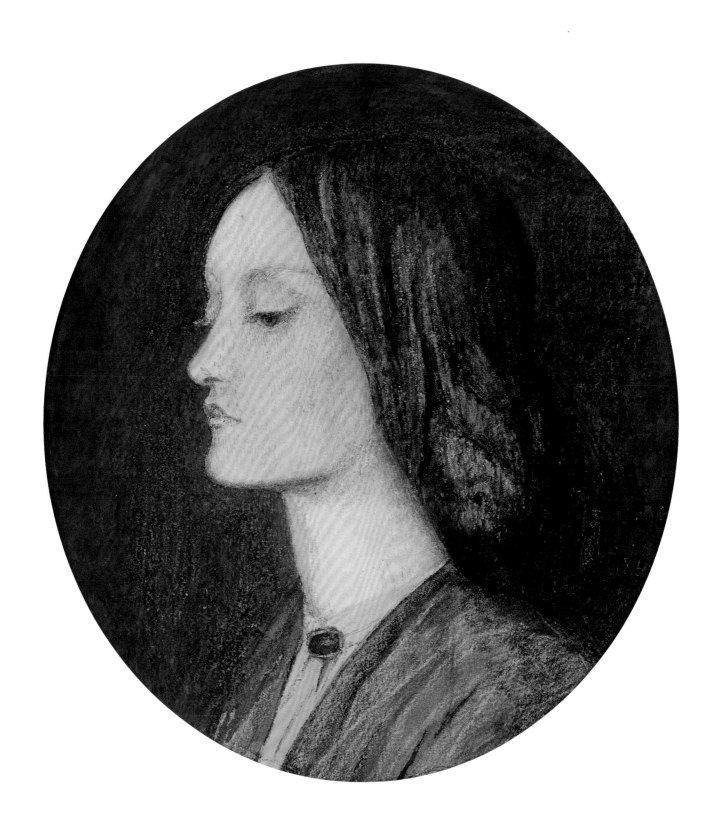

6

SIR JOHN EVERETT MILLAIS (1829–1896)
John Ruskin (sketch for portrait), 1853

Graphite on blue paper, 19.7 × 12.6 cm
Purchased, 1965; WA1965.85.8
LITERATURE: Funnell (1999) no.24

This drawing is a study for Millais's portrait of John Ruskin, now in the Ashmolean (fig.12). The work was largely painted out of doors in the valley of Glenfinlas or Glen Finglas, in the Trossachs, Scotland, while both artist and patron stayed at the village of Brig O'Turk nearby. They were there from July until late October in the summer of 1853, grappling with the problems presented by rain, midges and the complications caused by Millais's growing – and reciprocated – love for Ruskin's neglected wife, Effie, also one of the party.

At first all went well. On 6 July 1853 Millais wrote to Charles Collins:

> Ruskin and myself have just returned from a glorious walk along a rocky river near here and we have found a splendid simple background for a small portrait I am going to paint of him … I am going to paint him looking over the edge of a steep waterfall – he looks so sweet and benign standing calmly looking into the turbulent sluice beneath.[14]

Millais was later to revise his opinion of Ruskin as 'sweet and benign' once he learned the truth about his marriage.

Ruskin recorded in his diary that the painting was begun on 27 July, 'outlined at once, Henry Acland holding the canvas'.[15] Acland, a lifelong friend of Ruskin's, was then physician to the Radcliffe Infirmary in Oxford; he was staying with the Ruskins at the time. He later owned this drawing, noting on the back: 'The first sketch of J. E. Millais's Picture of John Ruskin/ done in the bed of the stream at B. of Turk/ Tuesday July 28. 1853'. Acland's inscription implies that the drawing records the 'outline' that Millais had drawn on the canvas on the previous day. Ruskin's stance, his clothing and his hat and stick are all as they appear in the finished oil painting.

In July 1854 Ruskin's marriage to Effie was annulled, and she married Millais the following year. Millais finished the portrait of Ruskin in 1854, after portrait sittings in London from January until April and another trip to Glenfinlas in May and June, accompanied by his friends Charles Collins and John Luard. Ruskin's father, John James Ruskin, paid Millais £350 for the portrait in December 1854. Ruskin himself was delighted with it and wrote a fulsome letter to Millais to thank him. Millais, however, made it clear that the two men could no longer be on 'terms of intimacy'. As a result John James Ruskin withdrew his permission for the portrait to be displayed at the Royal Academy.[16]

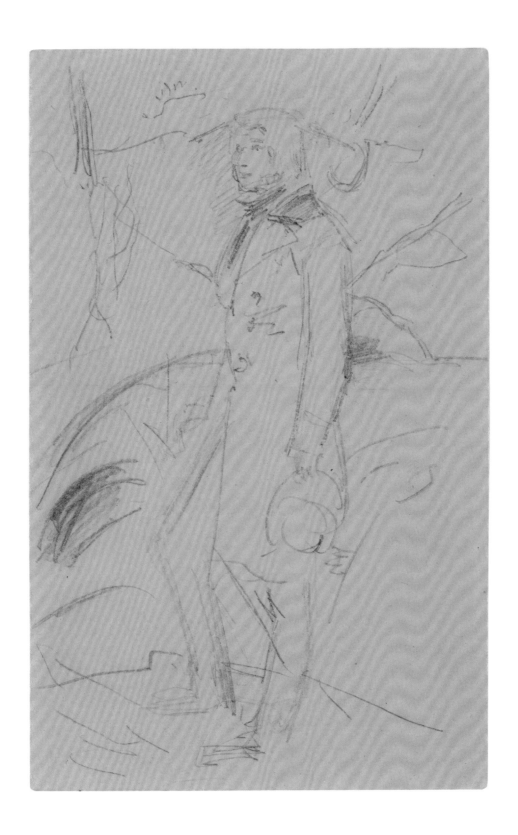

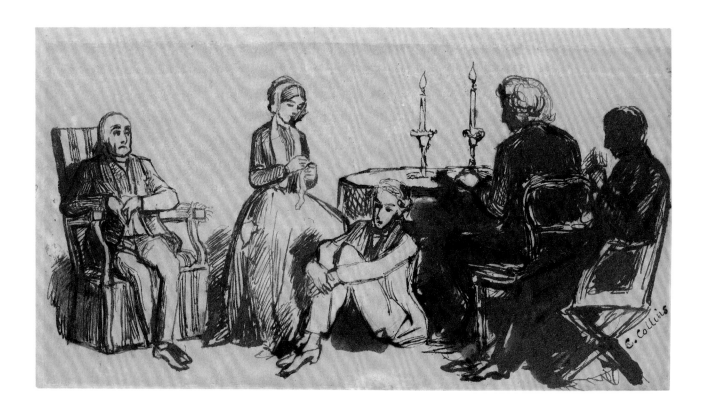

7

CHARLES ALLSTON COLLINS (1828–1873)
An Evening at the Combes's House, 1850

Pen and brown ink on pale brown paper, 9.8 × 17.8 cm
Purchased, 1976; WA1976.47

This lively drawing offers a glimpse into the sitting room of Thomas and Martha
Combe in the autumn of 1850, when Collins and Millais were staying with them.
The household is represented as frugal and Christian, with the assembled company
engaging in the limited number of occupations possible by light from only two candles.
Thomas Combe reads aloud from a large volume that looks like the Bible, while the
others listen attentively. Martha uses the time productively, perhaps darning a sock.
Seating is limited: old Mr Bennett sits in the best armchair; his niece Martha perches
on a stool and the notoriously long-legged Millais has to sit, uncomfortably, on the
floor. The artist Charles Collins is a rather awkward addition, appearing as a shadowy
figure on the extreme right. Millais's affectionate letters to the Combes, whom he
addressed as 'Early Christian' and 'Mrs Pat', indicate the close relationship between the
artists and the couple.

8

ELIZABETH ELEANOR SIDDAL (1829–1862)
Two Men in a Boat and a Woman Punting, c.1853–5

Pen and black ink on off-white paper, 11.6 × 18.3 cm
Inscribed, verso, in graphite, probably by William Michael Rossetti: *By Lizzie R?*
Bequeathed by John Bryson, 1977; WA1977.103

This drawing by Siddal appears to be a witty and spirited variation on a
drawing by Dante Gabriel Rossetti, *Boatmen and Siren* (fig.58). Rossetti's
drawing illustrates an Italian song that he had translated. It shows a
man beguiled by a siren, risking death from drowning by pursuing her
and being restrained by his friend. In Siddal's drawing, the man appears
to be pleading with the 'siren' who is using her pole to push him away,
a furious expression on her face. It is tempting to link this drawing to
Siddal's visit to Oxford in 1855, where she consulted Dr Acland, Ruskin's
physician, and may well have gone out punting. The main protagonists
look like portraits of Rossetti and Siddal. Dr Acland's verdict on Siddal's
condition was that she was suffering from no identifiable disease, but
from 'mental power long pent up and lately overtaxed'. He recommended
rest and country air.[17]

Fig.58 Dante Gabriel Rossetti (1828–1882), *Boatmen
and Siren, c.*1853. Pen and ink on paper. Manchester
Art Gallery. MAN6309430. Manchester Art Gallery /
Bridgeman Images.

9

WILLIAM HOLMAN HUNT (1827–1910)
Martha Combe, 1861

Red and black chalk on paper, 59.1 × 47.5 cm
Signed in monogram and dated 1861. Inscribed: *Mrs Combe* and
Presented to the Taylor Buildings Oxford by / W. Holman Hunt / 1895
Presented by the artist, 1895; WA1895.11
LITERATURE: Bronkhurst (2006) no.D214

Martha Combe (1806–1893) survived her husband by more than 20 years, and
consequently it was she who left the couple's substantial collection of Pre-Raphaelite
works to the Ashmolean. She also left a legacy of £2000 to Holman Hunt, who praised
her in his memoirs:

> Mrs Combe, though still young, was the foster-mother of the whole parish; she
> knew the troubles of every house, and left neither good, bad, nor indifferent
> without her solid sympathy.[18]

This portrait was executed in 1861, when Hunt was staying in Oxford to work on the
small version of *The Hireling Shepherd*. It does not appear to be a flattering likeness and
seems to have been left unfinished. Perhaps Martha, or her husband, disliked it. Unlike
the portrait of Thomas, it remained in Hunt's possession until 1895, two years after
Martha's death, when he gave it to the University.

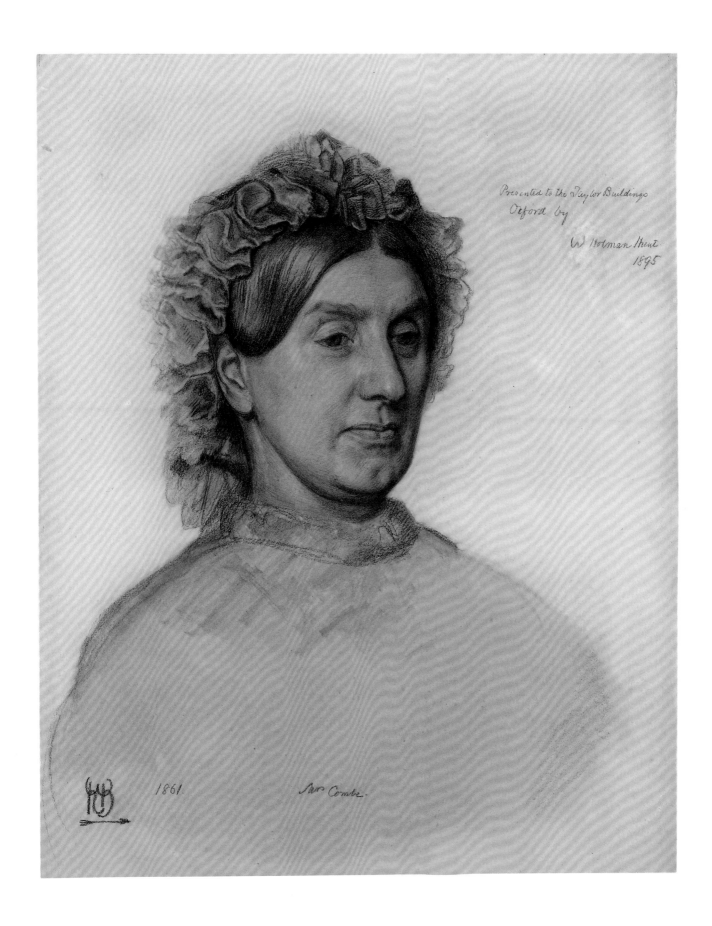

Presented to the Taylor Buildings
Oxford by

W Holman Hunt
1895

1861. Mrs Combe.

10

WILLIAM HOLMAN HUNT (1827–1910)

Thomas Combe, 1860

Red and black chalk on paper, 67.6 × 47.9 cm
Signed in monogram and dated: *Whh / 1860 / Oxford*
Bequeathed by Mrs Thomas Combe, 1893; WA1894.20
LITERATURE: Bronkhurst (2006) no.D197; Harrison (2015) no.65

From 1851 Thomas Combe (1796–1872) was senior partner in Oxford University
Press and the majority shareholder in the publisher's 'Bible' side. He and his wife
were committed members of the Tractarian or Oxford Movement, which sought to
restore ritual to the Anglican Church. He was known in Pre-Raphaelite circles as 'the
early Christian' and, once he had grown his magnificent beard, 'the patriarch'. The
Combes were important patrons of the Pre-Raphaelites, especially Hunt. Their first
purchase from the group was Hunt's *A Converted British Family Sheltering a Christian
Missionary from the Persecution of the Druids*,[19] which they bought in 1850. Three
years later they bought Hunt's painting, *The Light of the World* (fig.11). Hunt spent
Christmas with them in 1859 and returned for a summer holiday in 1860, when he
drew this portrait.

1860
Oxford

11

JOHN BRETT (1831–1902)
Portrait of Laura Theresa Epps (Lady Alma-Tadema) as a Child, 1860

Watercolour and bodycolour on paper, 17.9 × 15.7 cm
Signed with initials and dated: *J B 1860*
Presented by Miss Sylvia Gosse, 1965; WA1965.25.3
LITERATURE: Payne and Sumner (2010) no.20

Portrayals of beautiful young girls with wistful expressions are common in Pre-Raphaelite art. While painting *Autumn Leaves* (1855–6),[20] Millais wrote to Collins: 'the *only* head you could paint to be considered beautiful by *everybody* would be the face of a little girl about eight years old'.[21] This is the age of Laura Epps (1852–1909) when John Brett painted her portrait. He gave drawing lessons to Laura and her sisters and was to be one of the witnesses at her wedding to the painter Lawrence Alma-Tadema in 1871. Laura herself became a successful artist, specialising in domestic and genre scenes of women and children. In his portrait Brett used a skilful combination of watercolour and bodycolour to bring out the varied colours in Laura's coppery hair and the reflected lights on her grey jacket, setting them off against the complementary blue of the cushion.

12

WILLIAM BELL SCOTT (1811–1890)
Josephine Butler, 1856

Graphite on paper, 35.1 × 23.5 cm
Signed with initials and dated: *WBS Sepr 1856*. Inscribed: *Mrs Josephine Butler*
Purchased (Hope Fund), 2016; WA2016.67
LITERATURE: Wodehouse (2017)

Josephine Butler (1828–1906) was a noted social reformer and campaigner for the rights of women. William Bell Scott made this drawing of her when she was 28, pregnant with her third child and suffering from a lung complaint brought on by the damp climate of Oxford, where her husband was Public Examiner at the University. She was outraged by the University's attitude towards women – particularly the double standard which meant that women's sexual transgressions brought ruin while those of men went unpunished. Butler and Scott had many friends in common and they came from the same part of the country: the portrait was made when she was staying at her childhood home at Dilston, near Corbridge in Northumberland, while he was based in Newcastle. Scott's approach to the drawing is sympathetic – even flattering. Ironically, however, his sensitivity to her introspective, rather melancholy mood is combined with a format often used to portray women as submissive and modest creatures.

Mrs Josephine Butler

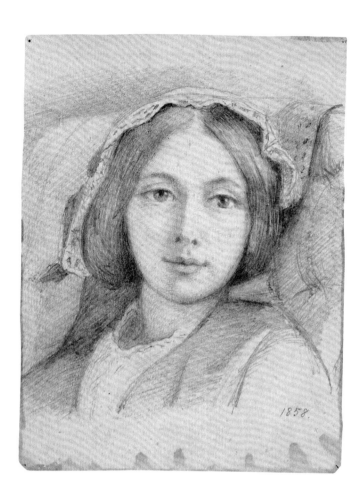

13

HENRY WALLIS (1830–1916)
Mary Ellen Meredith, 1858

Graphite on paper, 11.9 × 9.1 cm
Purchased (Bouch Fund) with the assistance of the Art Fund,
the Friends of the Ashmolean, and private donors, 2003; WA2003.97

This intimate drawing is the only known surviving portrait of Mary Ellen Meredith
(1821–1861), daughter of the poet Thomas Love Peacock. Mary Ellen published articles
on cookery and domestic economy, as well as undertaking philanthropic schemes. Her
first husband, a naval officer, was lost at sea only two months after their wedding. In 1849
she married the novelist George Meredith, who modelled for Wallis's celebrated painting
The Death of Chatterton (1856).[22] A painting by Wallis of Mary Ellen herself (untraced)
was exhibited at the Royal Academy in 1854 with the title of *Fireside Reverie*. In 1857
Wallis and Mary Ellen eloped, and in April 1858 she bore him a son, Felix. However,
the relationship was short-lived. Mary Ellen died in 1861 and Wallis brought up the boy
himself. He never married and kept this tiny drawing of her until his own death.

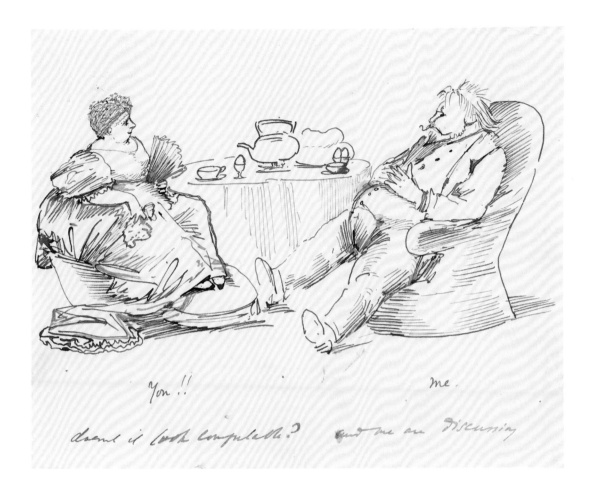

14

SIR EDWARD COLEY BURNE-JONES (1833–1898)
*Caricature of May Gaskell and Burne-Jones sitting together, at a table laid
with boiled eggs, a kettle and a loaf of bread between them*, 1893–8

Pen and black ink on off-white paper; 17.6 × 22 cm
Inscribed: *You!! / Me / doesn't it look comfortable? / We are discussing*
On folio 16 of an album of Burne-Jones's illustrated letters to May Gaskell, purchased (Blakiston,
Madan, Virtue-Tebbs Funds) with the assistance of the National Heritage Memorial Fund, the Art
Fund, the ACE/V&A Purchase Grant Fund, the Friends of the National Libraries, the Friends of the
Ashmolean and numerous private donations, 2015; WA2015.68.50

Throughout his life Burne-Jones used drawing as a vehicle for amusement, both for himself and
for others. His friendship with Helen Mary Gaskell (1853–1940), known as May, began in 1892
and lasted until the end of his life. It was one of several close relationships, platonic yet passionate,
that the artist developed with younger women in his later years. He wrote to May frequently,
sometimes as often as five times in one day, sharing intimate details of his feelings. He also sent a
series of illustrated letters, which she kept in albums. In this drawing he imagines the two of them
settling down companionably to breakfast. She wears evening dress and he represents himself as
short and plump, when in reality he was tall and thin. The letter is pasted into the album with the
verso hidden, so unfortunately we cannot know what they were discussing.

15

FREDERICK SANDYS (1829–1904)
Charles Augustus Howell, 1882

Coloured chalks on pale blue paper, 91 × 65 cm
Inscribed: *Charles Augustus Howell 1882*
Presented by John Bryson, 1942; WA1942.68
LITERATURE: Rose (1981) p. 117; Elzea (2001), no.4.29

Frederick Sandys was born in Norwich. He moved to London in 1851, when he began exhibiting at the Royal Academy. Sandys was a skilled draughtsman, and in the 1850s he worked mainly in portraiture and illustration. In 1857 he published 'The Nightmare', a print that parodied Millais's painting *A Dream of the Past – Sir Isumbras at the Ford*;[23] it portrays Millais as the knight with Rossetti and Hunt as children, all riding on a braying ass labelled JR (John Ruskin) and watched by despairing Old Masters on the riverbank. The print caused a stir in the London art world. It brought Sandys into contact with Rossetti, who appreciated (or forgave) the joke and became a close friend. Sandys, like Rossetti, became extremely skilled in his use of coloured chalks on tinted paper.

Charles Augustus Howell (1840–1890) was a flamboyant character who first came into the Pre-Raphaelite circle in 1857, when he met the Rossetti brothers. He was born in Oporto to an English father and a Portuguese mother and came to England in his youth. There were rumours that Howell was involved in the Orsini plot to assassinate Napoleon III in 1858 and he had to leave Britain for a while, returning in 1864. He worked for Ruskin as a secretary between 1865 and 1870, and acted as business manager to the poet Algernon Swinburne. During the mid-1860s Howell, Swinburne and Rossetti used to tour the pleasure gardens, theatres and junk shops of London together.[24] In 1869 Howell organised the secret exhumation of Elizabeth Siddal, so that Dante Gabriel Rossetti could retrieve the poems that he had buried in her coffin. He also made money as an art dealer, collecting and selling Japanese prints, furniture and porcelain, as well as paintings and drawings by Rossetti and Sandys.

Howell was a companion of Sandys from 1865: he took on Sandys's business affairs, but was apparently unsuccessful in turning them round to make a profitable living for him. This portrait, and an earlier one that Sandys painted of Howell's wife (*c.*1873–4),[25] were payments in kind for debts, both financial and personal.

Howell had a bad reputation as a blackmailer and exploiter of human weakness. He was also known for his charm and witty conversation, however, which made him a favoured guest at dinner parties. When the portrait was painted in 1882 Howell was only 42 years old, yet Sandys creates a convincing depiction of a man who had seen a great deal of both high and low life.

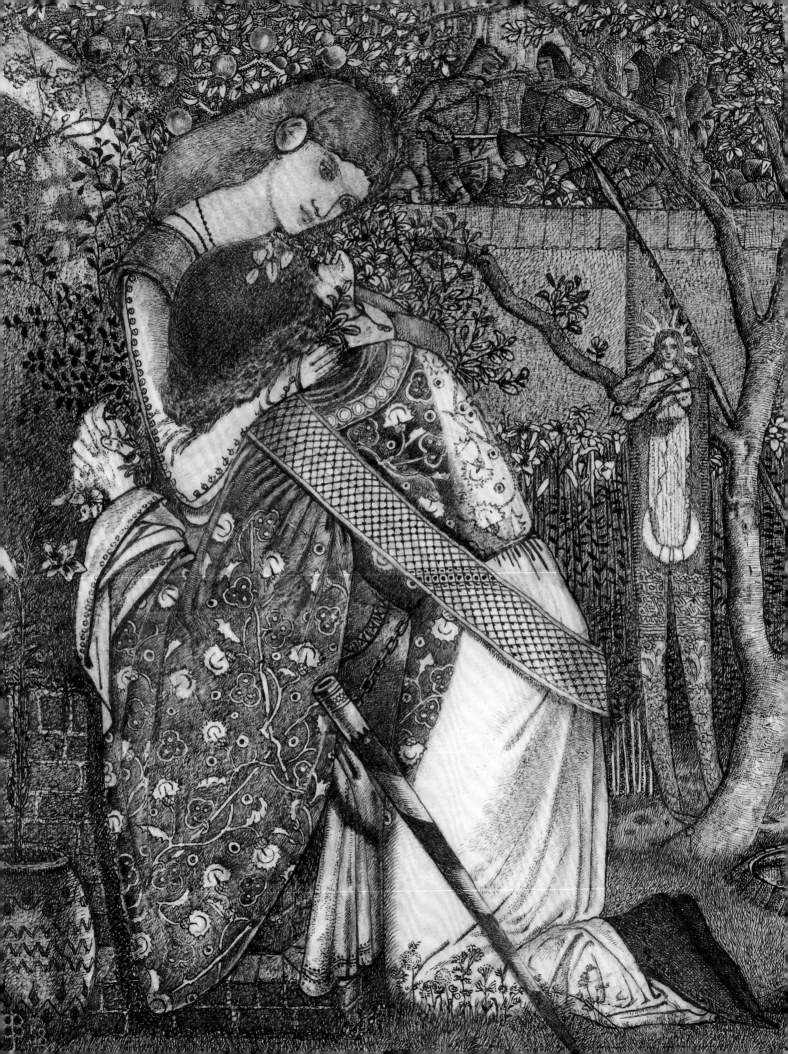

II

Contrasting Traditions, Media and Purposes

THE DRAWINGS AND watercolours in this section have been selected to show the great variety of styles, subject matter and media to be found in work by the Pre-Raphaelites. Highly finished drawings in pen and ink, made to be translated into black and white illustration, depict scenes from modern life among rich and poor (cats 16–17). Watercolour is given the intensity of oil paint in works by John Brett and Simeon Solomon, which offer further insights into the Victorian world of formal dress and religious ritual. These watercolours, too, are highly finished. Another side of modern life is conveyed in Ford Madox Brown's drawing of a greyhound, a cartoon for his famous painting *Work*.

Sketchier, preparatory works reveal the very different backgrounds the Pre-Raphaelites had in their artistic formation. Some, such as Holman Hunt, had benefited from the rigorous training of the Royal Academy Schools, which emphasised drawing of the human figure. His drawing for a picture that he never completed, of the biblical subject of Ruth and Boaz, demonstrates Hunt's skill in devising a multi-figure composition. In contrast to this are drawings by Rossetti and Burne-Jones – two artists who were relatively untrained and arguably more original as a result. Both men take their inspiration from medieval literature and from early Renaissance prints. A less finished use of watercolour, rich, dry and tempera-like, is to be seen in Rossetti's *Carlisle Wall*, an illustration to a medieval ballad by Sir Walter Scott.

Burne-Jones's early pen and ink drawing *The Knight's Farewell* is deliberately excessive in its intricate detail. In the 1860s, however, he gave himself the training he had lacked, studying sixteenth-century masters such as Michelangelo and drawing from classical sculpture and from the life model. He was able to achieve widely different effects with soft pencil, chalk on textured paper and gold paint.

John Ruskin came from a different tradition again, that of the amateur watercolourist. His watercolours of natural history specimens, such as his drawing of an iris, are extremely delicate, based on close observation and a finely controlled technique. This was one of the drawings Ruskin gave to Oxford University for its Drawing School. He wrote that 'the student will find great good in copying it without too laborious effort'.[26]

Among the landscape painters influenced by Ruskin was George Price Boyce, represented here by an atmospheric study of farm buildings near Streatley, Berkshire. Many of Boyce's watercolours include buildings, reflecting his initial training as an architect. The inscriptions on the watercolour show that it was painted out of doors in early November – a testament to Boyce's dedication to the Pre-Raphaelite emphasis on direct study from nature.

Opposite: detail of cat.25.

16

SIR JOHN EVERETT MILLAIS (1829–1896)
The Race Meeting, or *The Gambler*, 1853

Pen and black ink with touches of sepia on off-white paper, 24.8 × 17.6 cm
Signed in monogram and dated 1853
Purchased, 1947; WA1947.335
LITERATURE: Rosenfeld and Smith (2007) no.53; Barringer (2012) no.99

Millais made drawings in a wide range of different styles and media. This is one of
a series of pen and ink drawings he made in 1853 and 1854 on themes taken from
modern life. They are social satires in the tradition of the eighteenth-century British
painter William Hogarth, whom the Pre-Raphaelites greatly admired. In this group of
drawings Millais honed his skills as a social commentator and developed techniques
that would see him become one of the most popular illustrators of his time. Many of
them, including this work, passed into the collection of George Gray, probably as gifts
from his sister, Millais's wife Effie.

In this drawing Millais adopts the detailed treatment of popular illustration –
similar to the work of his friend John Leech who created humorous illustrations for
Punch magazine. Millais attended the Epsom Derby on 25 May 1853 and wrote to his
friend Charles Collins about the scenes he had witnessed:

> Such tragic scenes I saw on the course. One moustachioed guardsman was hanging
> over the side of a carriage guilty of a performance only excusable on board a ship in
> a state of abject intoxication, while with a white aristocratic hand dangling, as dead
> a lump, as the plaster casts of hands in painters' studios, in the same carriage seated
> beside him endeavouring to look as though she was not cognisant of the beastly
> reality; his mistress.[27]

Here he shows not the scene he described to Collins, but a parallel episode. The
'toff' in the carriage has gambled and drunk to excess, and his wife or mistress buries
her face in her hands in shame and despair. Companions and hangers-on crowd round.
The display of extravagance is contrasted with the poverty of the marginal figures of the
beggar woman and the hungry, dark-skinned child who chews on a bone, even as a pie
sits, barely touched, on the shelf of the carriage.

Millais introduces an extraordinary amount of anecdotal detail into his crowded
composition. In the distance, horses are on the track, watched by a man with
binoculars on the right. In the foreground, a man with a distinctly dark (presumably
red) nose steadies himself on the rim of the carriage while a companion fills up his
glass. Two 'Derby dolls' (popular decorations for racegoers' hatbands) mimic the
attitudes of the characters, one spreading out his hands while the other sits jauntily
in a brandy glass.

17

ARTHUR HUGHES (1832–1915)

*Illustrations for 'Cottage Songs for Cottage Children' by George Macdonald,
in* Good Things for the Young of all Ages, November 1873

Sweep the Floor
By the Cradle (shown here)
Pen and India ink over graphite on paper, 11.1 × 11.9 cm, 11 × 13.2cm
Presented by Charles Emanuel, 1950; WA1950.178.264–5

Arthur Hughes first came in contact with the PRB in 1850, and his modern life paintings
often draw their inspiration from Millais. He made many designs for illustrations, including
a set for Christina Rossetti's *Sing-Song* (1872). This pair was for a series of poems, 'Cottage
Songs for Cottage Children' by George Macdonald (1824–1905), which were published in
a magazine. The idyllic vision of cottage life presented here owes much to the genre painters
of the time. Cherubs and an angel watch over the family as they go about their daily tasks:
the husband labours in the field as the wife knits, the older child keeps the cottage neat and
tidy. The beehive, the sampler, the candlesticks on the mantelpiece, the cradle carved in the
shape of a heart all contribute to an idea of virtuous, self-sufficient peasant life very different
from the aristocratic depravity of Millais's *Race Meeting* (cat.16).

18

FORD MADOX BROWN (1821–1893)
*Study of a Greyhound, c.*1863

Graphite on off-white paper, outlined on reverse in red chalk for transfer, 15.3 × 38.9 cm
Presented anonymously in memory of James Bannatyne Stewart Robertson, 1966; WA1966.92
LITERATURE: Bennett (2010) no. A59.14

Ford Madox Brown had a traditional academic training in Antwerp. As a result he used
the Renaissance method of transferring drawings by means of a cartoon, even on his most
famous painting of modern life, *Work* (1852–63, fig.7). The drawing is the same size as the
detail in the painting; red chalk has been applied to its reverse and tracing the outline
on the right side would have caused some of this to adhere to the canvas. He prepared
his design very carefully, making cartoons for all three of the dogs in the painting – the
greyhound, bull terrier and mongrel – whose breed matched the social status of his
human characters. Brown described the greyhound as 'that exceedingly beautiful tiny
greyhound in a red jacket' that takes up the attention of the lady with a parasol, so that
she does not notice the poor children in the foreground.[28]

19

SIR JOHN EVERETT MILLAIS (1829–1896)
The Apple Gatherers / Picnic Scene, ?1851

Pen and sepia ink over graphite on paper, 18.4 × 28.6 cm
Bequeathed by John Bryson, 1977; WA1977.63
LITERATURE: Brown (1978) p. 291

This drawing is reproduced in J. G. Millais, *Life and Letters of Sir John Everett Millais*
(1899), in which it is suggested that it is the artist's first idea for *Spring (Apple Blossoms)*
(1856–9, fig.1).[29] The girl drawing a blade of grass through her teeth, in the lower
left-hand corner of the drawing, appears in a different guise in the right-hand corner of
the painting. However, one (perhaps two) of the figures in this drawing are men, and
the overall subject seems to be young girls assuaging their boredom by finding different
kinds of amusement in the countryside, including the petting of a small dog. In the
painting the figures are all young women and a more tragic theme, that of the fragility
of youth, is indicated by the presence of a scythe.

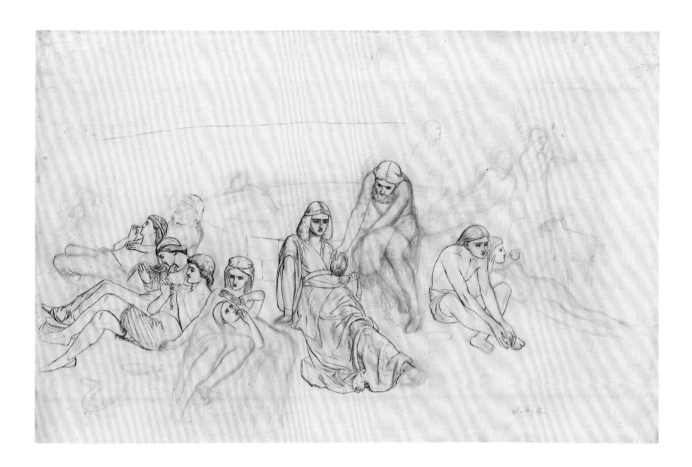

20

WILLIAM HOLMAN HUNT (1827–1910)
Ruth and Boaz, 1850

Graphite with pen and ink on paper, 32.8 × 51 cm
Purchased, 1952; WA1952.4
LITERATURE: Bronkhurst (2006) no.D 48

In 1850 both Millais and Hunt were planning ambitious multi-figure compositions, of the
type approved by the Royal Academy, illustrating scenes from the Bible. Millais's drawing for
The Flood[30] has figures arranged in a similar semi-circular way to this drawing, which takes as
its theme the Old Testament story of Ruth, a poor widow, who is invited by the rich farmer
Boaz to join the harvesters at their meal; eventually she marries him.

 Both Millais and Hunt talked of going to Jerusalem to paint their landscape backgrounds
on the spot, but in the event both scaled down their plans. Millais produced *The Return of the
Dove to the Ark* (1851)[31] while Hunt chose another harvest theme for his painting, *The Hireling
Shepherd* (1851–2).[32] Coincidentally, the French painter Jean-François Millet (1814–75) also
began a painting of Ruth and Boaz in 1850, exhibiting it at the Paris Salon in 1853.[33]

21

SIMEON SOLOMON (1840–1905)

Two Acolytes Censing: Pentecost, 1863

Bodycolour on paper mounted on canvas, 40.3 × 34.8 cm
Signed in monogram and dated 1863
Purchased, 1957; WA1957.83
LITERATURE: Cruise (2005) no.86

Simeon Solomon was the youngest in a Jewish family of talented artists. His siblings Abraham Solomon (1824–1862) and Rebecca Solomon (1832–1886) both had successful careers as genre painters. Simeon studied at the Royal Academy Schools; he met members of the Pre-Raphaelite circle in 1857, first exhibiting his work at the Academy in 1858. Solomon was gay, and his studies of beautiful young men offered a homoerotic counterpart to the female 'stunners' of Rossetti. His work was much admired in artistic and literary circles: he collaborated with the poet Algernon Swinburne (and wrote poetry himself), and Oscar Wilde owned works by him. Sadly, however, Solomon fell foul of the restrictive laws of his day. Following his arrest and conviction for homosexual activities in 1873, he ceased to exhibit.

Solomon produced a series of paintings of young men engaged in rituals from various religions, including paganism, Judaism and Christianity. His interest in Christian practices encompassed the Greek Orthodox and Roman Catholic churches, as well as the Church of England. Solomon was painting at a period of intense debate within the Anglican church about church furniture, vestments and sacraments, so his subject matter was of great topical interest.

There is no record of this work being exhibited, so it may have been sold directly from Solomon's studio. It may portray a Roman Catholic church: the incense, candlesticks and flowers on the altar were all features that aroused controversy in the Anglican church at the time. The older acolyte is using a thurible to cense an altar table as part of the celebration of Pentecost, when the Holy Spirit is supposed to have descended on the apostles, marking the beginning of the Christian church. Colin Cruise has pointed out that the two figures look like portraits: one wears the fashionably long hair of the Pre-Raphaelites, the other has short, cropped hair in a style not common at the time. Solomon has used bodycolour, on paper mounted on canvas, giving the painting the richness and durability of an oil painting. He manages to achieve a remarkably wide range of tones, from the deep shadow in the background to the gleaming lights on the thurible and candlestick, and the shimmer on the gold chasuble worn by the older acolyte.

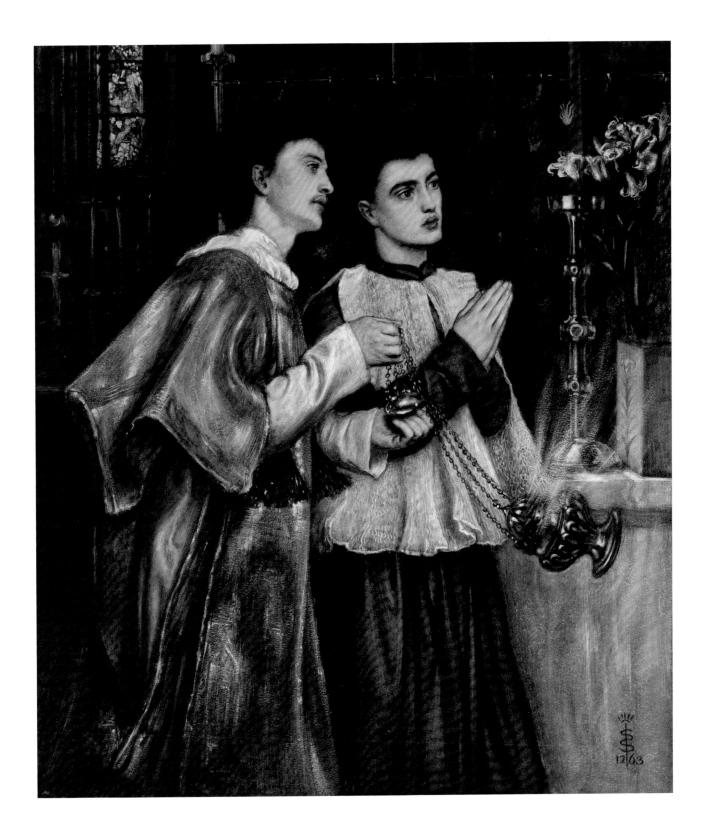

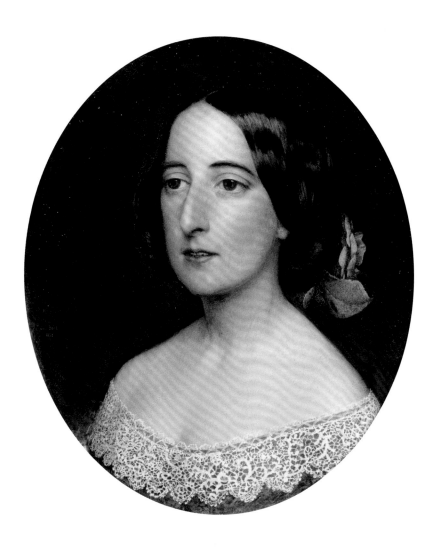

22

JOHN BRETT (1831–1902)
Emily Patmore, 1856

Watercolour and bodycolour on card, 34.6 × 29.5 cm
Presented by the executors of Mary Patmore, 1998; WA1998.217
LITERATURE: Payne and Sumner (2010) pp. 15–16

This watercolour portrait was until recently thought to be an oil painting: the watercolour and bodycolour have been applied in a meticulously detailed manner and heavily varnished. The writer Emily Andrews (1824–1862) married the poet Coventry Patmore in 1847. She was the inspiration for his famous poem *The Angel in the House*, which came to be regarded as the blueprint for the perfect wife and mother. The Patmores were on close terms with the Pre-Raphaelites and Millais also painted Emily's portrait, in 1851.[34] It is likely that the format of Brett's portrait was suggested by a poem Robert Browning had inscribed in Emily's album, 'A Face', which describes her 'lips ... opening soft', 'her lithe neck, three fingers might surround' and her 'fruit-shaped, perfect chin'.[35] The blue background and the intricate lace trim are reminiscent of English Renaissance miniatures.

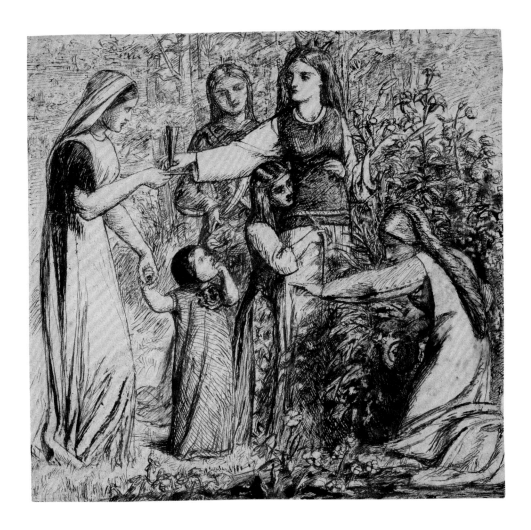

23

DANTE GABRIEL ROSSETTI (1828–1882)
*Dante's Vision of Matilda Gathering Flowers, c.*1855

Pen and brown ink on off-white paper, 17.8 × 18.5 cm
Purchased, 1942; WA1942.157
LITERATURE: Surtees (1971), no.72A

Dante Gabriel Rossetti was a poet as well as a painter and he liked to draw in pen, the same implement and medium that he used to write his poetry. This drawing is a detailed preparatory study for a watercolour (untraced) of the same title commissioned by John Ruskin, a companion to *Dante's Vision of Rachel and Leah* (1855).[36] Both subjects were taken from the *Divine Comedy* of Dante Alighieri (1265–1321), a poet with whom Rossetti identified and whose name he bore. In this scene Dante enters the terrestrial paradise, where he meets a beautiful woman gathering flowers. She is Matilda, who tells him that he is in the Garden of Eden. Dante's meeting with Matilda prepares him for the meeting with Beatrice, his idealised love. Rossetti learned to draw mainly by copying prints and illustrations, rather than following the academic practice of studying the nude figure. His drawings are often stronger in poetic intensity than in anatomical accuracy.

24

DANTE GABRIEL ROSSETTI (1828–1882)
Carlisle Wall (The Lovers), 1853

Watercolour and bodycolour on paper, 1.1 × 16.8 cm
Signed in monogram and inscribed: *Carlisle 1853*
Deposited by the Trustees of the Tate Gallery, in accordance
with the wishes of Miss E. K. Virtue-Tebbs, 1950 (Photo © Tate)
LITERATURE: Surtees (1971), no.60

Rossetti visited Carlisle, together with William Bell Scott, in June 1853. According to
Ford Madox Brown, he painted this watercolour over two evenings at Scott's house
and gave it to Brown in lieu of a debt of £5 and 8 shillings (£5.40). Brown called the
work 'Lovers on the Battlement'. Its present title comes from a ballad, 'It was an English
Ladye Bright', in Sir Walter Scott's poem 'The Lay of the Last Minstrel' (1805). This
tells the story of an English lady who fell in love with a Scottish knight and was killed
by her xenophobic brother:

> Blithely they saw the rising sun
> When he shone fair on Carlisle wall;
> But they were sad ere day was done
> Though Love was still the Lord of all.

Each verse repeats the lines (with minor variations): 'The sun shines fair on Carlisle
wall' and 'For Love shall still be lord of all'. In the following summer Rossetti and
Elizabeth Siddal planned a series of illustrations to Scott's *Minstrelsy of the Scottish
Border*: Siddal's watercolour *Clerk Saunders* (fig.13) illustrates one of these poems.

The theme of star-crossed lovers was popular in Pre-Raphaelite painting and poetry.
In 1851 Holman Hunt was contemplating two possible designs showing pairs of lovers
in castle walls and towers. One was to show a woman working a tapestry in a tower,
when her husband returns from the Crusades and catches her in his arms. The other,
an incident from the fifteenth-century Wars of the Roses, would depict the daughter of
a Lancastrian with a Yorkist man, seated on her father's castle walls. Hunt says that he
described to Millais the powerful tension he conceived at the heart of this work:

> I shall make him urging her to flee with him, and her sense of duty to her family
> raises the struggle in her mind as to which impulse she shall obey.[37]

Drawings for both subjects are on a sheet with drawings for *The Light of the World*
(cat.63). According to Hunt's account (written many years after the event), Millais
immediately thought of stealing his Wars of the Roses idea; only after Hunt managed
to dissuade him did the artist come up with the subject for his very successful painting
A Huguenot (1852).[38] All of these subjects are possible precedents for *Carlisle Wall*.

As Fiona Mann writes in her essay for this catalogue, Rossetti's use of a 'dry brush
style' of watercolour was a radical departure from traditional practices. It gives a jewel-
like intensity to the painting that matches the intensity of feeling shown by the lovers:
they cling to one another, enfolded by the castle walls.

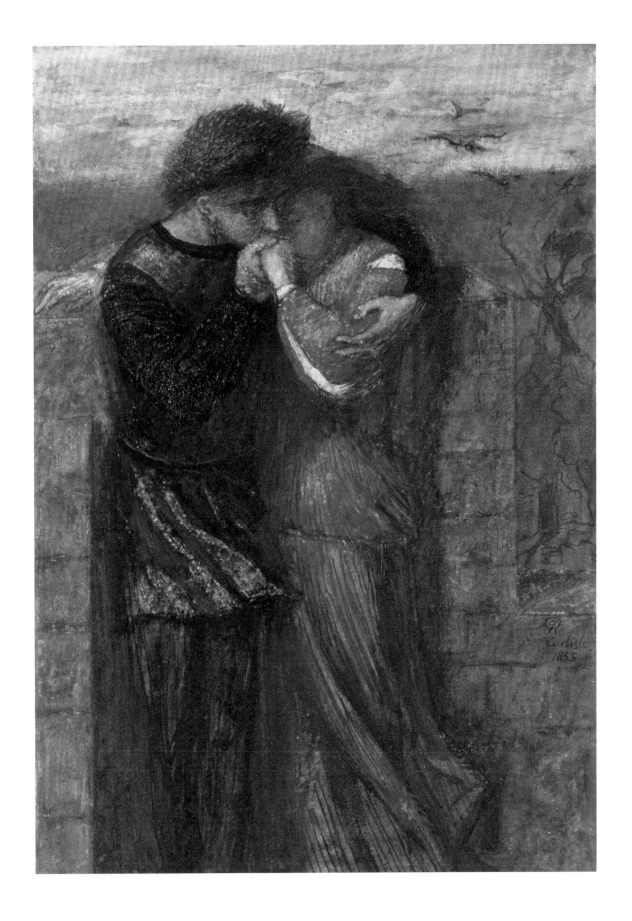

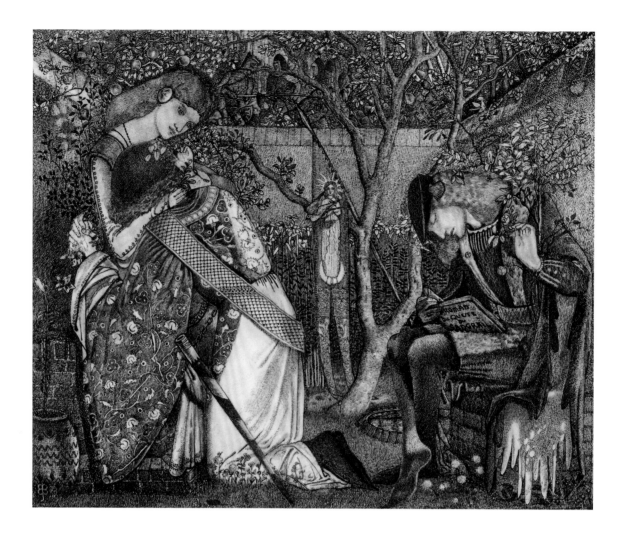

25

SIR EDWARD COLEY BURNE-JONES (1833–1898)
The Knight's Farewell, 1858

Pen and black ink over graphite on vellum, 17.6 × 24.2 cm
Signed in monogram and dated: *EBJ 1858*
Inscribed: *ROMAN / DU QUETE / DU / SANGRAIL*
Bequeathed by John Bryson, 1977; WA1977.34
LITERATURE: Wildman and Christian (1998) no.5; Harrison (2015) no.71

This is one of a series of pen and ink drawings executed by Burne-Jones in 1858, all on the theme of lovers having to part as the men leave for battle. *Going to the Battle*[39] and *Sir Galahad*,[40] from the same year, are also on vellum, the support used by makers of medieval illuminated manuscripts. *The Knight's Farewell* contrasts the anguish of the knight on the left, who clasps his lady love before joining his comrades beyond the walled garden, with the insouciance of the young man on the right; the latter only reads about battles in his 'Roman du Quete du Sangrail' – the story of the quest for the Holy Grail, from Malory's *Morte d'Arthur*. The amount of detail is extraordinary: the apple tree, rose bushes and tall lilies of the enclosed garden are indicated with a multitude of tiny strokes of the pen. The drawing was bought by William Morris.

26

SIR EDWARD COLEY BURNE-JONES (1833–1898)
Study of a Woman's Head, turned to the Left, 1868

Red and black chalk on textured paper, 21.5 × 20.6 cm
Signed in monogram and dated 1868
Bequeathed by John Bryson, 1977; WA 1977.32

The freedom of Burne-Jones's later drawings is radically different from the tightly
detailed penwork of his medievalising works of the 1850s. He loved experimenting with
different materials. For this drawing of a woman's head he used a very thickly textured
paper, applying black and red chalk lightly over much of the surface so that the chalks
lightly graze the parts of the paper that stand out in relief. This produces a pattern
similar to the effect of a brass rubbing. For the features, however, especially the eye,
he has applied the chalk in a much finer, more detailed manner. This may be a study
for a painting (as yet unidentified), or Burne-Jones may simply have been trying out a
different way of working.

27

SIR EDWARD COLEY BURNE-JONES (1833–1898)
Study for 'Pygmalion', c.1875

Graphite on off-white paper, 26 × 19 cm
Bequeathed by John Bryson, 1977; WA1977.35

Burne-Jones took up drawing from the nude relatively late in his career, but it became a highly important part of his practice and hundreds of life drawings by him survive. Like Renaissance masters such as Michelangelo and Raphael, Burne-Jones drew the nude first, in the pose needed for his painting, so that the anatomical details would be correct before the figure was clothed in drapery.

This work is a study for his painting *The Hand Refrains* (fig.59), from Burne-Jones's series *Pygmalion and the Image*. It tells the story of the Cypriot sculptor who fell in love with the nude he was sculpting, whereupon she came alive. The subject comes from Ovid's *Metamorphoses*. Pygmalion scorns the worship of Aphrodite, the goddess of love, and vows to remain celibate. In the first scene he is in his studio, pondering ideal beauty and ignoring the attentions of the young women outside. In the second picture, *The Hand Refrains*, we see him carving a marble sculpture of a nude woman, in the pose of a Venus. He has paused momentarily in his work, laying down his mallet to gaze thoughtfully at the sculpture. His expression suggests that he is falling in love. In the third scene the goddess Aphrodite appears and imparts life to the sculpture, now named Galatea. The final painting shows that Galatea has come down from her pedestal and Pygmalion kneels at her feet.

Burne-Jones made at least 28 drawings of this theme. He originally intended them as illustrations for William Morris's poem *The Earthly Paradise*, later adapting them for two sets of four oil paintings. The first set[41] was commissioned in 1868 by Euphrosyne Cassavetti, the mother of Burne-Jones's Greek model and lover, the sculptor Maria Zambaco. Burne-Jones was not a sculptor, but the theme of an artist falling in love with his creation had obvious significance for him. It was especially highly charged because of his passionate affair with Zambaco, which ended painfully in 1869.[42] In one of his last recorded utterances, Burne-Jones apparently said to his assistant, Thomas Rooke:

> Lust does frighten me … I don't know why I've such a dread of lust. Whether it is the fear of what might happen to me if I were to lose all fortitude and sanity and strength of mind – let myself rush down hill without any self-restraint …[43]

This drawing is a study for the later set, now in Birmingham Museum and Art Gallery.[44] The paintings were begun in 1875 and finished in time for the second exhibition at the Grosvenor Gallery, in 1878. The Grosvenor Gallery exhibitions were set up in competition with the Royal Academy and provided a congenial environment for Burne-Jones; his works were displayed together and much admired.

Fig.59 Sir Edward Coley Burne-Jones (1833–1898), *Pygmalion and the Image: The Hand Refrains*, 1875–8. Oil on canvas. Birmingham Museums and Art Gallery. 1903P24. Photo by Birmingham Museums Trust, licensed under CC0.

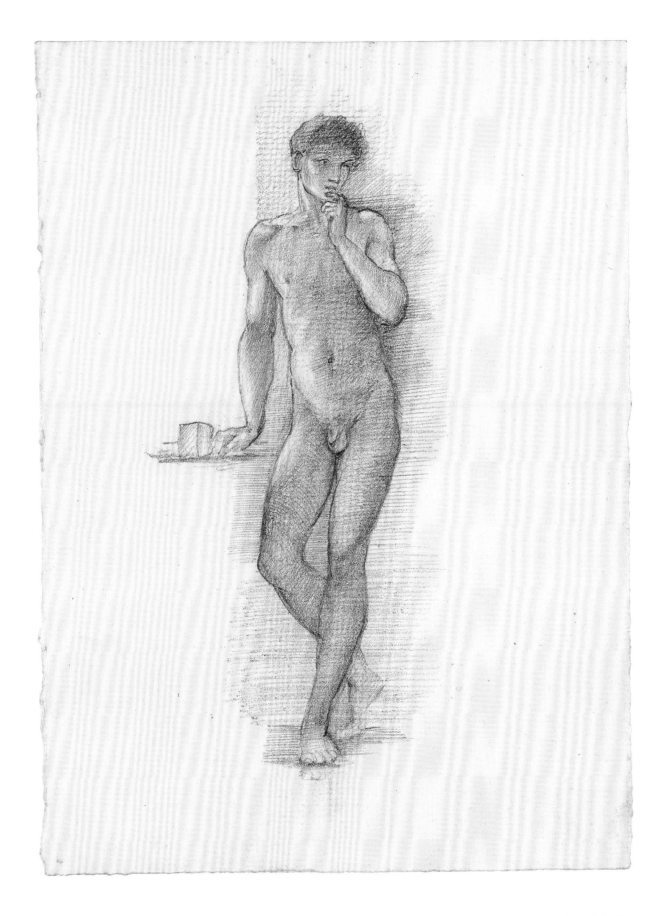

28

SIR EDWARD COLEY BURNE-JONES (1833–1898)
Hope, 1893

Metallic gold paint on prepared paper, 47.2 × 32.7 cm
Bequeathed by Mrs Helen Mary Gaskell, 1939; WA1939.11

The allegorical figure of Hope was a recurrent theme in Burne-Jones's work. In 1871 he made cartoons for three stained-glass panels in the south aisle at Christ Church Cathedral, Oxford; they portrayed the three theological virtues, Faith, Hope and Charity. The cartoons were later painted over in watercolour to form independent works of art; the watercolour of Hope is now in Dunedin Public Art Gallery, New Zealand.

In the window at Christ Church, now known as the Virtues Window (fig.36), Hope appears with her Latin name, Spes. She faces to the right, holding a palm in her right hand and stretching her left hand upwards, leading her gaze heavenwards. She stands against a background of flowers and foliage. In the watercolour she holds a flowering rod, is chained at the ankle and stands against a wall; a city is visible through the prison bars behind her. Burne-Jones used the same design again for a commission from a Massachusetts patron in 1896, an oil painting now in the Museum of Fine Arts, Boston. In all three versions Hope wears green, the colour associated with Hope by the ancients.

Burne-Jones would have known the very successful painting of *Hope* by George Frederic Watts, exhibited in 1886. In Watts's painting Hope is a blindfolded figure, seated on a globe and paying a lute in which all the strings but one are broken. Watts's figure of Hope is a comment on the state of the world. It was widely reproduced, and has been influential in recent years through its use in a sermon that inspired Barack Obama's campaign for the United States presidency.

In this drawing, however, Hope is unchained. She faces to the left, with both her arms lifted towards the sky. She is rising from a tomb in barren countryside, like a depiction of the Resurrection of Christ. Burne-Jones developed the idea further for another watercolour, *If Hope Were Not, Heart Should Break* (fig.60), in which flowers, natural symbols of resurrection, are growing out of the tomb; Hope, once again, is shown wearing green. In the 1890s, saddened by the deaths of friends and conscious of his own mortality, Burne-Jones seems to have used these images to explore the Christian promise of an afterlife.

Burne-Jones enjoyed experimenting with metallic paints. In this drawing, a gift for his great friend, Helen Mary Gaskell, he has used gold paint.

Fig.60 Sir Edward Coley Burne-Jones (1833–1898), *Hope*, c.1895. Watercolour and bodycolour on paper. Private Collection. CH828485. Photo © Christie's Images / Bridgeman Images.

29

JOHN RUSKIN (1819–1900)
Fleur-de-Lys (Iris Florentina), 1871

Watercolour over graphite on paper, 31 × 20.6 cm
Presented by John Ruskin to the Ruskin Drawing School, 1875; WA.RS.ED.012
LITERATURE: Elements of Drawing website http://ruskin.ashmolean.org/object/
WA.RS.ED.012

John Ruskin first became associated with the Pre-Raphaelites as a critic, when he
sprang to their defence in 1851, but he was also an accomplished draughtsman himself.
This is one of the drawings that he donated to the University of Oxford in the 1870s,
intending them to be used for teaching undergraduates. Ruskin's own training as an
amateur watercolourist would have included numerous copying exercises as well as
drawing and painting from life, and he hoped that Oxford undergraduates would
follow the same course. He wrote:

> I place the Fleur-de-Lis [sic] next the Strawberry that the student may compare
> the triple disposition of Form which gave to both plants, being coupled with the
> utmost exquisiteness in detail, their royal authority over the human mind.[45]

30

GEORGE PRICE BOYCE (1826–1897)
Farm Buildings near Streatley, Berkshire, 1863

Watercolour on paper, 10 × 35 cm
Signed and dated: *G. B. Boyce Nov. 4. 63*. Inscribed on verso:
Tull's Farm/ Southridge/ Boyce. Nov 4. 63/ foreground field greener
Bequeathed by Francis Falconer Madan, 1962; WA1962.17.58
LITERATURE: Newall and Egerton (1987) no.36

George Price Boyce trained as an architect, but decided to become an artist after a
meeting with the landscape painter David Cox (1783–1859) in 1849. Boyce favoured
sketchbooks with pages of a panoramic format for making his watercolours out of
doors. Here he depicts a scene that is not picturesque in the conventional sense – the
tall Lombardy poplars are not really balanced by the foliage on the left, while the long,
low, tiled wall pushes the farmhouse almost out of the field of vision – yet its very
awkwardness carries conviction. The corn ricks on the right indicate that the harvest
is over; the reaped field in the foreground is beginning to show new growth in the
stubble. Boyce repeated the composition, with only minor changes, for an exhibition
watercolour, *An Upland Farm in Berkshire*, which he showed at the Old Watercolour
Society exhibition in 1871.[46]

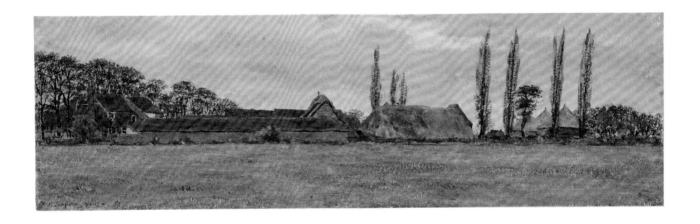

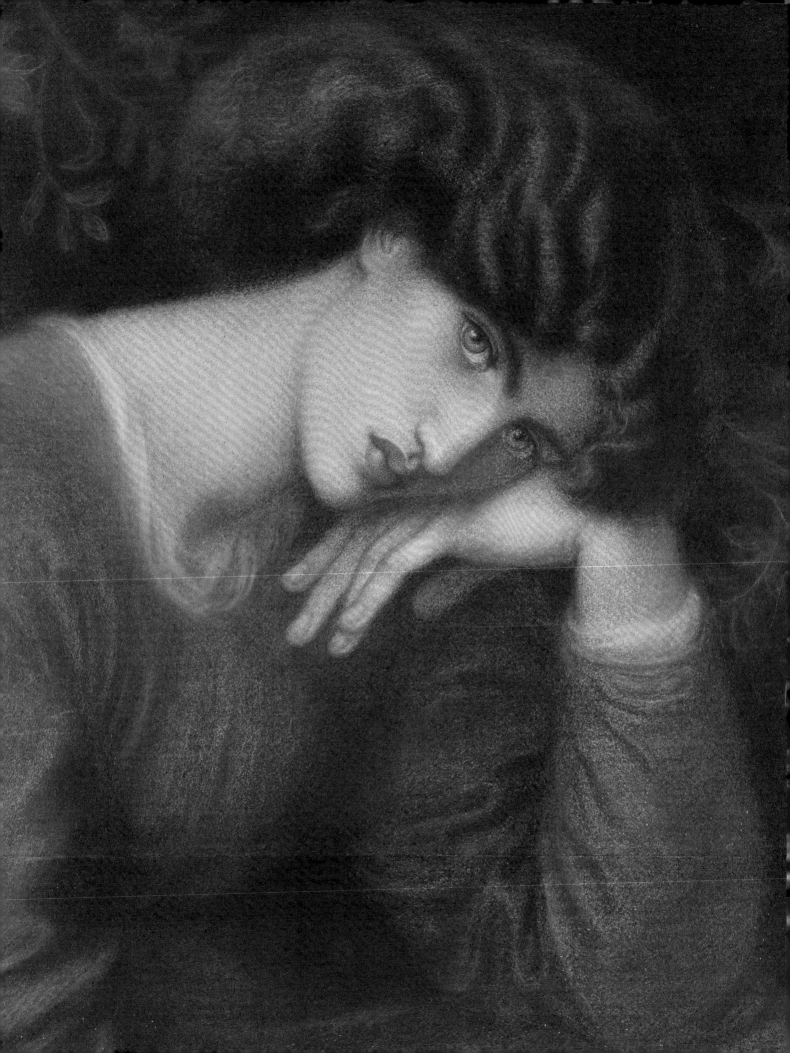

III

'Stunners'

IT SEEMS TO have been Dante Gabriel Rossetti's idea to refer to beautiful women as 'stunners', and his work dominates this section of the exhibition. Drawings of the model and artist who later became his wife, Elizabeth Siddal, match what we are told of her quiet, reflective character. Rossetti often drew her in the evening, by candlelight or gaslight, revelling in the way the light played across her features or the folds of her dress.

In 1858 he portrayed the actress Ruth Herbert in a very different way – beginning the focus on full lips and a long, rounded neck that was to become the hallmark of his later, more sensual drawings of women. He experimented with different media, sometimes using soft pencil, sometimes combinations of pen and ink and wash, resulting in subtle or dramatic effects of light. From the late 1850s and early 1860s he had two favourite models: Fanny Cornforth, his housekeeper and lover, and Jane Burden, who married William Morris in 1859. Both women had abundant, wavy hair, which also starts to be more of a feature in his drawings.

As with Elizabeth Siddal, Rossetti drew Jane Morris in pencil or in pen and ink, resting on a sofa in the evening, her head or shoulders propped up against a pillow. But he also made her the subject of large drawings in coloured chalks, emphasising her long, slender fingers and her melancholy expression. In *Reverie* and *The Day Dream* she is transformed into a goddess-like creature from another world.

Opposite: detail of cat.38.

When Burne-Jones drew Violet Manners (herself a skilled draughtswoman) he concentrated on her head. He used soft pencil to suggest an otherworldliness and a fragility of character that suited her role as one of the so-called 'Souls' – an aristocratic social circle that favoured refined intellectual and artistic pursuits. The drawing was given as a gift to Helen Mary Gaskell, with whom Burne-Jones had an intense, but platonic friendship.

Frederick Sandys made many drawings of women, often with a title suggesting some mythological subject, but with only a loose narrative connection. For *Hero* he used as model his neighbour Marianne Shingles, a silk weaver. *Nepenthe* is based on a drawing of his sister, the artist Emma Sandys. Executed in 1892, the fifteenth anniversary of Emma's death, the opium poppies and ecstatic expression echo Rossetti's paintings of *Beata Beatrix*,[47] a similar tribute to his dead wife.

These images of women by male Pre-Raphaelite artists frequently divide opinion. Some see them as objectifying the female sitters, turning them into passive objects designed to cater to the male gaze. For other viewers they are 'celebrations' of female beauty, and the fact that the women are often depicted alone or in thought lends them a kind of agency or inner life. Recent scholarship has proposed that the women were more active in the modelling process than has previously been recognised; far from being passive lay figures, they were active participants in the development of Pre-Raphaelite visual culture.

31

DANTE GABRIEL ROSSETTI (1828–1882)
Elizabeth Siddal, 1855

Pen and brown and black ink on paper, with some scratching out, 13 × 11.2 cm
Signed in monogram and dated: *DGR / Feb. 6 / 1855*
Bequeathed by Francis Falconer Madan, 1962; WA1962.17.77
LITERATURE: Surtees (1971) no.472; Surtees (1991) no.26; Harrison (2015) no.66

Elizabeth Siddal entered the Pre-Raphaelite circle in 1849 or 1850, having been spotted by Walter Deverell while working in a milliner's shop in Leicester Square. She initially modelled for a number of Pre-Raphaelite artists, including Holman Hunt and Millais, but from 1851 she modelled exclusively for Rossetti. His drawings of her were often made in the evening, under conditions of candle- or gaslight. Siddal's health was not good and her relationship with Rossetti was a complex one. From the intense closeness evident in the drawings the couple moved to a period of estrangement and then, in 1860, to marriage, but Siddal died of an overdose in 1862 after giving birth to a stillborn child. This drawing is unusual in showing her full face: the dramatic contrasts of light and shade hint at her changing moods, with an underlying theme of melancholy introspection.

32

DANTE GABRIEL ROSSETTI (1828–1882)
Elizabeth Siddal playing Double Pipes, 1852

Graphite on paper, 19.6 × 13.6 cm
Bequeathed by John Bryson, 1977; WA1977.79
LITERATURE: Surtees (1971), no.459; Surtees (1991), no.3

Most of Rossetti's drawings of Elizabeth Siddal are, like this one, in soft pencil with
subtle lighting, emphasising the delicacy of her character. This drawing is one of a
pair in which she plays different musical instruments; in each case Siddal kneels on
the floor, her full skirt gathered in folds around her knees. It is likely that Rossetti was
planning a composition which contrasted two women, representing one as chaste and
the other as sexually alluring. In the companion drawing[48] Siddal plays the cythern, an
instrument associated with angels. Here, however, she plays the double pipes or aulos,
an instrument played by prostitutes in ancient Greece and bearing obvious phallic
connotations. Although she is modestly dressed her long, loose hair may be intended to
indicate sexual availability; in the companion drawing it is tied back.[49]

33

DANTE GABRIEL ROSSETTI (1828–1882)
Portrait of Louisa Ruth Herbert, 1858

Graphite on paper, framed as an oval, 50.8 × 43 cm (frame)
Signed and dated: *Ruth Herbert / 1858 / DGR delt*
Presented by Virginia Surtees, 2014; WA2014.38
LITERATURE: Surtees (1971) no.325; Harrison (2015) no.67

Rossetti first saw the actress Louisa Ruth Herbert (1831–1921) at the Olympic Theatre
in February 1856. He made a quick sketch of her which he annotated 'Stunner No 1'.
Two years later he wrote to William Bell Scott:

> I am in the stunning position this morning of expecting the actual visit, at ½ past
> 11, of a model whom I have been longing to paint for years – Miss Herbert of the
> Olympic Theatre – who has the most varied and highest expression I ever saw in
> a woman's face beside abundant beauty, golden hair etc. ... Oh my eye! She has sat
> for me now and will sit for me for Mary Magdalene in the picture I am beginning.
> Such luck![50]

Herbert modelled for the central figure in Rossetti's pen and ink drawing *Mary
Magdalene at the Door of Simon the Pharisee* (fig.25). Rossetti also made many portraits
of her in pen and ink, pencil and watercolour in 1858 and 1859: seventeen such works
were in Herbert's possession at the time of her death. This delicate pencil drawing
is perhaps the finest of them all. The waves of her hair, the curves of her lips and
her downcast eyes are realised with extraordinary detail and subtlety. The work was
reproduced in Georgiana Burne-Jones's memoir of her husband's life.[51] It passed down
through Herbert's family to the Rossetti scholar Virginia Surtees, Herbert's great
grand-daughter, who in turn donated it to the Ashmolean.

Ruth Herbert was the daughter of a West Country brass founder. By the mid-
1850s she was known as 'Mrs Crabbe', having married and separated from Edward
Crabb [*sic*], a stockbroker. Her stage name was Miss Herbert, or Louisa Herbert, but
Rossetti usually refers to her as Ruth. She performed at the Theatre Royal, Glasgow
before making her London debut at the Royal Strand Theatre in October 1855. At the
Olympic Theatre she acted in Tom Taylor's *Retribution*, and it seems to have been the
playwright who gave Rossetti an introduction to her.

Rossetti's high opinion of Herbert's beauty is indicated in a watercolour he made
of her, round the sides of which he wrote 'BEATRICE HELEN GUENEVERE [*sic*]
HERBERT.'[52] In this inscription he gave her the names of three women famed for their
beauty: Dante's Beatrice and King Arthur's Queen Guinevere, both of whom often
appear in his work, and Helen of Troy, whom he depicted only once, in a painting now
in the Kunsthalle, Hamburg.

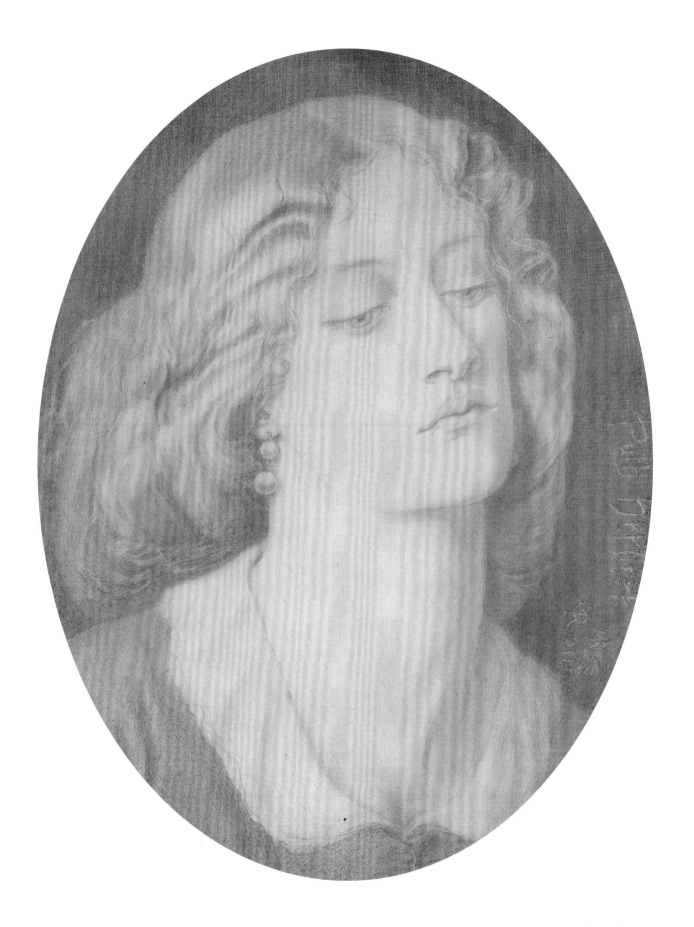

34

DANTE GABRIEL ROSSETTI (1828–1882)
Study of Louisa Ruth Herbert, c.1858

Graphite and pen and ink on paper, 20.7 × 16.6 cm
Purchased, 1943; WA1943.116
LITERATURE: Surtees (1971) no.1091

In this drawing it is clearly Herbert's facility for adopting varied expressions that has appealed to Rossetti as much as her good looks. For his pen and ink drawing *Mary Magdalene at the Door of Simon the Pharisee* (fig.25), he needed a model who would look yearningly towards the right, where, in the drawing, Christ's head is visible through a window. She would be shown removing her finery, including her earrings, in her determination to leave her sinful ways and follow Christ.

Herbert was not only a skilled actress. She managed the St James's Theatre, London from 1864 to 1868. While she was there she hired Henry Irving as her leading man and assistant stage manager, and commissioned W. S. Gilbert's first successful solo play. She later remarried and published *The St James's Cookery Book* in 1894 under her married name of Louisa Rochfort.

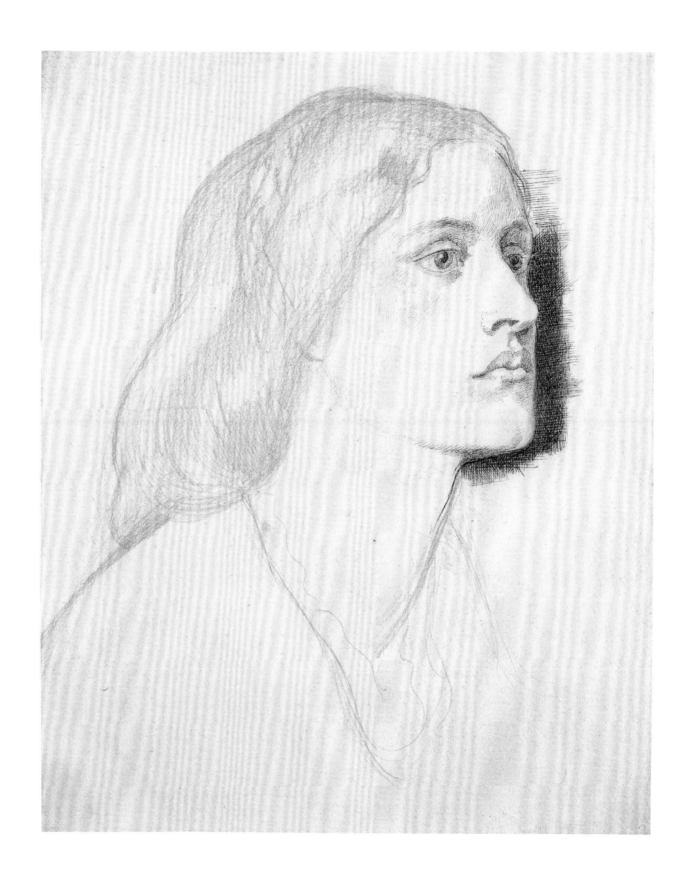

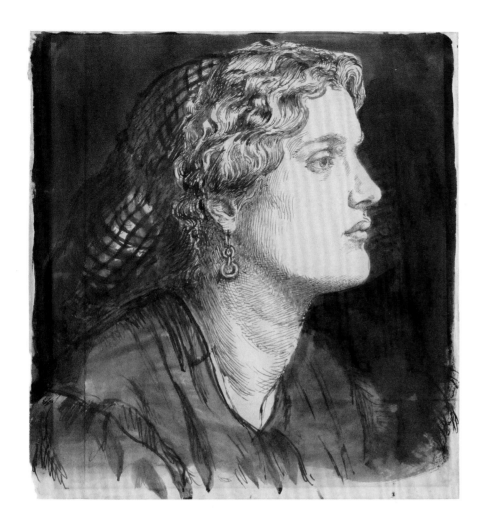

35

DANTE GABRIEL ROSSETTI (1828–1882)
*Portrait of Fanny Cornforth, c.*1860

Pen and brown ink with brown wash on pale blue paper, 22.4 × 21.2 cm
Bequeathed by John Bryson, 1977; WA1977.81
LITERATURE: Surtees (1971) no.286

Fanny Cornforth (1835–1909), née Sarah Cox, came into the Pre-Raphaelite circle in
1856, when she met Rossetti. She was the daughter of a blacksmith and had previously
worked as a domestic servant. She modelled for him over many years and also acted
as his housekeeper from 1862, after the death of Elizabeth Siddal. In later years they
referred affectionately to each other in their correspondence as 'Elephant' (Fanny) and
'Rhinoceros' (Rossetti) in recognition of their expanding girths. Many of Rossetti's
drawings of Fanny are preparatory studies for paintings, but that does not seem to be the
case here. He has used dark wash to make her pale skin and fine profile stand out against
the background. Pen strokes indicate the delicate curves of her jaw, neck and hair.

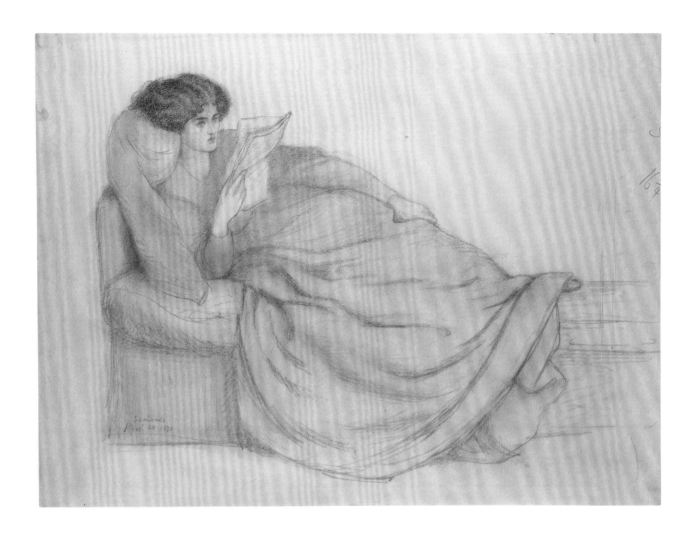

36

DANTE GABRIEL ROSSETTI (1828–1882)
Jane Morris reading a Newspaper, 1870

Graphite on off-white paper, 35 × 47.5 cm
Inscribed: *Scalands / April 30 1870*
Bequeathed by John Bryson, 1977; WA1977.83
LITERATURE: Surtees (1971) no.376

Jane Burden (1839–1914), the daughter of an Oxford stableman, modelled for
Queen Guinevere in Rossetti's murals in the Oxford Union in 1857 and married
William Morris in 1859. By the late 1860s she and Rossetti had become intimately
involved, and her striking looks are a familiar feature in his later work. She suffered
from recurrent bouts of ill-health of uncertain origin and was often unable to sit up
because of backache or dizziness: Morris took her to the spa at Bad-Ems in Hesse-
Nassau for a cure in July 1869.

　　This is one of a series of drawings of Jane reclining on a sofa that Rossetti made in
1870 when she was convalescing, and they were both staying at a cottage owned by the
artist Barbara Bodichon at Scalands in Sussex.

37

DANTE GABRIEL ROSSETTI (1828–1882)

Jane Morris in Icelandic Costume, c.1873

Pen and ink on paper, 36 × 29 cm
On loan from a private collection
LITERATURE: Surtees (1971) no.398

William Morris recognised, and to some extent accepted, his wife's love for Rossetti. In 1871 the two men became joint tenants of Kelmscott Manor, near Lechlade in Gloucestershire, and in the summer of 1871 Morris travelled in Iceland – leaving Rossetti and Jane, along with the Morrises' two daughters, free to enjoy the secluded manor house and its surrounding countryside. Morris made a second trip to Iceland in 1873, and it was presumably from this trip that he brought back Icelandic clothes as a gift for his wife. Another, much more intimate drawing by Rossetti, dating from around the same time, shows Jane in the same embroidered blouse, without the dress. She is reclining against a pillow, apparently asleep; her head is supported by a raised arm, displaying her long, elegant neck.[53]

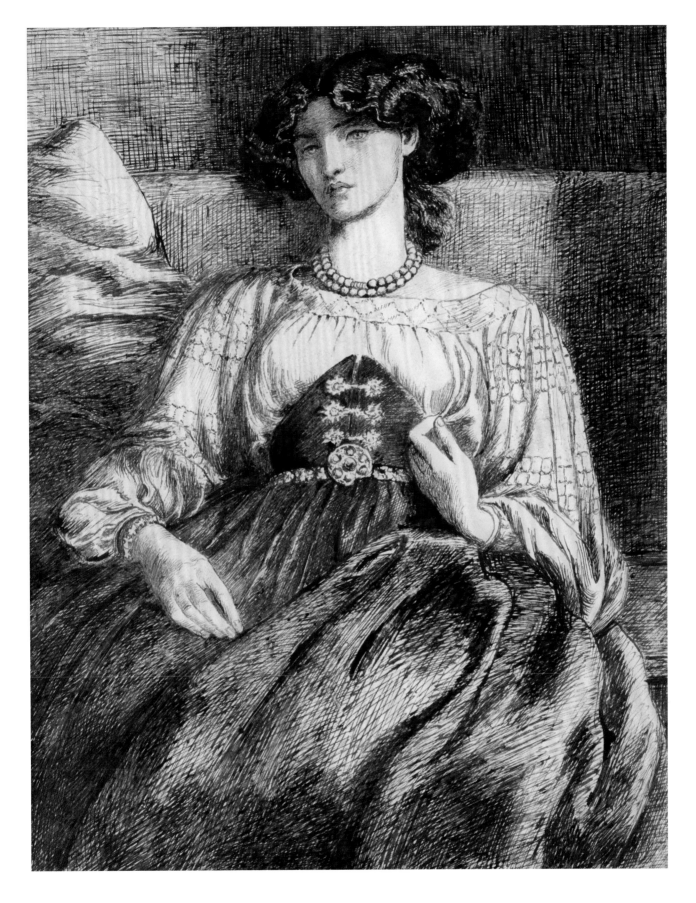

38

DANTE GABRIEL ROSSETTI (1828–1882)

Reverie, 1868

Coloured chalk on tinted paper, 86 × 72 cm
Signed and dated: *I. M. 1868 / D. G. R delt*
Bequeathed by May Morris, 1939; WA1939.3
LITERATURE: Surtees (1971) no.206, R.1

Rossetti used Jane Morris as the model for many large-scale drawings and paintings. He represented her as Proserpine, Queen of the Underworld, and as La Pia de' Tolomei, a character from Dante's *Divine Comedy* who is imprisoned by her husband in a fortress until her death. These paintings and drawings often have a meditative or melancholy tone, and it is difficult to avoid associating this with Jane's marital situation and the complications caused by her relationship with Rossetti. This drawing, which the artist bequeathed to Jane, is a replica of another chalk drawing that belonged to Rossetti's close friend Theodore Watts-Dunton; it was later owned by L. S. Lowry. The pose is loosely based on one of the photographs of Jane taken by John R. Parsons in Rossetti's garden in July 1865.

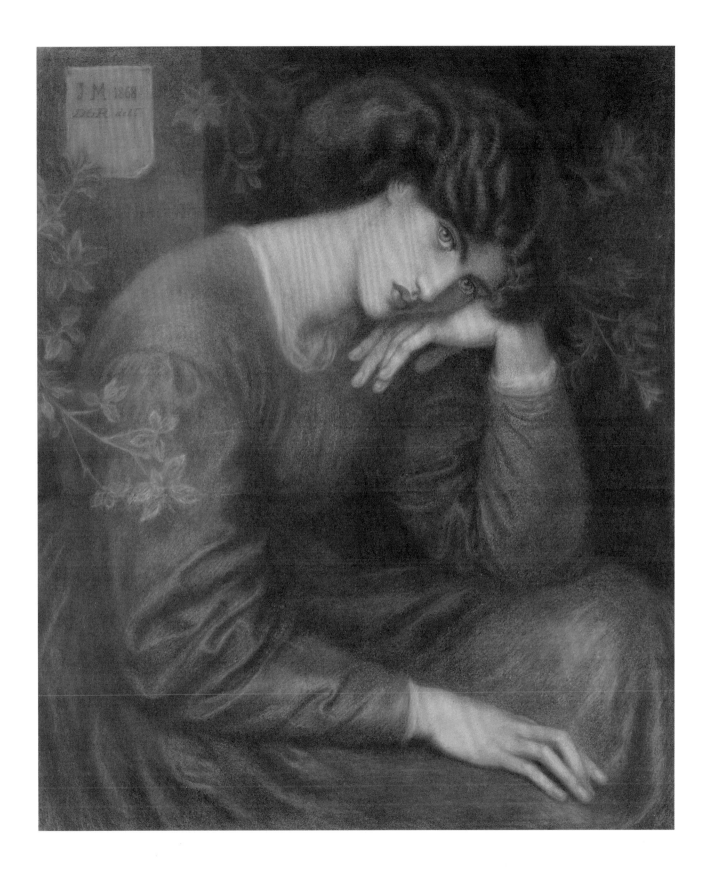

39

DANTE GABRIEL ROSSETTI (1828–1882)

Head of a Woman (attendant for 'Astarte Syriaca'), 1875

Coloured chalks, heightened with white, on pale green paper, 54.4 × 40.4 cm
Signed in monogram and dated 1875
Bequeathed by John Bryson, 1977; WA1977.84
LITERATURE: Surtees (1971) no.249E

This drawing is a study for the left-hand attendant spirit in Rossetti's painting '*Astarte Syriaca*' (fig.2) – a depiction of the Syrian Venus (also known as Ishtar), goddess of fertility, sexuality and war. In the painting the winged attendants serve as a foil to the very sensuous appearance of Astarte herself; it has been suggested that they are derived from the paired angels in William Blake's *Book of Job* series.[54] In this finished drawing, however, the treatment is much more erotic, with its emphasis on the swollen neck, thick lips and luxuriant hair. Rossetti probably hoped that a drawing like this would be attractive to a collector. In the event, however, drawings of both attendants remained on his hands and appeared in the sale of his work after his death.

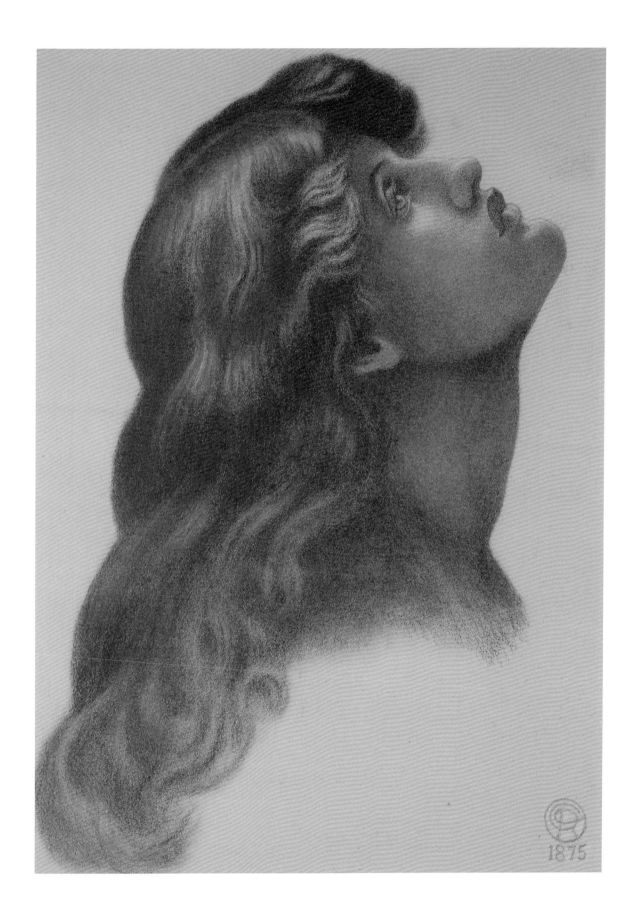

40

DANTE GABRIEL ROSSETTI (1828–1882)
The Day Dream, 1872–8

Pastel and black chalk on tinted paper, 104.8 × 76.8 cm
Bequeathed by May Morris, 1939; WA1939.6
LITERATURE: Surtees (1971) no.259A

In 1879 Constantine Ionides commissioned a painting from Rossetti, to be based on
a drawing he had seen over the chimneypiece in Rossetti's studio. The painting was
The Day Dream (1879–80, fig.29). It turned out to be Rossetti's final finished painting
and this drawing, begun in 1872 or earlier, is the one that inspired it. On 3 March 1879
Rossetti described his encounter with Ionides in a letter to Jane Morris:

> I know you will be pleased to hear that Constantine Ionides looked in with his
> sister Aglaia on Saturday & commissioned me to paint the drawing on the mantle
> piece of you seated in a tree with a book in your lap – the one to which I put the
> hands last year.[55]

It seems, then, that the work began as a black chalk drawing, with pastel added for the
face and hands at a later date.

Rossetti wrote a poem to go with the painting, which describes the day dream
causing the sitter to forget both her book and the flower she holds:

> Lo! tow'rd deep skies, not deeper than her look,
> She dreams; till now on her forgotten book
> Drops the forgotten blossom from her hand.

In the painting, the tree is a sycamore and the flower a honeysuckle. In this drawing,
however, the tree is a willow and the flower a convolvulus or bindweed flower, a symbol
of affection.

Willow trees are common in the watery meadows around Kelmscott, where Rossetti
and Jane Morris went for walks during the summer of 1871, when William Morris had
left them to be alone together. In that year Rossetti painted a portrait of Jane holding
willow branches, entitled *Water Willow*.[56] Willows are traditionally a symbol of sorrow
and longing, and Rossetti's poem 'Willowwood' (1868) describes a place where lovers
pine for those they have lost. In this drawing Jane's sad expression and ghostly figure
reflect the doomed nature of the couple's relationship.

For the painting, having chosen to make the tree a sycamore in spring, Rossetti
worried about having to introduce a different flower. He thought of snowdrops,
but finally settled on honeysuckle. Rossetti wrote several letters to Jane Morris and
to Ionides about the progress of the painting in 1879 and 1880, seeking their advice
and approval of his choice of title, tree and flower. In the drawing, he observed,
'the beautiful play of the convolvulus leaf & stem greatly aids the design of the hand
& flower'.[57]

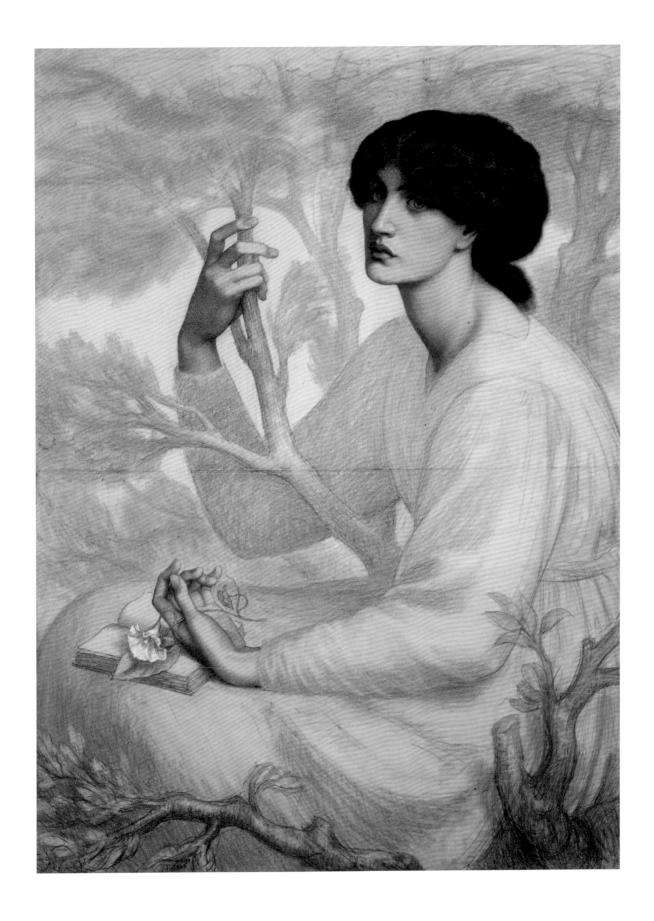

41

JOHN BRETT (1831–1902)
Georgina Hannay ('Repose'), 1859

Pen and black ink on white paper, 23 × 20.6 cm
Signed and dated: *J. B. / Decr. 29. 59*
Purchased, 1964; WA1964.50.1
LITERATURE: Payne and Sumner (2010) no.18

John Brett made many intimate drawings of his family and friends. He employed a variety of media, including red chalk, pencil, and pen and ink. Pen and ink drawings such as this one are comparable in their fine detail to those of Rossetti and Millais. The sitter, Georgina Hannay, was to marry Brett's brother Arthur in 1862, but at the time Brett made this drawing he was clearly smitten by her himself. He described his feelings in his diary, remarking that

> her sweet voice and brilliant wit and lovely temper do a wonderful deal towards keeping away the gloom that would hang over us, and also do a great deal towards making me feel dreary and spooney. When shall I leave off being a fool![58]

Georgina is portrayed as another 'stunner', but in this instance the fussy dress and potted geraniums suggest the stifling constraints of Victorian society – a contrast to the looser, 'aesthetic' dress of Rossetti's models.

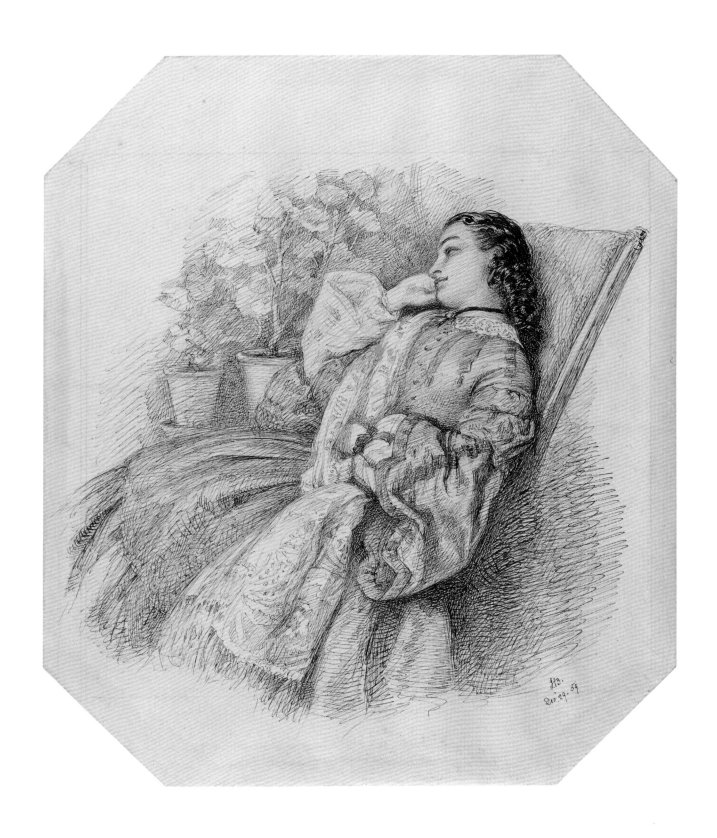

42

SIR EDWARD COLEY BURNE-JONES (1833–1898)

Violet Manners, later Duchess of Rutland, 1883

Graphite on paper, 25.2 × 16.5 cm
Signed and dated: *E B-J / 1883.* Inscribed: *to HMG*
Presented by Mrs Helen Mary Gaskell, 1939; WA1939.15.1

Violet Manners, Duchess of Rutland (1856–1937), was an artist and socialite. Born Violet Lindsay, she married Henry Manners in 1882. He inherited the title of Marquess of Granby in 1888, followed by that of Duke of Rutland in 1906. Violet regularly exhibited her works at the Grosvenor Gallery, opened by her cousin Sir Coutts Lindsay in 1877. From 1881 she also exhibited at the Royal Academy her many pencil portraits of her friends – the group known as the 'Souls', which included the future Prime Minister, A. J. Balfour, and the Viceroy of India, George Curzon. Despite having no formal training, Violet was a prolific artist who made sculptures as well as drawings; she published a selection of her *Portraits of Men and Women* in 1900. In this drawing Burne-Jones, who was a friend of the Manners family, portrays Violet as delicate and otherworldly, in keeping with her role as the hostess of the 'Souls'.

43

FREDERICK SANDYS (1829–1904)
Hero, 1871

Red chalk on tinted paper, 32.5 × 23.5 cm
Signed: *F. Sandys*. Inscribed: *Hero:*
On loan from a private collection
LITERATURE: Elzea (2001) no.3.17

This drawing was the basis for an oil painting of the same title, now in a private
collection. It may represent the priestess of Aphrodite whose lover, Leander, swam the
Hellespont every night to be with her; or she may be the heroine of Christina Rossetti's
fairytale, 'Hero: A Metamorphosis' (1866). This story describes the adventures of a
girl who wanted to be admired. Offered a gift by a fairy, she tried becoming a jewel
or a rare plant, but ended up only too happy to return to her human life in a fishing
village. Nothing in the drawing or the oil painting connects them to either literary
source, although her expression would fit the description of Rossetti's Hero before she
meets the fairy, when she is 'sick alike of herself and others'. The model was Marianne
Shingles, later Mrs George Lewis Warren, who worked as a silk weaver before her
marriage. Sandys's use of red chalk imparts a subtle warmth to the sitter's face.

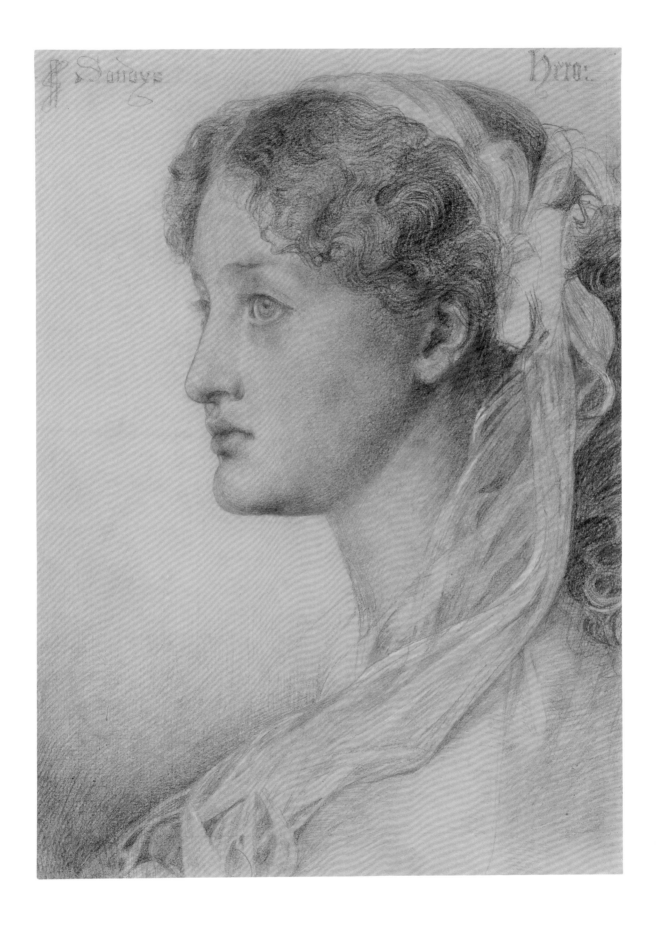

44

FREDERICK SANDYS (1829–1904)

Nepenthe, 1892

Black and white chalks on tinted paper, 32 × 24.5 cm
Signed and dated: *F Sandys 1892*. Inscribed: *Nepenthe* (in Greek characters)
Presented by Sir Karl Parker, 1942; WA1942.81
LITERATURE: Elzea (2001) no.5.5; Harrison (2015) no.79

This drawing was adapted from a full-length drawing, *Lethe* (1870–4)[59] – probably modelled by Sandys's sister, the artist Emma Sandys. It may be based on the scene in Dante's *Divine Comedy* where the poet meets Matilda, singing and gathering flowers on the bank of a brook (see cat.23). She makes Dante drink the waters of Lethe, the river of oblivion in ancient Greek mythology, to erase his memory of past sin and prepare him for Paradise. Nepenthe is in fact a drug to take away grief and care. It is mentioned in Homer's *Odyssey* and in Edgar Allen Poe's poem 'The Raven' (1846), for which Dante Gabriel Rossetti had produced a set of illustrations (1846–8). The poppies in Sandys's drawing suggest what many scholars have thought, that nepenthe is another name for opium. Sandys would have known Rossetti's depictions of Elizabeth Siddal as *Beata Beatrix*[60] and his model wears a similar rapt expression, with closed eyes and slightly open mouth.

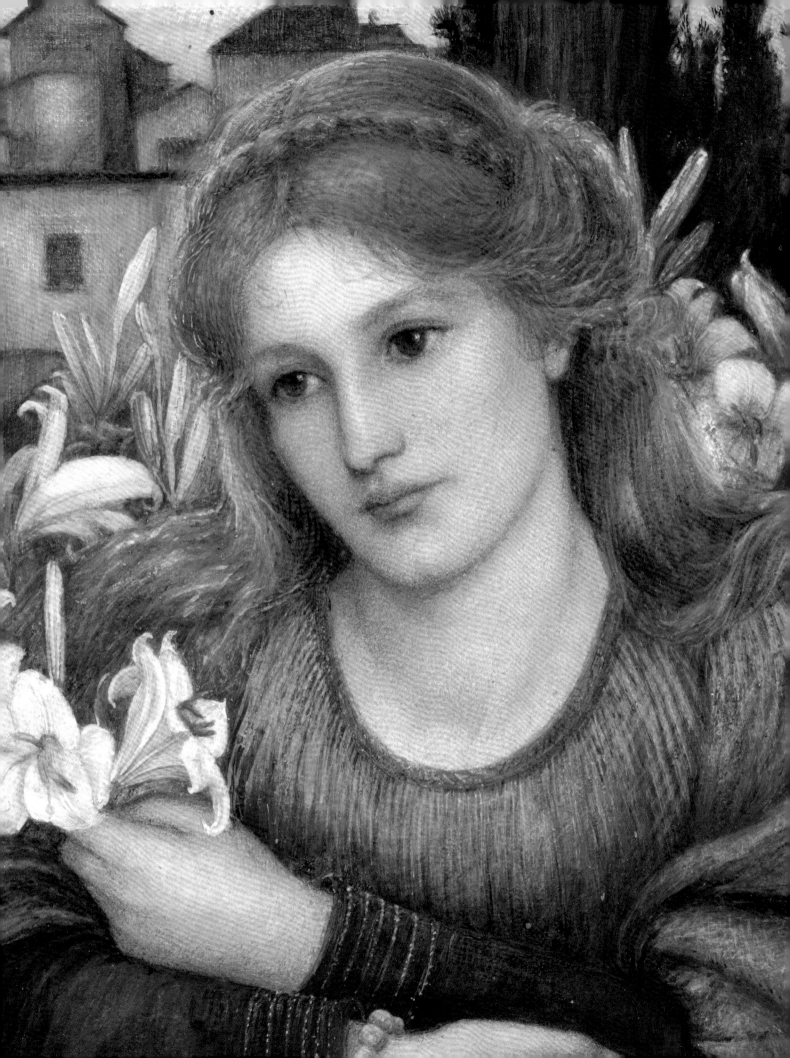

IV

Inspiration from History and Literature

L IKE MANY ARTISTS in the nineteenth century, the Pre-Raphaelites were fascinated by the costumes and artefacts of the past. The romance of medieval Britain is evident in Arthur Hughes's *The Knight of the Sun*, while a different time and place, that of the Italian Renaissance, is evoked in Marie Spartali Stillman's *Cloister Lilies*.

Edward Burne-Jones and William Morris met in 1853 when they arrived at Exeter College in Oxford as undergraduates. Their shared interest in medieval art and literature led them to study manuscripts in the Bodleian Library. Burne-Jones made a 'pilgrimage' to the ruins of Godstow nunnery at Wolvercote; on the way back he experienced a vision of the olden days: banners and knights and ladies, hawking parties and all the pageantry of the golden age. The vision was so intense, he said, that he had to throw stones into the river to break the spell.[61]

One of the young artists' favourite books was Thomas Malory's *Morte d'Arthur*, the fifteenth-century account of King Arthur and his Knights of the Round Table. Their exploits became the subject of an important Pre-Raphaelite commission, the murals in the Debating Chamber (now the Library) of the Oxford Union. The murals unfortunately began to deteriorate soon after they were completed, but surviving drawings by Rossetti and Arthur Hughes give some idea of the original glowing colours.

The Pre-Raphaelites had great admiration for the writers of the past, with members of the PRB placing Chaucer and Shakespeare among their list of 'Immortals'.[62] Chaucer had two stars while Shakespeare had three (the highest rating apart from Jesus Christ, who had four), according to Holman Hunt's recollection of the list. They also admired, and had close links with, the poets of their own times. Millais's exquisite drawings for the Moxon edition of Alfred Tennyson (awarded only one star) formed part of a further shared project, to which several members of the group contributed. Another favourite poet was Robert Browning (two stars); his poem 'Pippa Passes' is illustrated here by Elizabeth Siddal.

Following his early concentration on medieval subjects, Burne-Jones illustrated a great variety of literary sources, including the Greek myths. His pencil drawings of Orpheus and Eurydice and of Cerberus, the dog that guards the entrance to the Underworld, were designs for the decoration of a piano, created for his young friend Frances Graham.

William Morris founded the Kelmscott Press with the aim of reviving the beauty of medieval manuscripts and fifteenth-century hand-printed books. He wanted *The Golden Legend*, a thirteenth-century collection of saints' lives by Jacobus de Voragine, to be its first volume, but the length of the work made this impractical. It was published in 1892 with illustrations by Burne-Jones, whose design for the frontispiece is shown here.

Opposite: detail of cat.53.

45

DANTE GABRIEL ROSSETTI (1828–1882)
Sir Lancelot's Vision of the Sanc Grael :
Study for Painting in the Oxford Union, 1857

Watercolour and bodycolour over black chalk on paper, 71 × 107 cm
Purchased, 1950; WA1950.7
LITERATURE: Surtees (1971), no.93A

In 1857 seven artists – Rossetti, Burne-Jones, Morris, Arthur Hughes, Val Prinsep,
John Hungerford Pollen and John Roddam Spencer Stanhope – joined forces to
decorate the new Debating Chamber of the Oxford Union, recently completed by
Rossetti's friend, the architect Benjamin Woodward (fig.61). The subjects came from
the story of King Arthur and the search for the Holy Grail.

Each design had to accommodate two circular six-foil windows; they also had to
be legible from below, as the spaces for painting are high up on the walls, just below
the ceiling.

Rossetti wrote to Charles Eliot Norton, in July 1858:

> My own subject ... is Sir Launcelot [*sic*] prevented by his sin from entering the
> chapel of the San Grail. He has fallen asleep before the shrine full of angels, and,
> between him and it, rises in his dream the image of Queen Guinevere, the cause
> of all. She stands gazing at him with her arms extended in the branches of an
> apple tree ... The works you know are all very large, – the figures considerably
> above life size, though at their height from the ground they hardly look so ...
> There is no work like this for delightfulness in the doing, and none I believe in
> which one might hope to delight others more according to his powers.[63]

Jane Burden modelled for the figure of Guinevere and Burne-Jones for the figure
of Lancelot.

Fig.61 Dante Gabriel Rossetti (1828–1882),
Sir Lancelot's Vision of the Sanc Grail, 1857.
Distemper on brick. By permission of the
President of the Oxford Union Society.

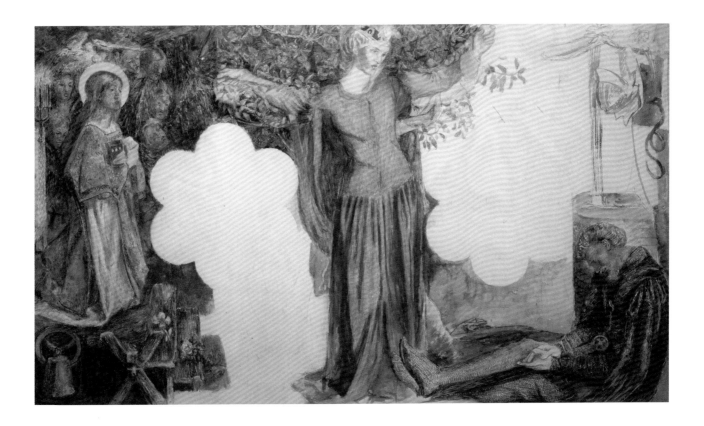

On the left is the Chapel of the Holy Grail. The Angel of the Grail holds the bread and the chalice, the object of the knights' quest. Behind her is an altar with three candles on it and in the background are more angels. Guinevere, Arthur's queen and Lancelot's lover, stands against an apple tree, in a reference to Eve's eating of the apple in the Garden of Eden. The snake on the far right, on the shield above Lancelot's head, is a further reminder of the biblical story of original sin.

Unfortunately none of the artists had any training in mural painting materials or techniques. They painted in distemper, directly onto whitewashed brick. The windows were covered over while the painting was in progress, but as soon as they were uncovered the murals became hardly legible. Soon after completion they began to decay. Although the murals have been restored in recent years, it is only from sketches and studies such as this that we can get an impression of what they would have been like at the end of the Long Vacation of 1857.

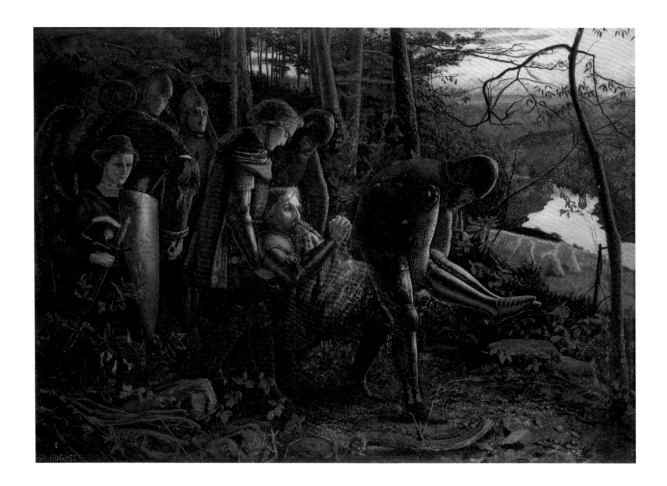

46

ARTHUR HUGHES (1832–1915)
The Knight of the Sun, 1860–1

Watercolour and bodycolour on paper, 22.3 × 31.6 cm
Signed: *A HUGHES*
Presented by Mrs Reginald Cripps, 1949; WA1949.189
LITERATURE: Roberts and Wildman (1997) no.43.8; Harrison (2015) no.72

Arthur Hughes was one of the seven artists who decorated the Oxford Union in 1857,
his own subject being *The Passing of King Arthur*. This watercolour, which dates from a
few years later, gives some idea of the rich colour of the murals that so impressed visitors
when they were first completed. The subject here is not Arthur, however, but an old
knight whose emblem was the sun, being taken out to see his last sunset. The knight had
lived a Christian life; when Hughes exhibited an oil version of the subject at the Royal
Academy in 1860, he showed it with lines from George Macdonald's poem, 'Better
Things': 'Better a death when work is done / Than earth's most favoured birth.'
 The artist described finding his inspiration in the natural world:

 a study of the sky reflecting river seen thro' a wild cherry tree autumn turned ...
 gave me the first idea for the subject.[64]

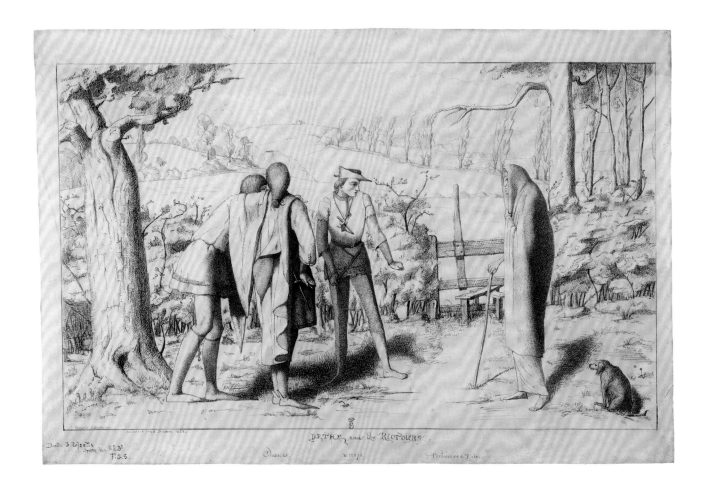

47

FREDERIC GEORGE STEPHENS (1827–1907)

Dethe and the Riotours, from 'The Pardoner's Tale' by Chaucer, 1848–53

Pen and black ink over indications in graphite on off-white paper, 29.5 × 44.6 cm
Inscribed: *DETHE and the RIOTOURS / Chaucer v. 12575, Pardoneres Tale / Composed
1848, Drawn 1852 / Dante G. Rossetti from his P. R. Br. / F. G. S.*
On verso a long extract from the appropriate passage in Chaucer, and the date *July 1st 1853*
Bequeathed by John Bryson, 1977; WA1977.106
LITERATURE: Brown (1978) p. 288

This is the most finished drawing that survives by Frederic George Stephens, one of the
original members of the Pre-Raphaelite Brotherhood. Stephens trained as an artist, but
he made his name as a critic and art historian. This drawing illustrates Chaucer's story of
the three drunken friends who resolve to find Death and kill him. On the road they meet
an old man who has been waiting for Death to take him; he leads them to a tree where, he
explains, he left Death some time ago. Here the friends find eight bushels of gold. They
send the youngest to town and plot to kill him for his share of the gold; he, meanwhile,
brings back poisoned bottles of wine for the rest. As a result all the friends die: they have
indeed found Death under the tree. Chaucer presents the story as a warning against
avarice. Stephens gave the drawing to his friend Dante Gabriel Rossetti.

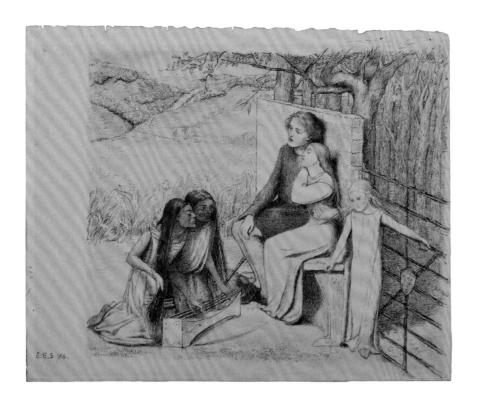

48

ELIZABETH ELEANOR SIDDAL (1829–1862)
Two Lovers Listening to Music, 1854

Pen and brown ink on off-white paper, 23.8 × 29.5 cm
Signed with initials and dated: *E. E. S. 54*
Bequeathed by John Bryson, 1977; WA1977.93
LITERATURE: Marsh (1991), p. 21; Marsh and Nunn (1997) no.21

In 1852 Elizabeth Siddal is first referred to as the pupil of Dante Gabriel Rossetti, who had great admiration for her powers of invention. The subject of this enigmatic drawing has not been positively identified. It was one of the drawings bought from Siddal by John Ruskin in 1855 and was later owned by William Michael Rossetti, who described it in 1903 as 'two lovers listening to the music of two dark, Malay-looking women'.[65] He believed that the man's face was taken from his brother; the woman could be a self-portrait of Siddal. The child standing by the gate is Love, while the closely packed trees confined by a wall suggest some allegorical meaning, perhaps the temptations of sexual passion. The landscape evokes the countryside around Hastings, where Siddal and Rossetti spent a summer holiday in 1854. It was to Hastings, too, that they went to get married in 1860.

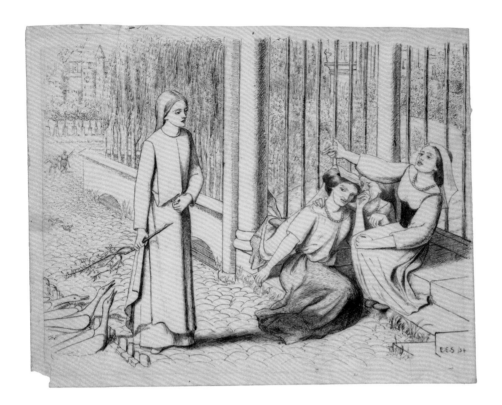

49

ELIZABETH ELEANOR SIDDAL (1829–1862)

Pippa Passes, 1854

Pen and brown ink on off-white paper, 23.3 × 29.6. cm
Signed with initials and dated: *E. E. S. 54*
Bequeathed by John Bryson, 1977; WA1977.94
LITERATURE: Marsh (1991), p. 21: Marsh and Nunn (1997) no.20

The subject of this drawing is taken from a scene in Robert Browning's poem 'Pippa Passes', in which the virtuous heroine, wandering through the city of Asolo, passes a group of women gossiping about their lovers and clients. Rossetti wrote to Browning in October 1855:

> I was, and am, very eager to show you the little design (which is of the scene where Pippa meets the girls) as, in spite of immature execution, I think you would agree that it is full of very high genius.

The following month he told the poet William Allingham that he had shown Browning the drawing 'with which he was delighted beyond measure'.[66] The drawing was shown in the Pre-Raphaelite exhibition at Russell Place in 1857, along with *Clerk Saunders* (fig.13) and a self-portrait. Two other identical versions of *Pippa Passes* were made by the artist.

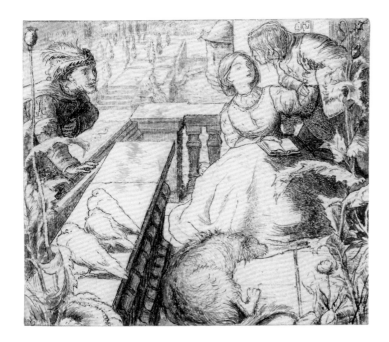 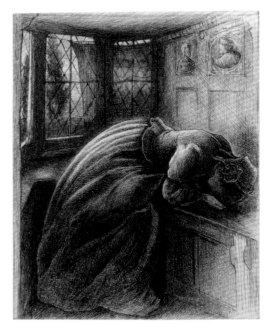

50

SIR JOHN EVERETT MILLAIS (1829–1896)
Five illustrations for 'The Moxon Tennyson', 1855–7

The Sleeping Palace (above left)
Mariana (above right)
The Death of the Old Year (opposite, top left)
The Lord of Burleigh (opposite, top right)
St Agnes Eve (opposite, bottom)
Pen and black ink on paper, 8.3 × 9.6 cm, 9.6 × 7.9 cm, 9.7 × 8.4 cm, 9.7 × 7.2 cm and 8.3 × 9.6 cm
Purchased, 1954 and 1958; WA1954.58 and WA1958.53.1–4
LITERATURE: Rosenfeld and Smith (2007) no.71; Harrison (2015) no.64

In 1849 the publisher Edward Moxon began planning a new edition of Tennyson's
poetry, to be based on the text published in 1842. In addition to the well-established
artists William Mulready and Thomas Creswick, Moxon also approached the Pre-
Raphaelites. He started with Millais, who discussed the project with Tennyson: he
became one of the first visitors to Tennyson's new home, Farringford, on the Isle of
Wight, in November 1854. Millais's son describes how his father made drawings for the
project in the winter of 1855, after his wedding to Effie Gray:

> he worked mainly in the evenings, with the aid of a reflector lamp, commencing
> immediately after dinner and seldom leaving off before midnight.

He was able to carry on a lively conversation with his wife and guests at the same time,
according to the artist Henry Wells, who visited the newly-weds at Annat Lodge,
Perthshire with John Leech.[67]

Eventually Millais provided eighteen designs for the Moxon Tennyson, all of
which were copied onto wood blocks by professional wood engravers. Rossetti and

Holman Hunt also contributed to the volume (cat.51). This set of five highly finished pen and ink drawings may be reproductions of the wood engravings, made subsequently for sale to collectors. Their details are exquisite and they have been recognised as some of his most successful works.

Millais seems to have been generally faithful to the texts, though he added details of his own. In the illustration to 'The Death of the Old Year' he shows the church bell that is tolled 'sad and slow' but adds the owl, a traditional symbol of death not mentioned in the poem. His illustration to 'St Agnes Eve' illustrates the lines:

> Deep on the convent roof the snows
> Are sparkling to the moon:
> My breath to heaven like vapour goes
> May my soul follow soon!

The poem also mentions the 'pale taper' carried by the nun. The idea of the spiral staircase, however, was an invention of Millais's. In 1896 Edward Burne-Jones, who was not generally satisfied with the volume, said of the illustration to 'St Agnes Eve': 'look at her little breath, the snow and everything – that's Millais at his best'.[68]

On its publication in 1857 the Moxon Tennyson was not a great success. The work was expensive and the poet was known to be unhappy with some of the Pre-Raphaelite illustrations, feeling that the artists had taken too many liberties in their interpretation of his texts. However, it had a great impact on subsequent book illustration, which reached a high standard in Britain in the latter part of the nineteenth century. Illustration began to be recognised as an art form in itself, not just as an adjunct to the written word.

51

DANTE GABRIEL ROSSETTI (1828–1882)
St Cecilia, 1856–7

Pen and brown ink on discoloured white paper, 12.6 × 9.9 cm
Purchased, 1938; WA1938.104
LITERATURE: Surtees (1971) no.83A

This is Rossetti's first idea for his illustration in the Moxon Tennyson (see cat.50) to lines from 'The Palace of Art'. Rossetti was rather more inventive than Millais in his approach to the text. The verse simply describes Cicely (St Cecilia) sleeping 'in a clear-wall'd city on the sea, / Near gilded organ-pipes, her hair / with white roses ... / An angel look'd at her'. William Michael Rossetti wrote that his brother

> supposes Cecilia, while kept as a prisoner for her Christian faith, to be taking the air on the ramparts of the fortress; as she plays on her hand-organ an Angel gives her a kiss, which is the kiss of death.

He also says that Siddal had made a design for the subject that preceded Rossetti's, and that the details of the invention, including the saint's death, were also hers.[69]

52

DANTE GABRIEL ROSSETTI (1828–1882)
Hamlet and Ophelia, 1866

Watercolour and gum arabic on paper, 38 × 27.8 cm
Signed in monogram and dated 1866
Accepted by HM Government in lieu of inheritance tax from the estate of
Miss Jean Preston and allocated to the Ashmolean Museum, 2008; WA2008.18
LITERATURE: Surtees (1971) no.189

Like the other Pre-Raphaelites, Rossetti greatly admired Shakespeare and was
particularly interested in the tragedies of *Hamlet* and *Macbeth*. He first made an
elaborate drawing of this subject in 1858 (fig.31): it illustrates the scene in Act III,
Scene I where Ophelia is in her oratory. She tries to return the presents that Hamlet
has given her and he scornfully tells her to enter a nunnery. Writing about the earlier
drawing, Rossetti said that he 'wished to symbolize the character and situation, as well
as to represent the incident'; he acknowledged that 'a simpler treatment might have
been better'.[70] Both drawings have autobiographical overtones, with Ophelia looking
very like Elizabeth Siddal. By 1866 this resemblance had acquired additional resonance,
since there were suspicions that Siddal, like Ophelia, had died by her own hand.

53

MARIE SPARTALI STILLMAN (1844–1927)
Cloister Lilies, 1891

Watercolour and bodycolour on paper, 45 × 36 cm
Signed in monogram and dated: *MS 91*
Purchased, 1965; WA1965.89
LITERATURE: Frederick and Marsh (2015) no.30

Marie Spartali, later Stillman, was the daughter of Michael Spartali, a wealthy merchant who served as Greek consul-general in London from 1866 to 1879. Through her father she met the artist James Abbott McNeill Whistler, who introduced her to Dante Gabriel Rossetti in 1864. She was famous for her statuesque beauty, so at first her role in the Pre-Raphaelite circle was that of a model. She was photographed by Julia Margaret Cameron and painted by Rossetti and Burne-Jones. Spartali Stillman was therefore both a 'stunner' herself and a painter of 'stunners' – many of her paintings feature beautiful young women, often depicted in Renaissance settings and with expressions that suggest thought or reverie.

She was trained as an artist by Ford Madox Brown and exhibited her own work regularly from 1867 onwards. Her paintings are often feminist and enigmatic in theme. In 1871 she married (against her family's wishes) the American artist and journalist William James Stillman. As a result of his job as a foreign correspondent the couple made their home abroad, first in Florence and then in Rome.

Cloister Lilies is set in Florence, where the artist lived from 1878 to 1883. It has been suggested that the building in the background may be the portico of the Chiostrino dei Voti in the Santissima Annunziata, Florence. Lilies are the emblem of the Annunziata – the Virgin Mary at the time of the Annunciation – and 'Voti' means vows, perhaps a reference to the vows that the young woman would have to take if she became a nun. The painting was exhibited at the New Gallery in London in 1892, accompanied by lines from Edward Fitzgerald's translation of the *Rubáiyát of Omar Khayyám*:

> Alas, that Spring should vanish with the Rose!
> That Youth's sweet-scented Manuscript should close!
> The Nightingale that in the Branches sang
> Ah, whence, and whither flown again, who knows!

The young woman, with her lilies, rosary beads and prayer book, is presumably thinking of her youthful life; this will come to an end if she decides to enter a convent, suggested by the building behind her. The subject echoes Charles Allston Collins's *Convent Thoughts* (fig.9), but the implications are completely different. The composition is derived from Renaissance portraiture (for example, Raphael's *Portrait of Maddalena Doni* of 1506),[71] but with an added sensuality comparable to Rossetti's half-length paintings of beautiful women such as *Bocca Baciata* (1859).[72] However, Spartali Stillman's young woman is not simply an object for male admiration: she is thinking hard about her past – and her future.

54

DANTE GABRIEL ROSSETTI (1828–1882)

A Passover in the Households of Joseph and Zacharias, 1849

Graphite and pen and black ink and grey wash on white wove paper, 27 × 24 cm
Inscribed: *A Passover in the Households of Joseph and Zacharias*
Presented by Virginia Surtees, 2014; WA2014.37
LITERATURE: Surtees (1971) no.78B

In 1849 Rossetti was much occupied with plans for pictures illustrating the life of the Virgin
Mary. His first major painting, *The Girlhood of Mary Virgin*,[73] was exhibited in March 1849.
In August he was planning a triptych, the central panel of which was to show

> the eating of the passover by the Holy Family, in which he proposes to make Zachariah
> [*sic*] and Elizabeth joining, as it is said that, if a household were too small for the purpose,
> those of a neighbouring household were to be called in.[74]

He took up the subject again in a watercolour, *The Preparation for the Passover in the Holy
Family* (1854–5).[75] Rossetti stressed that this was not a made-up incident but an important
feast in the Jewish calendar, which must actually have occurred every year in their life.[76] Mary,
Jesus and Joseph are on the left, Zacharias, Elizabeth and St John the Baptist on the right.

55

ELEANOR FORTESCUE-BRICKDALE (1872–1945)
The Childhood of Our Lord, 1906

Watercolour on paper, 24.8 × 18.8 cm
Bequeathed by Francis Fortescue-Brickdale, the artist's nephew, 1988; WA1988.234

Eleanor Fortescue-Brickdale has been called 'the last Pre-Raphaelite'. She had a successful career as a painter in oils and watercolours, and as a book illustrator. This watercolour is a design for an illustration to a book by her contemporary Mabel Dearmer (1872–1915), *A Child's Life of Christ*. It was used on the cover of the English edition and inside in the American edition. Its caption read: 'The Quiet Childhood. "Mary kept all these things and pondered them in her heart".'

Here Fortescue-Brickdale continues the Pre-Raphaelite tradition of rethinking traditional scenes. The appearance of Christ, and the close physical proximity of the two figures, are reminiscent of Millais's *Christ in the House of his Parents* (1849–50)[77] and Holman Hunt's *The Finding of the Saviour in the Temple* (1854–60).[78]

56

SIR EDWARD COLEY BURNE-JONES (1833–1898)
Orpheus playing to Eurydice, 1872–5

Graphite on paper, 23.9 × 24.2 cm
Signed with initials and dated: *EBJ 1875*. Inscribed: *EURYDICE / ORPHEUS*
Bequeathed by Sir Philip Burne-Jones, 1926; WA1926.21

Burne-Jones made a series of drawings, apparently intended to accompany a poem by
William Morris, 'The Story of Orpheus and Eurydice'. In the event, the poem was not
published and Burne-Jones re-used the designs as decorations for a piano, commissioned
by William Graham for his daughter Frances (fig.39). The drawings are conceived as
illustrations to a text, set in roundels with decorative borders. The flowing curves and
soft draperies are perfectly suited to the classical origins of the story. Here Orpheus plays
to Eurydice at the idyllic moment when they are about to be married, before tragedy
strikes. Eurydice is subsequently bitten by a snake and dies; Orpheus pursues her to the
Underworld. He is allowed to take her away with him to the living world on condition that
he does not once look back – but he does so, and she has to return to Hades.

57

SIR EDWARD COLEY BURNE-JONES (1833–1898)
Cerberus, 1872–5

Graphite on paper, 24.3 × 24.4 cm
Signed with initials and dated: *EBJ 1875*. Inscribed: *CERBERUS*
Bequeathed by Sir Philip Burne-Jones, 1926; WA 1926.22

This second drawing from the *Orpheus and Eurydice* cycle depicts Cerberus, the ferocious, three-headed dog who guards the entrance to the Underworld. He is usually portrayed as a horrifying monster, but Burne-Jones manages to make him almost appealing. This is appropriate to the story, as Cerberus is said to have been charmed, like everyone else, by Orpheus's beautiful singing and playing on his lyre. Burne-Jones's interpretation of the story is closer to the classical myths than to Morris's poem, a lengthy meditation on life, death, love and immortality that is connected only loosely to the original narrative. His drawings were also perfectly suited to their eventual destination as decorations for a piano, with their theme of the enduring power of music.

58

DANTE GABRIEL ROSSETTI (1828–1882)
The Death of Lady Macbeth, c.1875–6

Pen and brown ink on paper, 30.7 × 35.8 cm
Bequeathed by Miss Ida Taylor, 1932; WA1932.217
LITERATURE: Surtees (1971) no.242B

Late in his career Rossetti turned again to some of the visual sources he had found inspirational in his youth, such as the work of Henry Fuseli (1741–1825) and Theodore von Holst (1810–1844). He made several drawings of this composition, hoping to use them as the basis for a painting. The subject is from *Macbeth*, Act V, Scene 1: Lady Macbeth, delirious with guilt, is watched by her physician and attendants as she cries:

> Out, damned spot! Out, I say ...
> Here's the smell of the blood still:
> all the perfumes of Arabia will not sweeten this little hand. Oh, oh, oh!

The nightmarish effect is suited to the dark subject. Rossetti's own failing health, and his increasing dependence on the drug chloral, may also have had a part to play.

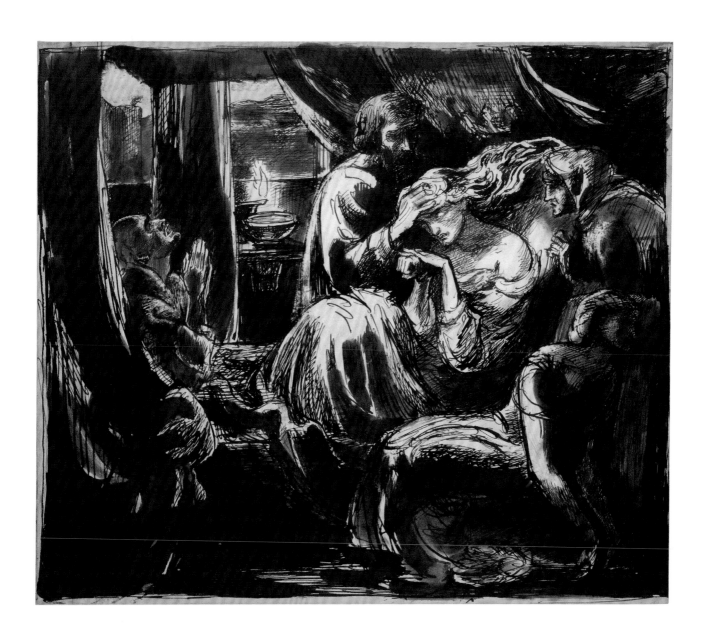

59

SIR EDWARD COLEY BURNE-JONES (1833–1898)

The Golden Legend, from an album of 48 drawings, 1884–8

Pen and ink, watercolour and bodycolour on paper, album bound in
dark brown leather, tooled and gilded, 37.1 × 27.7 × 4.5 cm, open at fol.29
Presented by Mrs Helen Mary Gaskell, 1939; WA 1939.9.29

This is a design for the frontispiece of the Kelmscott Press edition of *The Golden
Legend*, by Jacobus de Voragine – a thirteenth-century collection of saints' lives which
was enormously popular in the Middle Ages and an important source of material
for artists. It was one of the first books printed in English by William Caxton, who
translated the text from Latin. Burne-Jones's frontispiece shows angels receiving souls
into heaven. His use of white bodycolour perhaps indicates that he was planning to
change the lines in the draperies and wings, or that he wished to see how the outlines
worked without the internal modelling. The drawing is in an album given to Burne-
Jones's great friend Helen Mary Gaskell. It contains studies for paintings and stained
glass as well as book illustration.

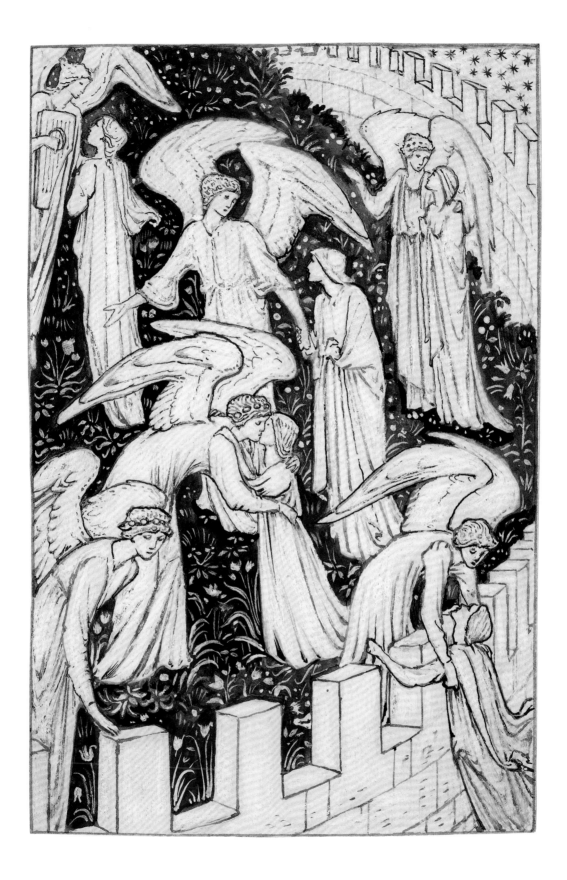

V

Sketches and Studies

MANY OF THE drawings in the exhibition are works of art in their own right. The drawings collected in this section, however, were all part of the preparation for something else: a painting, a piece of furniture, a stained glass window. They range from studies of details to complete compositions. Figure drawings by Burne-Jones display his versatility in the use of different media, while a large drawing of the heads of two young women is a study for John William Waterhouse's famous painting *Hylas and the Nymphs* (1896, fig.17).

Sketches and studies can provide us with important information about how an artist's ideas evolved. The set of drawings for Holman Hunt's painting *The Light of the World* (fig.11) tell us that he first thought of the painting as part of a multi-panel work, like a traditional altarpiece, and that he originally envisaged Christ to be wearing a simple garment, without the priestly cloak and jewelled breastplate of the final version. Hunt's specifications for the lantern, which he had specially made, indicate the importance he attached to the symbolism of the openings in its domed cover.

There are drawings for two well-known paintings in the Ashmolean collection. Charles Allston Collins's drawing for *Convent Thoughts* (fig.9) shows how carefully he worked out the details, including the different varieties of lilies, with each petal and leaf separately outlined. From Arthur Hughes's drawings for *Home from Sea* (fig.62), we can see how his first thoughts were only of the grief-stricken boy returning to find his mother's newly turfed grave. In the painting the grave is much less prominent,

while the painful story is softened by the addition of a sympathetic sister.

Millais's semicircular drawings of *Poetry* and *Music* are among the studies he made for a commission that pre-dates the foundation of the PRB, a set of six lunettes for a house in Leeds. The large drawings of women in classical drapery by Burne-Jones were made for John Ruskin; they are designs for needlework hangings, never completed, illustrating Chaucer's *Legend of Good Women*. The Pre-Raphaelites had a special interest in textiles. Jane Morris was an expert embroiderer and William Morris taught himself tapestry weaving. They dreamed of recreating the colourful tapestries that had once given the inhabitants of draughty castles and mansions some protection from the cold.

In 1861 Morris and his friends founded a company of 'Fine-Art Workmen' to produce a range of goods to bring beauty into people's homes. Ford Madox Brown's drawing of *King René's Honeymoon: Architecture* was for one of the painted door panels of an architect's cabinet. The greater part of the Firm's production, however, was stained glass. Rossetti's watercolour *St George Slaying the Dragon* is a replica of a study for a set of six windows telling the story of the saint, made for a private house. The designs by Burne-Jones, depicting musician angels, were for stained-glass windows in churches. Morris's own designs are represented here by two drawings of women that could be adapted for a variety of purposes, including embroidered hangings as well as stained glass.

Opposite: detail of cat.67.

60

SIR JOHN EVERETT MILLAIS (1829–1896)
Designs for Decorative Lunettes, 1847

Lunette for Poetry (above)
Lunette for Music (below)
Pen and black ink with blue bodycolour on paper, 14.9 × 27.4 cm, 15.4 × 27.2 cm
Bequeathed by Mrs J. G. Links, 1999; WA1999.521–2

These drawings are related to Millais's first major commission – a set of six painted
lunettes (now in Leeds City Art Gallery) for the hall of John Atkinson's house, No.3
Hyde Terrace, Leeds. Millais worked on this project during the summer of 1847 and
possibly 1848, before the founding of the Pre-Raphaelite Brotherhood. In 'Poetry'
the central male figure is flanked by female figures representing comic and tragic
verse; in 'Music' the organ is played by angels. The other four lunettes illustrate
Childhood, Youth, Manhood and Old Age. The Ashmolean also holds preparatory
designs for Childhood and Old Age, and there are further drawings for the scheme
in the collections of the Royal Academy, London and the William Morris Gallery,
Walthamstow. At this stage in his career Millais was a competent practitioner of the
'outline' style of drawing, popularised by John Flaxman (1775–1826) and Moritz
Retzsch (1779–1857).

POETRY

MUSIC

61

CHARLES ALLSTON COLLINS (1828–1873)
Finished Study for 'Convent Thoughts', 1851

Graphite on paper, 41.2 × 26.8 cm
Signed with monogram and dated 1851
Purchased, 1894; WA1894.59

This is a study for Charles Allston Collins's well-known painting *Convent Thoughts* (fig.9). Since the drawing is dated 1851 it may have been made after the painting, or at least its background, was completed. The painting's setting, with its many kinds of lilies, was executed in the summer of 1850, partly in Thomas Combe's garden at the Clarendon Press in Oxford. Collins worked on the figure in January 1851, when he encountered some difficulties with the nun's habit that he had borrowed from Hunt: the sleeves were too long for his model and threatened to obscure the hand holding the book.[79] This book is important to the meaning of the painting as it is open at an illustration of the Crucifixion, also symbolised by the passion flower on which the nun meditates. In the painting another page shows an illustration of the Virgin Mary, whose symbol is the lily.

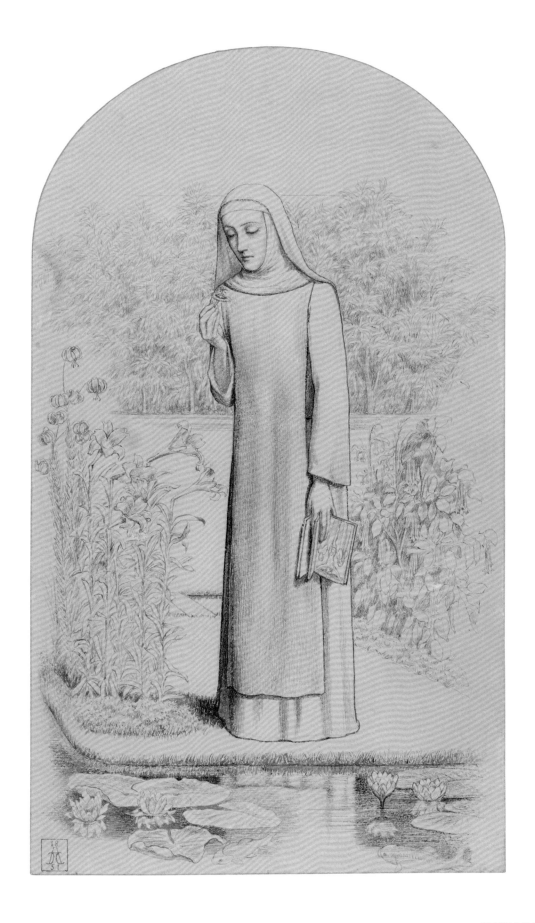

62

WILLIAM HOLMAN HUNT (1827–1910)
Study for 'The Light of the World', 1851

Pen and brown ink on discoloured white paper (an envelope), 12.5 × 7.2 cm
Bequeathed by John Bryson, 1977; WA1977.61
LITERATURE: Bronkhurst (2006) no.D58

This is Holman Hunt's first idea for his famous painting *The Light of the World* (1851–3, fig.11) – a hasty drawing on the back of an envelope. It shows that he first conceived this subject, showing Jesus Christ knocking on the door of the human soul, as part of a diptych or triptych, like a free-standing altarpiece. The triptych was a classic form, often used in the fifteenth century. In 1849 Rossetti had been planning to paint a triptych on the life of the Virgin Mary, for which his design of *The Passover in the House of Joseph and Zacharias* (cat.54) was to have been the central panel.

The initial source for Hunt's figure of Christ seems to have been Collins's *Convent Thoughts* (fig.9): the simple costume, the three-quarter profile and the placing of the right arm are all similar, and Christ holds his lantern just as Collins's nun holds a prayer book. In Hunt's final painting, however, the effect is very different. The lantern casts eerie shadows in the moonlit setting and Christ's face is turned to look directly at the viewer.

The sketch was drawn on the back of an envelope postmarked 'Belfast Se[ptember] 25' and addressed to Holman Hunt at 5, Prospect Place, Cheyne Walk, apparently in Rossetti's hand. It must originally have contained a letter from the Belfast cotton merchant Francis McCracken, a significant early patron of the Pre-Raphaelites. McCracken bought Rossetti's oil painting *Ecce Ancilla Domini (The Annunciation)* (1849)[80] and Hunt's *Valentine Rescuing Sylvia from Proteus* (1850–1).[81]

In his memoirs Hunt says that this drawing dates from mid-October 1851. He notes that he showed it to Millais, who planned to make a companion design of a repentant sinner. Hunt was alarmed by this suggestion and managed to persuade Millais to drop the idea.[82]

The subject is based on a passage from the Bible, in the Book of Revelation:

> Behold, I stand at the door, and knock: if any man hear my voice, and open the door, I will come in to him, and will sup with him, and he with me.

It is not known what subject Hunt envisaged for the accompanying panel or panels, but he declared that his painting *The Awakening Conscience* (1853)[83] represented the 'material interpretation of the idea ... how the still small voice speaks to a human soul in the turmoil of life';[84] it is thus possible that, at this stage, he imagined the two subjects together. In the event the depiction of Christ became a free-standing painting with an arched top, suitable for either a domestic or an ecclesiastical setting.

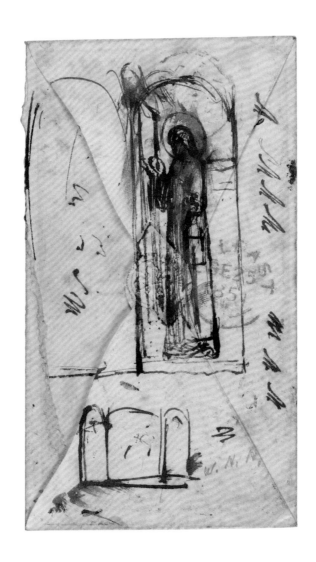

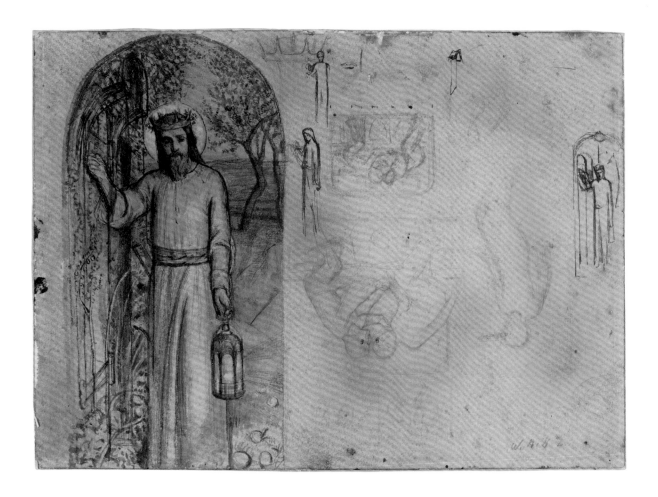

63

WILLIAM HOLMAN HUNT (1827–1910)
Studies for 'The Light of the World', 1851

Graphite with pen and brown ink on off-white paper
On verso, studies for Crusader subject, 25.7 × 35.8 cm
Presented by Mrs Warwick Tompkin, 1970; WA1970.34
LITERATURE: Bronkhurst (2006) no.D59

This sheet contains one fully worked out sketch for *The Light of the World* and three smaller studies for it. Hunt has determined that Christ should have a crown (not present in the first sketch); he later added a priestly cope with jewelled clasps. The lantern is also quite simple at this stage in the design process. It was subsequently to be given openings of richly symbolic significance around its top.

 The pencil drawings (upside down) are studies for another subject Hunt was working on at the same time. This was a theme from the Wars of the Roses, in which a Yorkist soldier attempts to persuade a Lancastrian lady to run away with him.[85] On the other side of the sheet are drawings for a further idea for a painting, from the time of the Crusades.

64

WILLIAM HOLMAN HUNT (1827–1910)

Studies for the Lantern in 'The Light of the World', 1851–2

Pen and brown ink over graphite on discoloured off-white paper, 24.5 × 34.6 cm
Presented by Mrs Warwick Tompkin, 1970; WA1970.35
LITERATURE: Bronkhurst (2006) no.D60

In his preparatory work for *The Light of the World*, Hunt was meticulous in his attention to detail. He had a lantern (now in Manchester Art Gallery) specially made to his design, so that he could study the light cast on the clothing of Christ. As he himself observed

> it would have been quite impossible to represent the shapes of the lights on the dress, and adjacent objects, unless the openings had been quite true.[86]

The varied apertures at the top of the arches were of great iconographic importance. They include the three stars of David (representing Judaism), a flint (representing paganism) and the single star of Bethlehem. In the painting, therefore, they show the progression from paganism to Christianity, implying that the light of God can come to the human soul through different routes.

65

ARTHUR HUGHES (1832–1915)
Studies for 'Home from Sea', c.1857

At the Grave (illustrated opposite, above)
Pen and black ink over graphite on paper, 12.4 × 8.4 cm
Presented by Messrs P. and D. Colnaghi, 1954; WA1954.54

Sketch for 'Home from Sea' (illustrated opposite, below)
Pen and brown ink and graphite on paper, 20.8 × 25.9 cm
Signed on gravestone
Presented by John Arthur Ruskin Munro, 1917; WA 1917.13
LITERATURE: Roberts and Wildman (1997) no.33.2

Arthur Hughes's painting *Home From Sea* (fig.62) was begun in the summer of 1856
and shown at the Pre-Raphaelite exhibition, Russell Place, in 1857 as 'The Mother's
Grave'. It was exhibited, in a revised form, at the Royal Academy in 1863. In its original
state the painting showed only one figure: a boy who had returned from sea to find
that his mother had died and been buried in his absence. Around 1862 Hughes altered
the background and added a crucial figure, the boy's sister, whose presence softens the
sadness of the theme. In a letter in 1901 Hughes described the painting:

> a young sailor lad in his white shore going suit, castdown [*sic*] on his face upon
> the newly turfed grave where his mother had been put in his absence – his sister
> kneeling beside him – his handkerchief bundle beside – Sunshine dappling all with
> leafy shadows – old Church behind with yew tree painted at Old Chingford ...
> Essex.[87]

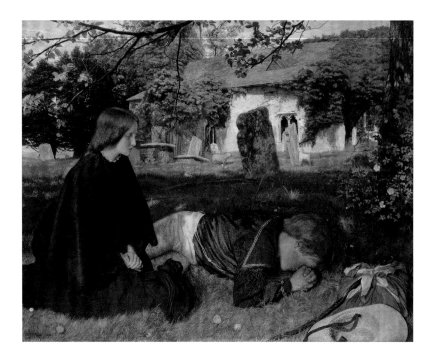

Fig.62 Arthur Hughes (1832–1915), *Home from Sea*, 1862. Oil on panel. Ashmolean Museum. WA1907.3.

The painting was bought from Hughes by John Trist of Brighton. It is not known whether the buyer asked for the sister to be added to the composition. Hughes may have decided himself that it would make the picture more saleable.

These two sketches show how the design evolved. In the smaller sketch the focus is entirely on the raised mound of the grave, with tombs in the background and only a glimpse of countryside; the boy wears a jacket. In the larger sketch, which is closer to the painting, the sheep and lamb, the picturesque old church and the elm branches all put the emphasis on new life rather than death. This sketch differs, too, in the clothes worn by the boy, as these now clearly show that he has been away at sea. In the painting another addition, the rose bush at the base of the elm tree, provides a flash of colour to lighten the shade.

Hughes's first idea for the composition came from one of Holman Hunt's illustrations to Thomas Woolner's poem 'Of My Lady in Death', published in the first number of the Pre-Raphaelite magazine, *The Germ*, in 1850. The figure prostrate on a newly dug grave echoes the Hunt illustration, but other details come straight from Woolner's poem: the 'light globes of seeds' of dandelions (one visible as a circle just below the boy's waist in the larger sketch) and the leaves above the boy's head.

66

SIR JOHN EVERETT MILLAIS (1829–1896)
Study for 'The Black Brunswicker', c.1859–60

Pencil, black ink, black chalk and grey wash on paper,
on verso: further figure studies, 32 × 20 cm
Presented in memory of Margaret Byam Shaw, 1966; WA1966.68

This is a study for Millais's painting *The Black Brunswicker*,[88] with which he hoped to repeat the success of his earlier painting *A Huguenot* (1851–2).[89] The drawing shows a Prussian officer, on the eve of the Battle of Waterloo, taking leave of his English lover. Millais has already established the emotional tension between the figures: the officer tries to open the door while his lover holds the doorknob in her hand, pressing herself against his chest. On the verso of the sheet there are other drawings, of the officer (upside down) and of the group; there is also a drawing of *A Huguenot* which makes the connection between the two compositions very clear. These drawings show that Millais originally intended the officer to be on the right, but ultimately reversed the positions of the two protagonists – probably so that he would not seem to be repeating himself.

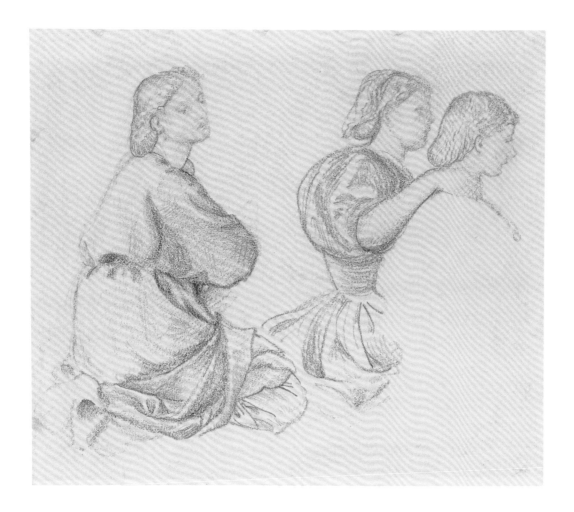

67

SIR EDWARD COLEY BURNE-JONES (1833–1898)
Studies for 'Green Summer', c.1864

Two Women Seated
Studies of Women Seated
Red and black chalks over graphite on off-white paper, 19.4 × 16.7 cm, 21.9 × 25.6 cm
Bequeathed by Dr James Granville Legge through the Art Fund, 1940; WA1940.3.3.1–2

These two drawings are studies for Burne-Jones's watercolour *Green Summer* (fig.16),
exhibited at the Old Watercolour Society in 1865. The two women seated together are
studies for the two figures on the right-hand side in the painting; the other drawing
consists of two ideas for the group on the extreme left. The completeness of the
first drawing suggests that the figure in black in the painting, thought to have been
modelled on Burne-Jones's wife Georgiana, may have been an afterthought.

The studies date from a time in Burne-Jones's life when he was becoming interested
in the sixteenth-century Venetian painters Giorgione and Titian, following a trip to
Venice in 1862. Just as the painting relies on subtly toning, rather than contrasting,
shades of green to produce its effect, the medium of red chalk produces gentle
transitions from light to shade, enhancing the dreamy mood of the subject.

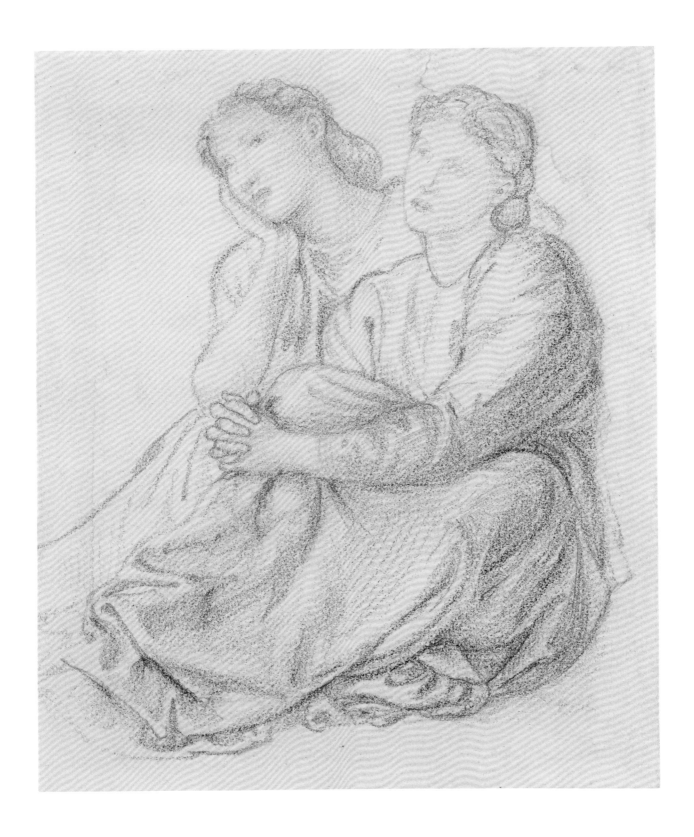

68

SIR EDWARD COLEY BURNE-JONES (1833–1898)
Study for 'Danaë', c.1885

Black and white chalks on brown paper, 34 × 15.4 cm
Presented by Ingram Bywater, 1908; WA1908.5

Burne-Jones was deeply interested in the story of Danaë, the king's daughter who was imprisoned in a tower of brass because her father had been warned by an oracle that a son born to her would be the cause of his own death. But Zeus visited her in a shower of gold, resulting in the birth of Perseus. In the painting *Danaë and the Brazen Tower* (1872)[90] she looks at the tower as it is being constructed; in this drawing she is waiting, lightly robed, for Zeus to visit her. The design was developed into a small gouache, for Sir George Lewis, in which the shower of gold falls upon the virginal Danaë, who is swathed in white.[91] In this drawing Burne-Jones uses brown paper and the lightest of touches of white chalk to define Danaë's form.

69

SIR EDWARD COLEY BURNE-JONES (1833–1898)
Antonia, 1877

Silverpoint, graphite and bodycolour on paper with a grey prepared ground, 32 × 15.2 cm
Signed and dated: *EB-J / 1877*. Inscribed: *ANTONIA / To HMG.*
Presented by Mrs Helen Mary Gaskell, 1939; WA1939.15.2
LITERATURE: Wildman and Christian (1998) no.110; Harrison (2015) no.76

From the mid-1860s Burne-Jones made hundreds of life studies from the nude in preparing his paintings, following the traditional academic practice. He occasionally used silverpoint, a method employed by Italian Renaissance artists, including Verrocchio and Raphael. The technique involves using a metal stylus to make a precise line by drawing over a surface prepared with ground bone ash and bodycolour. Great discipline is needed, as erasure is almost impossible.

This drawing is a study for Burne-Jones's enigmatic painting *The Golden Stairs* (1880).[92] A professional model, Antonia Caiva, posed for all the figures, though their faces were based on studies of young women he admired – in this case Frances Graham. Daughter of the Glasgow MP William Graham, she was the recipient of the piano decorated with scenes from the story of Orpheus and Eurydice (fig.39).

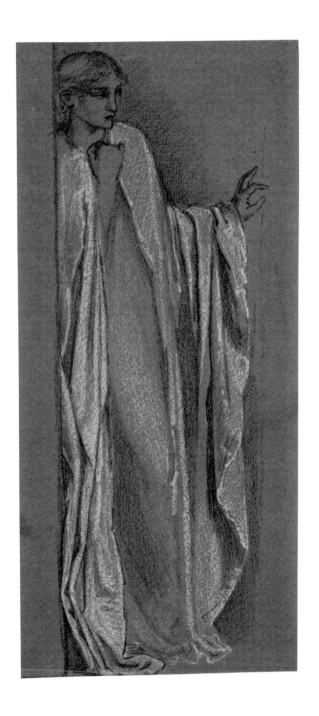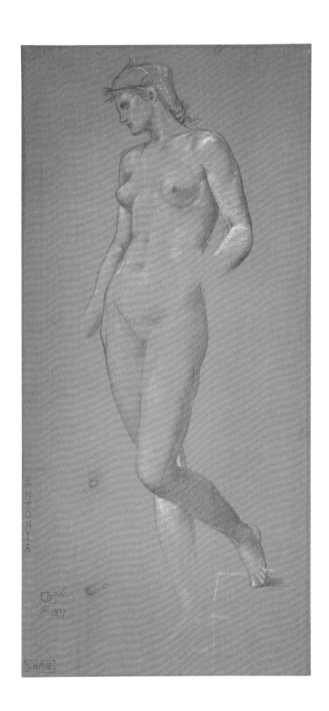

70

SIR EDWARD COLEY BURNE-JONES (1833–1898)
Love bringing Alcestis back from the Grave, c.1864

Watercolour, bodycolour, black and coloured chalks on paper, 134 × 135 cm
Presented by John Ruskin to the Ruskin Drawing School, 1875; WA.RS.WAL.03.
LITERATURE: Hewison (2000) no.124

These two large drawings (cats 70 and 71) were cartoons for embroideries, intended to furnish a room for John Ruskin. In 1863 Ruskin was unhappy and thinking of settling in Switzerland; Edward and Georgiana Burne-Jones hoped to persuade him to buy a house in Herefordshire instead. As an incentive, Burne-Jones designed a series of illustrations to Chaucer's *Legend of Good Women*. The idea was to have a 'tapestry room' at the centre of the house. The design would start with Chaucer himself, on one side of the fireplace, followed by figures encircling the room and ending with King Edward III and Queen Philippa listening to the poem, on the other side of the fireplace. Ruskin welcomed the idea with enthusiasm: he wrote to Burne-Jones, 'I should like that better than any-any-anything ... it will be very wonderful and helpful and holy to me'.[93]

In the Prologue to his poem, Chaucer writes about strolling through meadows full of daisies in the month of May. He sees the God of Love, with angel-like wings, approaching, leading Alcestis, the epitome of the good woman. Alcestis, the subject of a play by the ancient Greek writer Euripides, sacrificed herself to save her husband Admetus and was subsequently rescued from the Underworld.

The embroideries were to be worked by the girls (or 'damozels', as Ruskin and Burne-Jones referred to them in their correspondence) of Winnington School, where Ruskin visited as occasional drawing master, tutor and patron. The designs were to be worked in wool on backgrounds of green cloth or serge.

Burne-Jones promised Ruskin that it would be 'the sweetest and costliest room in the world', with fourteen or fifteen figures accompanied by scrolls, roses, daisies and birds. Love was to be in red and white and Alcestis in green, as she is in the poem. He declared that 'We will fill the room with everything you delight in, and make it a Joyous Gard for you'; Joyous Gard was the home of Sir Lancelot in the Arthurian legend.[94]

In 1867 Ruskin showed this cartoon as an illustration to a lecture at the Royal Institution, entitled 'On the Present State of Modern Art'. In the lecture he described Alcestis as 'the Greek womanly type of faithfulness and eternity of love'. He also made a distinction between 'constant' and 'dramatic' art. Most modern art concentrated too much on dramatic action; Burne-Jones, he argued, was closer to the ancients in his focus upon classical tranquillity and repose, and this would lead to his pre-eminence as a contemporary artist.[95]

The design was adapted for a small stained-glass panel, made by Morris, Marshall, Faulkner and Co. and now in the Victoria and Albert Museum.

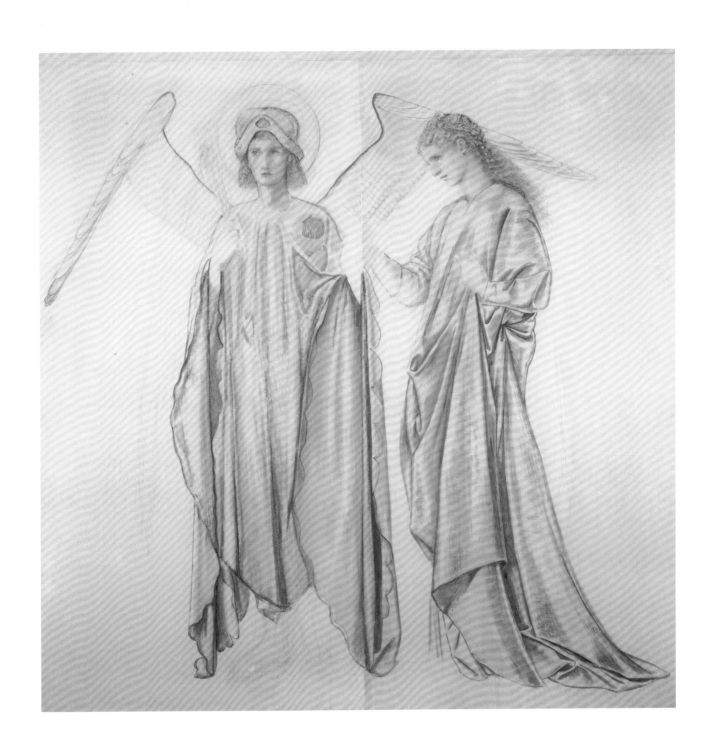

71

SIR EDWARD COLEY BURNE-JONES (1833–1898)
The Two Wives of Jason, c.1864

Watercolour and bodycolour over black chalk on paper, 133 × 133 cm
Inscribed:
Left: *Thou roote of fals loveres duke Jason! / Thou slye devourer, and confusion / Of gentil women, gentil creatures! / For foule delyte, which thou callest love*
Right: *If that I live, thy name shall be shove / in Englyssh, that thy sleighte shal be knowe: / Have at the, Jason! now thyn horn is blowe*
Presented by John Ruskin to the Ruskin Drawing School, 1875; WA.RS.WAL.04

This cartoon for Ruskin's tapestry room (see cat.70) shows Medea and Hypsipyle, whose figures were to have a background of the sea and shells. Hypsipyle, Jason's first wife, was abandoned by her husband. Medea was also abandoned by Jason, but had less of a claim to be a 'good woman' since she murdered several people including her own children, although Chaucer's poem only mentions her wisdom and glosses over the sanguinary details of her story. Indeed Burne-Jones reported that he had to explain the subjects, as the girls at Winnington could not see how either Cleopatra or Medea could be considered good women.[96] The scheme for the tapestry room proved in the end to be too ambitious, and after the death of his father in March 1864 Ruskin abandoned his plan to settle in Herefordshire.

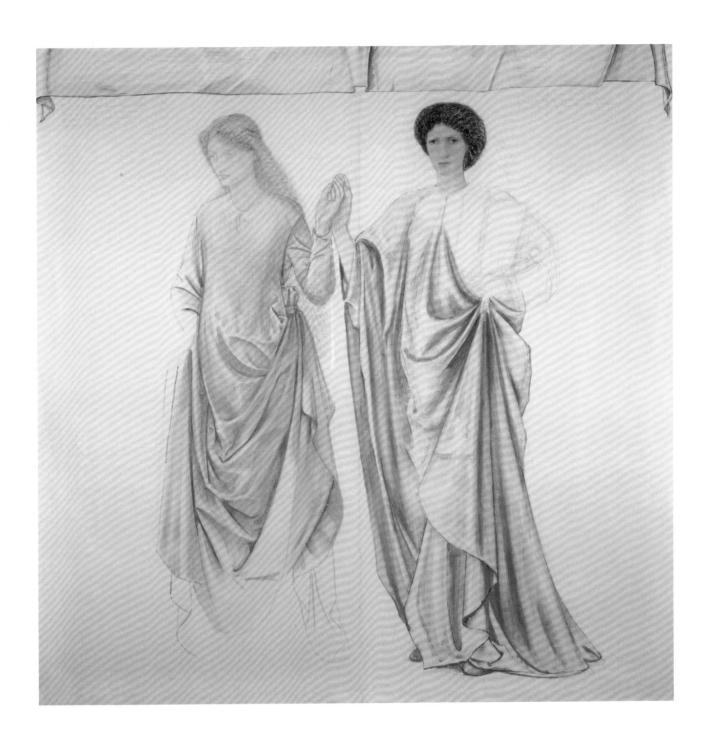

72

FORD MADOX BROWN (1821–1893)

*King René's Honeymoon: Architecture, c.*1861

Brush with black and grey wash on paper, 45.5 × 31 cm
Purchased, 1940; WA1940.40
LITERATURE: Bennett (2010) no.C58.2

The Pre-Raphaelites collaborated in designing painted furniture, as part of their efforts
to recreate the colourful interiors of the Middle Ages and Early Renaissance. This
drawing is a cartoon for one of the door panels of King René's Honeymoon Cabinet
(1861).[97] An architect's desk, it was designed by John Pollard Seddon for his own use
and executed by his family firm of cabinet makers. The Morris firm undertook to
embellish it with panels representing the Fine and Applied Arts. This one shows an
imaginary incident from the life of King René of Anjou (1409–1480), as recounted in
Sir Walter Scott's *Anne von Geierstein, or The Maiden of the Mist* (1829). Other panels
were painted by Rossetti, Burne-Jones and Morris. The cabinet was exhibited in the
International Exhibition, London in 1862.

73

WILLIAM MORRIS (1834–96)
*Minstrel Angel playing Cymbals, c.*1867

Pen with blue and brown ink and watercolour on discoloured pale buff paper,
squared for transfer, 32.6 × 17.4 cm
Bequeathed by John Bryson, 1977; WA1977.70
LITERATURE: Brown (1978), p. 291

William Morris produced several designs of angels playing musical instruments,
intending to use them as the basis for stained-glass windows and other furnishings.
Wings could be added if the commission was for a church and backgrounds could be
varied so that each window was unique. This drawing has been identified as a design in
reverse for the stained-glass window of a minstrel figure, recorded in the possession of
Mr J. A. Ross, Netherton Lodge, Bieldside, Aberdeenshire.[98] Another *Minstrel Angel
with Cymbals* window, in green drapery against a red background, is in the collection
of the William Morris Gallery, Walthamstow. An embroidered version, in the same
collection, in which the angel has very large wings, was made by Morris's sister-in-law
Bessie Burden. An embroidery by May Morris, his daughter, follows the design of this
drawing faithfully, including the background of an orange tree but with the addition
of a tiled floor.[99]

74

WILLIAM MORRIS (1834–1896)
*Minstrel Angel playing a Portative Organ, c.*1867

Pen with blue and brown ink and watercolour on discoloured pale buff paper,
squared for transfer, 32.4 × 16.4 cm
Purchased, 1940; WA1940.61

Both designs, the angel playing cymbals and the angel playing a portative organ (cats 73
and 74), were used for a stained-glass window, dated 1869, in the Church of St Michael,
Tilehurst, Berkshire. Here the figures are accompanied by a third angel playing a lute:
all three have gold drapery and tall red or green wings, set against a blue background.
They also appear in panel paintings, with tiny wings and haloes, and against a gold
background, in the organ screen of Beddington Church, Surrey. Portative organs
were small pipe organs, played while strapped to the performer at a right angle. The
performer manipulates the bellows with one hand and fingers the keys with the other.
Portative organs are often illustrated in illuminated manuscripts. They were popular
from the twelfth to the sixteenth centuries.

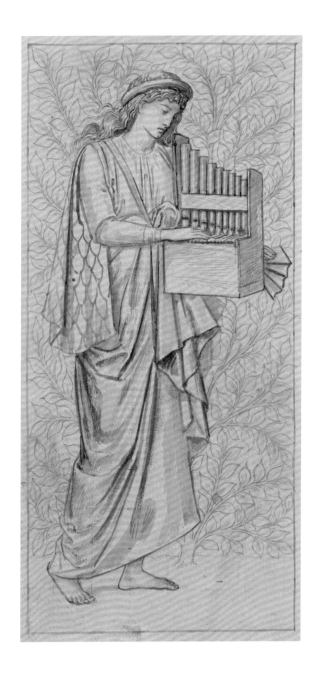

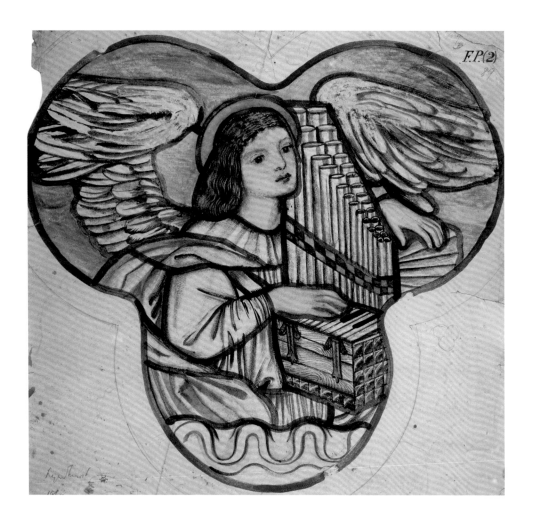

75

SIR EDWARD COLEY BURNE-JONES (1833–1898)
Design for Stained Glass in Lyndhurst Church: An Angel Organist, 1862

Brown and blue washes over graphite on paper, 55 × 58 cm
Bequeathed by Archibald George Blomefield Russell, 1959; WA1978.121

Burne-Jones made hundreds of designs for stained glass, for windows to be
manufactured by the firm of Morris, Marshall, Faulkner and Co. Burne-Jones drew
the figures and William Morris chose the colours, adding decorative backgrounds
as necessary. Burne-Jones used to make his designs in the evenings while his wife
Georgiana read to him. This pair of musician angels was done for the East Window
of the Church of St Michael and All Angels, Lyndhurst, Hampshire. The church is
a neo-gothic one, constructed between 1858 and 1869. The artist Frederic Leighton
painted a fresco entitled *The Wise and Foolish Virgins* for the church and suggested
Morris's newly established firm for the challenging design of the large window above.
The window was to be one of their early triumphs, leading to a steady stream of
further commissions.

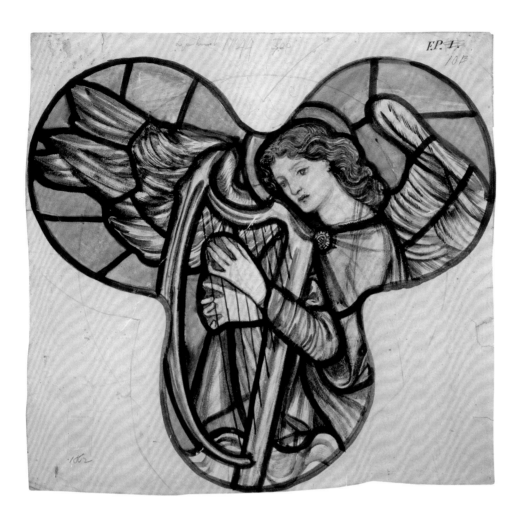

76

SIR EDWARD COLEY BURNE-JONES (1833–1898)

Design for Stained Glass in Lyndhurst Church: An Angel Harpist, 1862

Brown and blue washes over graphite on paper, 54 × 54 cm
Bequeathed by Archibald George Blomefield Russell, 1959; WA1978.120

Burne-Jones was already an experienced designer of stained glass when he made
these drawings: one of his early designs was for the St Frideswide Window (1859) in
the cathedral of Christ Church, Oxford. The subject of the Lyndhurst window was
The New Jerusalem, from the Revelation of St John, with eight musician angels in
trefoils above. The trefoils based on these designs were, therefore, very high up, with
the harpist on the top right and the organist in the centre, just above the main lights.
Conscious that fine details would not be visible from below, Burne-Jones used strong
lines to ensure that the angels' forms, especially their sweet faces, musical instruments
and wings, would be legible from a distance. Morris chose a deep blue for the
backgrounds, so that the angels seem to be floating in the sky.

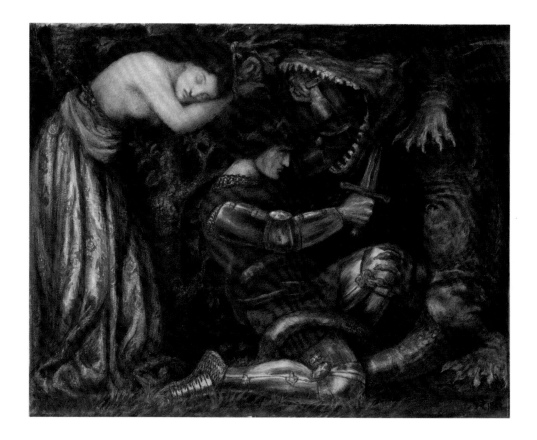

77

DANTE GABRIEL ROSSETTI (1828–1882)
St George slaying the Dragon, 1863

Watercolour and bodycolour on paper, 34.7 × 43.9 cm
Signed with monogram and dated 1863
On verso, bearded male standing figure, gesticulating or holding a book
Presented by Miss H. M. Virtue Tebbs, 1944; WA 1944.27
LITERATURE: Surtees (1971) no.148A R. I

Rossetti designed a series of six windows illustrating the story of St George and the
Dragon (*c*.1862)[100] for the newly founded firm of Morris, Marshall, Faulkner and Co.
They were intended for a private house. This watercolour was developed from one of
the six original designs now in Birmingham Museum and Art Gallery. Charles Augustus
Howell (see cat.15) is said to have modelled for the figure of St George. Rossetti's is an
unusual interpretation of the subject, with the saint's lower arm perilously holding off
the dragon's jaw, within inches of the princess's bound hands, as he stabs him in the
neck. Each window had a text beneath the image; this one read 'How the good Knight
St George of England slew the dragon and set the Princess free'. Rossetti's light-hearted
interpretation of the story ends with a scene in which St George and the Princess enjoy a
wedding breakfast, the centrepiece of which is the dragon's head.

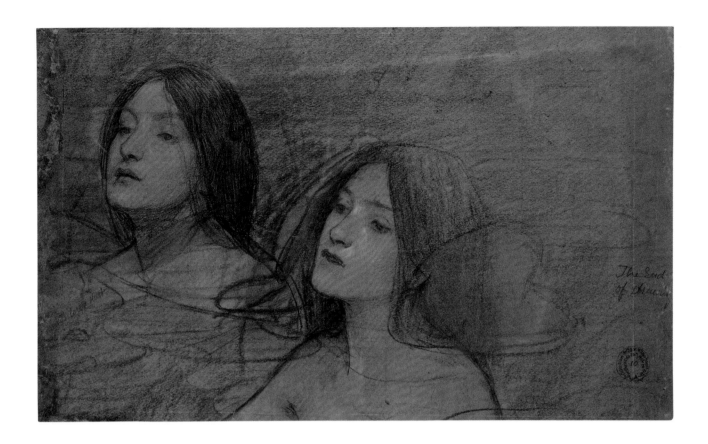

78

JOHN WILLIAM WATERHOUSE (1849–1917)
Study of Two Nymphs for 'Hylas and the Nymphs', 1895–6

Black chalk with some heightening on faded grey paper, 30.7 × 51 cm
Purchased, 1966; WA1966.72.3

John William Waterhouse was born a year after the formation of the Pre-Raphaelite
Brotherhood, yet a recent exhibition of his work was entitled 'The Modern Pre-
Raphaelite' (Royal Academy, 2009). He was deeply influenced by their work,
particularly by that of Burne-Jones. This drawing is a study for his celebrated painting
Hylas and the Nymphs (fig.17), which shows the Argonaut Hylas being enticed into
a pond by innocent-looking water nymphs or naiads; they will then pull him under
the water, from which he will never emerge. The theme has affinities with works by
Burne-Jones, such as *The Depths of the Sea* (1887),[101] in which a mermaid pulls a sailor
down into the water. The drawing does not correspond precisely to the figures in the
painting, so it seems that Waterhouse was using the sheet to try out different poses.

VI

John Ruskin

IN 1843 a book entitled *Modern Painters* caused a sensation. Its author, described only as 'A Graduate of Oxford', was the 24-year-old John Ruskin, who had been an undergraduate at Christ Church, Oxford between 1836 and 1842. The book, which eventually ran to five volumes, was devoted mainly to showing why J. M. W. Turner was superior to any other artist in his depiction of the natural world. In 1851, the year of Turner's death, Ruskin spoke out in favour of the Pre-Raphaelites, defending them against unsympathetic critics, as he had previously done with Turner.

Consequently, from 1851 Ruskin was irrevocably associated with the PRB and their followers. He befriended first Millais and Hunt and then, later on, Rossetti, Siddal and Burne-Jones. He claimed that the PRB had followed the advice he had given to young artists, in *Modern Painters* Volume I, to 'go to nature in all singleness of heart, and walk with her laboriously and trustingly ... rejecting nothing, selecting nothing and scorning nothing.'[102] Ruskin came from a relatively wealthy background and had received the artistic training of a gentleman amateur in drawing and watercolour. He had great natural talent.

Ruskin's landscapes are indebted to Turner, especially in their treatment of perspective and atmospheric effects. However, in his studies of foreground material, and especially of rocks, flowers and leaves, he adopts a style of hyperreal clarity and meticulous detail. This is especially apparent in his virtuoso drawing *Study of Gneiss Rock at Glenfinlas*. The work was executed while Millais was painting his portrait and suggests that he was, to some extent, learning from the younger artist.

Ruskin drew throughout his life, except when he was too ill to do so. He made many delicate studies of natural history specimens, such as the *Velvet Crab* and the *Study of the Plumage of a Partridge*. His defence of Gothic art in his book *The Stones of Venice* (1851–3) was enormously influential. He made many studies of buildings in Florence, Venice and Pisa, drawing attention to idiosyncratic details and to the subtle effects of colour.

Ruskin was passionate about the teaching of drawing. He took classes and encouraged his artist friends to teach drawing classes at the Working Men's College in London; he also published his own manual for amateurs, *The Elements of Drawing* (1857), and donated a collection of drawings to Oxford University for use in training undergraduates and working people. He wanted to promote in any pupil 'a perfectly patient, and ... a delicate method of work, such as may ensure his seeing truly', reflecting his conviction that 'when once we see keenly enough, there is very little difficulty in drawing what we see.'[103]

Opposite: detail of cat.86.

79

JOHN RUSKIN (1819–1900)
Study of Gneiss Rock, Glenfinlas, 1853

Pen, brown ink, ink wash (lampblack), bodycolour and some graphite on wove paper, 47.8 × 32.7 cm
Presented by John Ruskin to the Ruskin Drawing School, 1875; WA.RS.REF.089
LITERATURE: Hewison (2000) no.143

Ruskin made this detailed study of gneiss rock when Millais was painting his portrait
(fig.12) at Glenfinlas, in the Trossachs, in the summer of 1853. Ruskin was already an
accomplished draughtsman, but this drawing marks a new, more finely detailed approach
in his work, in response to Millais's Pre-Raphaelite precision. He probably hoped that it
would help Millais by demonstrating the structure of the rock, doubtless accompanied by
Ruskin's explanations about the processes that had led to its formation.

On 6 September 1853 Ruskin wrote to Lady Trevelyan:

> We all go out to the place where he [Millais] is painting – a beautiful piece of Torrent
> bed overhung by honeysuckle and mountain ash – and he sets to work on one jutting
> piece of rock – and I go on with mine ... on another just above him.[104]

He originally thought this drawing would serve as an illustration to the next volume
of *Modern Painters* – this is presumably the reason why he chose to execute it in
monochrome rather than colour – but he did not in the end use the work for this purpose.

Ruskin had a passionate interest in geology, which had its origins in his family holidays
in the Alps. The fourth volume of *Modern Painters*, published in 1856, was subtitled 'On
Mountain Beauty' and four of its 20 chapters were on 'The Materials of Mountains'. He
also collected specimens: by the time he died he had amassed one of the finest privately
owned collections of minerals in the world.

Gneiss was Ruskin's favourite rock. He loved it because of the way it recorded the
upheavals that had created it:

> as we look further into it, it is all touched and troubled, like waves by a summer
> breeze; rippled far more delicately than seas or lakes are rippled ... this rock trembles
> through its every fibre, like the chords of an Aeolian harp ... The tremor which fades
> from the soft lake and gliding river is sealed to all eternity upon the rock.[105]

Ruskin probably began this drawing in July, the time when Millais started working on the
portrait. He later described it as comprising 'two months' work in what fair weather could
be gleaned out of that time'.[106] However, in his diary, Ruskin recorded that he finished the
drawing on 8 February 1854 – several months after he had left the area. When he exhibited
it at the Fine Art Society in 1878 he wrote that this was a work

> which really had a chance of being finished, but the weather broke; and the stems in
> the upper right-hand corner had to be rudely struck in with body-colour.[107]

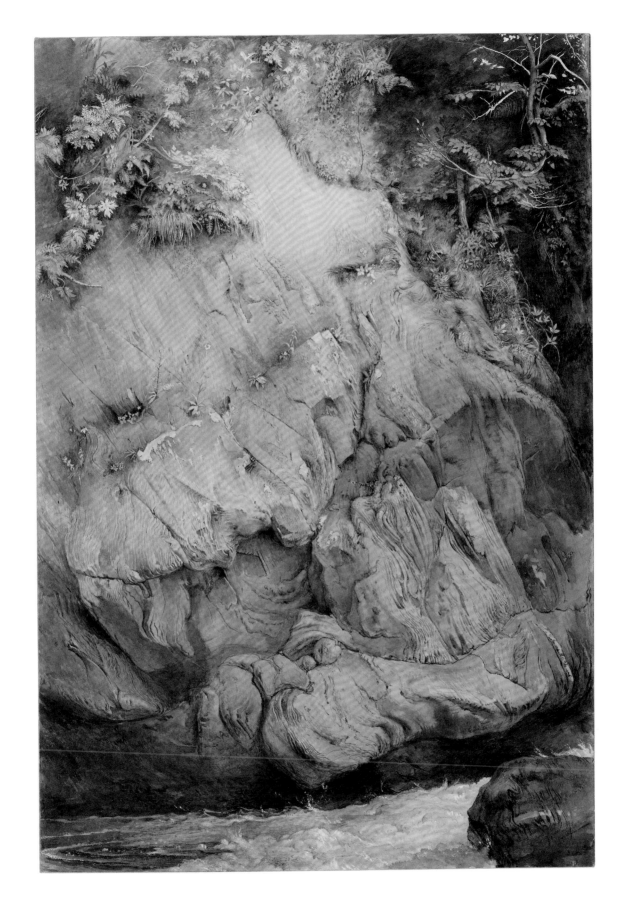

80

JOHN RUSKIN (1819–1900)
*Spray of Olive, c.*1870

Watercolour and bodycolour over graphite on wove paper with a blue wash, 34.7 × 26.4 cm
Presented by John Ruskin to the Ruskin Drawing School, 1875; WA.RS.ED.010
LITERATURE: Elements of Drawing website http://ruskin.ashmolean.org/object/
WA.RS.ED.010

Many of Ruskin's surviving drawings feature leaves and sprays of foliage. One of his
teachers, James Duffield Harding (1798–1863), was the author of important manuals
on tree-drawing; Ruskin himself wrote in his autobiography *Praeterita* of how, in his
youth, he used to draw 'a fresh-gathered outer spray of a tree' every morning for half
an hour after breakfast, while his father read aloud.[108] In donating this drawing to the
Ruskin Drawing School, he apologised for giving so many drawings by himself, but
explained

> I cannot find Studies by any other Draughtsman which unite the absolute fidelity
> to Natural Form, which I require from the Landscape student, with the Florentine
> methods of outline.[109]

He criticised other artists for painting leaves that were all alike. In his drawings each
one is individual in its form, in its angle of growth and in the way it reflects the light.

81

JOHN RUSKIN (1819–1900)
Moss and Wild Strawberry, c.1873

Graphite with heightening in white chalk, on blue-grey paper, 54.1 × 37.6 cm
Presented by John Ruskin to the Ruskin Drawing School, 1875; WA.RS.REF.090
LITERATURE: Hewison (2000) no.156

Like many of Ruskin's drawings, this one leaves large areas of the paper untouched,
so that the viewer has the sense of watching the artist as he works. In 1873 he noted in
his diary that he had been 'two days drawing wild strawberry'.[110] He wrote of another
drawing of wild strawberry: 'I give the strawberry-blossom to Demeter [the goddess
of the harvest] because it is the prettiest type of the uncultured and motherly gifts of
the earth'.[111] Elsewhere he praised the 'utmost exquisiteness in detail' of the strawberry
(see cat.29). The origin of this drawing is unknown; it was included in the drawings
Ruskin presented to his Drawing School, but he never listed it in his own catalogues
of the collection.

82

JOHN RUSKIN (1819–1900)
Study of the Plumage of a Partridge, 1867

Watercolour and bodycolour over graphite on card, 28.2 × 39.9 cm
On verso: Sketch of a landscape with trees
Presented by John Ruskin to the Ruskin Drawing School, 1875; WA.RS.RUD.178
LITERATURE: Hewison (2000) no.167

Ruskin was fascinated by the plumage of birds, with its infinite variety of forms and colours, and the challenges it offered to the artist. He owned watercolours by Turner of a dead pheasant and commissioned a study of a dead chick by William Henry Hunt (now in the Walker Art Gallery, Liverpool). This study of a partridge was completed over two days in January 1867. Ruskin has varied his touch so that the contrasting textures of each part of the bird, from the hardness of the claws to the softness of the feathers on the breast, are convincingly indicated. He had a long-standing interest in birds and in 1873 gave lectures at Oxford on 'English and Greek Birds as the Subjects of Fine Art', which were published in his book *Love's Meinie* (1873–81).

83

JOHN RUSKIN (1819–1900)
Study of a Velvet Crab, c.1870–1

Graphite, watercolour and bodycolour on grey-blue paper, 24.5 × 31.5 cm
Presented by John Ruskin to the Ruskin Drawing School, 1875; WA.RS.ED.199
LITERATURE: Hewison (2000) no.171

This is one of Ruskin's most famous drawings. It was placed in the Educational Series,
of drawings to be used by students at the Ruskin Drawing School, in the section
entitled 'Elementary Zoology'. The velvet crab, *necora puber,* also known as the devil
crab or lady crab, is the largest of the swimming crab family found in British coastal
waters. Its body is coated with short hairs, giving it a velvety texture, and its carapace
is up to 10 cm (3.9 inches) wide. Ruskin's rendition of the crab is very accurate, but he
has also created a very attractive drawing with his use of subtly toning blues and violets,
in the background as well as on the crab itself. The angle from which he has chosen to
represent the crab does not show its red eyes, which give it a devilish appearance. He
has also slightly underplayed the menacing aspect of the claws.

84

JOHN RUSKIN (1819–1900)
Evening in Autumn under the Castle of Habsburg, c.1858

Watercolour and bodycolour over graphite on paper, 21.8 × 29 cm
Presented by John Ruskin to the Ruskin Drawing School, 1875; WA.RS.ED.299
LITERATURE: Elements of Drawing website http://ruskin.ashmolean.org/object/
WA.RS.ED.299

Despite his patronage of the Pre-Raphaelites, Ruskin continued to believe in the
greatness of Turner; his own landscape watercolours were deeply influenced by the
artist. This watercolour was made in 1858 or 1863: when he catalogued it for the Ruskin
Drawing School, Ruskin placed it in Case XII of the Educational Series, which was
devoted to 'Rocks, Water and Clouds'. The unfinished foreground, the sketchily
indicated rows of trees and buildings and, above all, the misty blue mountains in the
distance evoke the series of late Swiss watercolours that Turner made in the 1840s.
Only the green of the meadows introduces a brighter and more Pre-Raphaelite note.
The view is to the south-west, across the Aar valley towards Wildegg. Part of the castle
is shown, but the emphasis is very much on the distance and the atmospheric effects.
Ruskin's title also puts the time of day and the season before the topographical detail.

85

JOHN RUSKIN (1819–1900)
The Kapellbrücke at Lucerne, 1861

Graphite, watercolour and bodycolour on paper, 29.7 × 39.3 cm
Presented by John Ruskin to the Ruskin Drawing School, 1875; WA.RS.ED.116
LITERATURE: Hewison (2000) no.157

The lakeside town of Lucerne in Switzerland was a favourite painting location for
Turner in the 1840s. Ruskin knew and admired his depictions of the town, including
the ancient covered wooden bridge, whose rafters were hung with paintings of
historical scenes. When he stayed there in mid-October 1861, Ruskin records working
on this watercolour until he was 'stopped by cold'.[112] The misty reflections in the water
are like a homage to Turner, but with a Pre-Raphaelite depth of pure colour; the careful
delineation of the wooden panels of the bridge, in their varied hues, is even more
Pre-Raphaelite.

86

JOHN RUSKIN (1819–1900)
Apse of the Duomo, Pisa, 1872

Watercolour and bodycolour over graphite on paper, some lines ruled, 45.8 × 31.7 cm
Presented by John Ruskin to the Ruskin Drawing School, 1875; WA.RS.REF.076
LITERATURE: Elements of Drawing website http://ruskin.ashmolean.org/object/
WA.RS.REF.06

Ruskin had a lifelong interest in architecture. Some of his first articles were published
in *The Architectural Magazine*, 1837–8, and his book *The Stones of Venice* (1851–3) was
arguably his most influential work. It affected ideas about art and society and the
role of the craftsman, as well as offering stylistic precedents for many new buildings
in the second half of the nineteenth century. One of the artists Ruskin most admired
in his earlier years was the topographical artist Samuel Prout (1783–1852), a prolific
painter of street scenes, especially of older, picturesque buildings and ruins. Of the
drawings Ruskin gave to the University of Oxford, 161 are of buildings. Of these 80
are by Ruskin himself and 19 by Samuel Prout. Ruskin admired, and emulated, Prout's
careful drawing of architectural features. Many of his own architectural drawings
are monochrome, as were Prout's, but he also had a lively appreciation of colour in
architecture.

Ruskin was especially fond of polychrome Romanesque architecture. Under the
influence of Pre-Raphaelitism, he employs pure colour to bring out the beauty of the
varied marbles and inlaid decoration under the warm light of the Mediterranean sun.
As with many of Ruskin's drawings, the fragmentary nature of the study enhances its
appeal, making it seem that it has appeared by magic on the white sheet of paper.

This watercolour shows the apse of the Duomo (cathedral) at Pisa, from the south-
east. It is presumably to this study that Ruskin refers in Letter 18 of his *Fors Clavigera*,
dated 29 April 1872, when he notes that he had drawn the east end of the Duomo in
Pisa on the day before.[113]

In 1873 Ruskin said of this building, constructed between 1068 and 1118, that
'no architecture on this grand scale, so delicately skilful in execution, or so daintily
disposed in proportion, exists elsewhere in the world'.[114] When the drawing was
exhibited in 1878, he drew attention to

> the subtlety of the arch curves, intersections of the horizontal curve of the circular
> apse with stilted Saracenic curves [in the middle storey] widening the voussoirs
> [that is, the wedge-shaped stones in the arch] as they spring.[115]

In his view, the irregularity of the building was evidence of the freedom and satisfaction
in their work enjoyed by its builders, before the uniformity of the Renaissance stifled
such creativity. In his own time, Ruskin believed, the substitution of machine-cut stone
for hand carving had degraded architecture still further.

VII

Pre-Raphaelite Landscapes

IN THE EARLY years of the PRB, John Everett Millais and William Holman Hunt painted the landscape backgrounds to their oil paintings out of doors, aiming to capture the effects of sunlight and shadow and to include every detail that they could see. Ruskin encouraged the artists in this, although he ideally wanted them to paint grand mountain scenery rather than the fields and rivers of south-east England. Yet Ruskin himself was entranced by the simplest of natural details. In his manual *The Elements of Drawing* (1857) he told his readers to sketch river banks and clusters of farmhouses. Albert Moore's *Study of an Ash Trunk*, completed in the same year, is an extraordinarily painstaking study of ferns, ivy and mosses growing on and around a tree trunk. It may have been prompted by Ruskin's book.

Those Pre-Raphaelites who specialised in landscape were often torn between, on the one hand, travelling abroad in order to record significant and spectacular scenery and, on the other, simply responding to the beauty to be found nearer home. Thomas Seddon accompanied Holman Hunt to Palestine, where Hunt intended to paint biblical scenes, such as his famous *Scapegoat* (1854–6),[116] in an authentic setting. George Price Boyce also visited the Middle East while John William Inchbold followed Ruskin's advice and went to Switzerland.

Seddon's watercolour *Jerusalem and the Valley of Jehoshaphat* is a smaller version of his oil painting of the same theme – a work on which he spent 120 days, working up to eleven hours a day. He avoided the conventional views of the city, choosing instead to look towards the important Christian sites of the Garden of Gethsemane and the Mount of Olives. In his depiction of the *Hills of Moab and the Valley of Hinnon* Seddon conveys the clear, dry atmosphere and the unusual colour effects of an exotic terrain.

Inchbold's watercolours, by contrast, are of more familiar scenes. His *Wooded Slope* suggests the pleasures of visiting the woods in springtime, when flowers are starting to appear and the warmth of the sun begins to make itself felt. In *A Stream with a Large Standing Stone* the rising sun and the monolith evoke ancient pagan rituals, set off by the mistiness of a winter morning.

Boyce was a close friend of Dante Gabriel Rossetti and wealthy enough to become a collector of his friends' work. While he did travel abroad in search of subjects, much of his work consists of poetic evocations of everyday rural scenery. He had a particular fondness for old cottages and barns.

Alfred William Hunt was, until 1861, an Oxford-based painter – first an undergraduate and then a Fellow of Corpus Christi College. Encouraged by Ruskin, he exhibited watercolours from 1854 and in 1861 gave up his Fellowship to get married. His landscapes, like those of all the artists represented in this section of the exhibition, display a direct engagement with nature and a patient attention to detail.

Opposite: detail of cat.95.

87

WILLIAM HENRY MILLAIS (1828–1899)
*A View in Yorkshire, c.*1850s

Watercolour and bodycolour with some varnish on paper, 30.5 × 46.6 cm
Bequeathed by Mrs Thomas Combe, 1894; WA1894.19

William Henry Millais has been overshadowed by his famous younger brother, John
Everett, but he was a very competent landscape painter. In 1850 he became 'the first
artist who set out to be a Pre-Raphaelite landscape painter', working systematically
out of doors and painting directly from nature.[117] William Millais had one painting
accepted by the Royal Academy in 1852, but in 1853 they rejected an ambitious oil
painting, *Hayes Common*; he subsequently painted mostly in watercolour.[118] This
watercolour belonged to Thomas and Martha Combe, which suggests that it was
executed in the 1850s, when the Combe and Millais families were on close terms.
The location has not been identified.

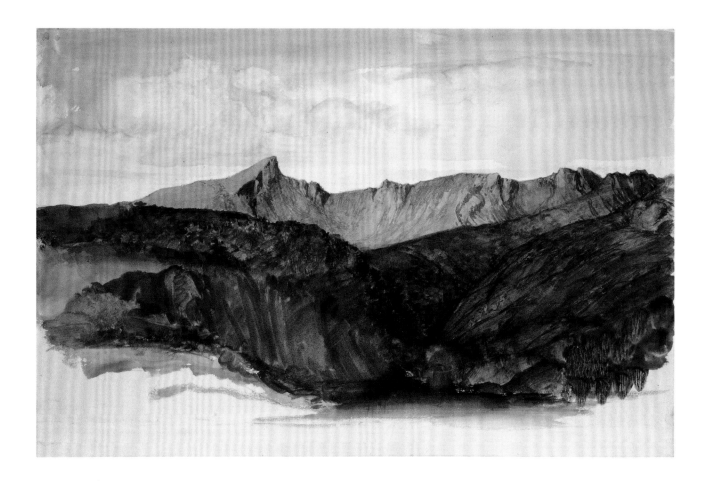

88

WILLIAM DYCE (1806–1864)
Study of a Distant Range of Mountains, 1859

Watercolour and bodycolour on paper, 22.8 × 35.1 cm
Purchased, 1943; WA1943.87

The Scottish painter William Dyce was a generation older than the members of the
Pre-Raphaelite Brotherhood. He appreciated their work from early on, however, and his
landscapes reveal his absorption of their principles. In 1850 Dyce persuaded Ruskin to
look seriously at *Christ in the House of his Parents* (1849–50) by John Everett Millais,[119]
then on show at the Royal Academy exhibition. This watercolour was probably made on
a holiday on the Isle of Arran in 1859. It shows the summit and rocky ridge of Ben Nuis
above the valley of Glen Rosa.

Dyce shared Ruskin's interest in geology, which drew him to the wild landscapes of
Arran and Wales. He commented to a friend that 'the only place I have seen in Scotland
which reminds me of the very wild parts of North Wales is Glen Rosa in Arran'.[120] Glen
Rosa is a site of significant glacial erosion, resulting in spectacular landforms.

89

THOMAS SEDDON (1821–1856)
View of Jerusalem and the Valley of Jehoshaphat, 1854

Watercolour and bodycolour on photograph, salted paper print, 17.9 × 22.1 cm
Presented by Miss H. M. Virtue-Tebbs, 1944; WA1944.29

Thomas Seddon began his career as a designer in the family firm of cabinet makers. He came into the Pre-Raphaelite circle through his friendship with Ford Madox Brown and began exhibiting at the Royal Academy in 1852. In December 1853 he travelled to Egypt, where he was joined in January 1854 by Holman Hunt. Here he painted the Pyramids and the Sphinx (fig.63).

This watercolour is a reduced copy of Seddon's masterpiece, the oil painting of *Jerusalem and the Valley of Jehoshaphat from the Hill of Evil Counsel* (1854–5, fig.8). The work was painted over a photograph of a photograph of the painting, taken before the painting was framed. It resembles the oil painting very closely in every respect.

Before he reached Jerusalem, Seddon was reading John Keble's poem for the Monday before Easter from his book *The Christian Year* (1827). The poem, Seddon wrote, made him want to paint the Garden of Gethsemane by moonlight.[121] Although, as far as we know, he painted no moonlight scenes during his stay, Seddon deliberately chose an unusual viewpoint for his view of Jerusalem. This enabled him to include sites of importance in Christ's life, including both the Mount of Olives and the Garden of Gethsemane. The walls of the city are visible on the extreme left; the dome is that of the Al-Aqsa mosque on the Temple Mount.

Seddon arrived in Jerusalem on 3 June 1854. A week later he wrote to his fiancée that 'the country is exceedingly beautiful, and by no means the barren place I expected'.[122] He noted especially the flowers and fruits of the pomegranate trees in the valley. Seddon felt that the landscape was much more arid than it would have been in Christ's

Fig.63 Thomas Seddon (1821–1856), *The Great Sphinx of the Pyramids of Giza* (1854), watercolour on paper. Ashmolean Museum. WA1944.30.

day, however, partly because of mismanagement. For nearly five months the artist lived on the hillside outside the city, in a tent pitched under an ancient olive tree, accompanied by 'servants and boys' who spoke only Arabic.[123]

Although he painted most of the oil version of *Jerusalem and the Valley of Jehoshaphat* on the spot, it was not quite finished when Seddon left Jerusalem. He completed the work in Brittany, with the help of photographs of the area by James Graham. The painting was photographed before it was framed, probably in Brittany. Seddon then added watercolour to one of the photographic prints, as a way of recalling the scene.

When the oil version was exhibited in London in 1855, it was criticised by some for its lack of atmosphere. However, the work received praised from viewers who knew the terrain for its truthful representation of the dry air and arid landscape. Mr Young, the former English consul at Jerusalem, visited Seddon's studio. Here he admired the 'extreme and extraordinary accuracy' of the painting, including its general effect, 'the distance so unlike the thick atmosphere of England'.[124]

90

THOMAS SEDDON (1821–1856)

The Hills of Moab and the Valley of Hinnom, 1854

Watercolour and bodycolour on paper, 25.2 × 35.2 cm
Deposited by the Trustees of the Tate Gallery, in accordance
with the wishes of Miss E.K. Virtue-Tebbs, 1950; L1214.2
LITERATURE: Staley and Newall (2004) no.62

Seddon described this watercolour in a letter to his fiancée:

> Today I have been going on with a water-colour drawing of the mountains of
> Moab, beyond the Dead Sea, looking down the Valley of Hinnom. I have taken
> them half an hour before sunset, when they are bathed in a mist of rosy light, while
> the valley front is in shadow.

He was ambitious for the work, hoping that it would be 'the best water-colour
landscape that I have done'.[125] In the event it may have been completed by Holman
Hunt, who finished one of Seddon's watercolours for him after he had left Jerusalem.
The mountains of Moab are some 40 to 50 km east of Jerusalem, and the buildings on
the hill to the left are part of the village of Siloam.

91

GEORGE PRICE BOYCE (1826–1897)
The Nile Valley, Mokkatam, and the Citadel of Cairo, from the Neighbourhood of the Pyramids of Gizeh, 1861–2

Watercolour and bodycolour on paper, 6 × 22.4 cm
Presented by Miss H. M. Virtue-Tebbs, 1944; WA1944.33

George Price Boyce travelled to Egypt in October 1861, together with two other artists, Frank Dillon and Egron Lundgren. While there they apparently hired a house in Gizeh, near the Pyramids, and lived 'in Oriental fashion', receiving hospitality from Iscander Bey, son of the late Solomon Pasha.[126] By April 1862 Boyce was back in London, bringing with him 'costumes and curiosities'. This drawing was done in a sketchbook and remained in Boyce's possession. Its panoramic format enables Boyce to give an impression of a vast space on a small sheet of paper, the forms softened by the rich colours of the evening light. The Mokkatam are a range of hills to the south-east of Cairo.

92

GEORGE PRICE BOYCE (1826–1897)
Old Barn at Whitchurch, 1863

Watercolour, bodycolour, pen and ink on paper, 20.4 × 28.7 cm
Signed and dated: *G. P. Boyce – Aug.63*
Presented by Miss H. M. Virtue Tebbs, 1944; WA1944.32
LITERATURE: Newall and Egerton (1987) no.38; Payne (1993) no.75

Boyce loved painting ancient agricultural buildings, particularly barns and mills. Traditional barns, with tall doors large enough to take loaded waggons, were becoming obsolete in the latter half of the nineteenth century, as machines were then able to thresh much of the grain crop directly after harvesting. Boyce exhibited this watercolour at the Old Water Colour Society in 1864, where it was described as a 'Sketch for a larger drawing'. The work was favourably reviewed by Frederic George Stephens in the *Athenaeum*, who wrote:

> No commonplace painter could have invested the barn and farmyard ... with so much of the dignity of a magnificent building, nor could such a one have given to stable-litter and pigs the charm of admirable colour.[127]

Whitchurch-on-Thames is a village to the north-west of Reading. Sadly the fine barn is no longer there, but its site is marked by Old Barn Cottages.

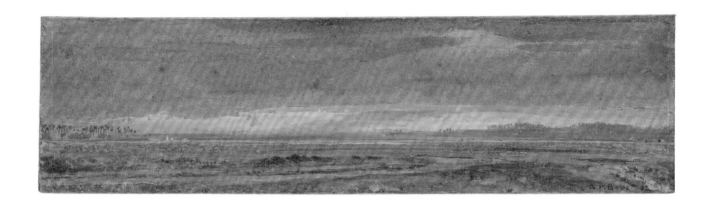

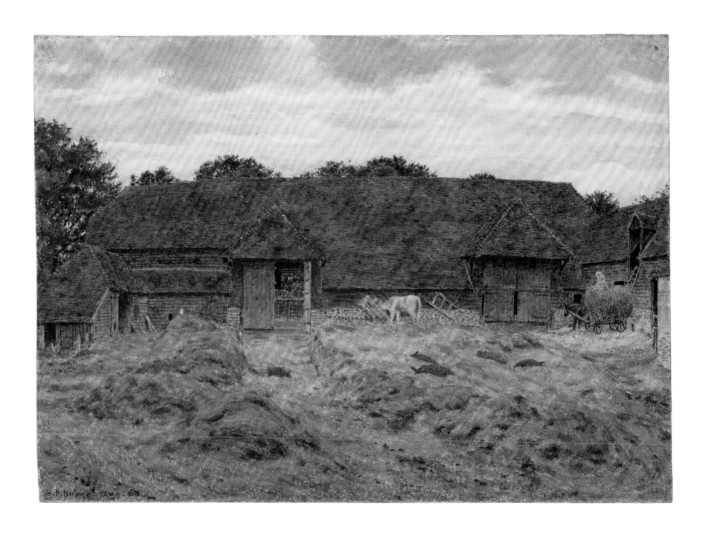

93

GEORGE PRICE BOYCE (1826–1897)
Pangbourne, Berks, After Sunset, 1865

Watercolour and bodycolour on paper, 12.6 × 28.4 cm
Signed and dated: *G. P. Boyce Aug. 1865*
Bequeathed by Ingram Bywater, 1915; WA1915.18

Boyce loved the River Thames and the Thames valley. Each summer from 1859 and through most of the 1860s he explored the river on foot and by rowing boat, painting in the villages of Streatley, Pangbourne and Mapledurham as well as Whitchurch.[128] In 1854 Boyce had met Ruskin, who gave him some advice:

> On my expressing my liking for after sunset and twilight effects, he said I must not be led away by them, as on account of the little light requisite for them, they were easier of realisation than sunlight effects.[129]

Happily, Boyce continued to produce his poetic evocations of evening light. After taking rooms in Blackfriars in 1862 he made studies of moonlight on the River Thames, anticipating his friend Whistler's nocturnes of the early 1870s.[130]

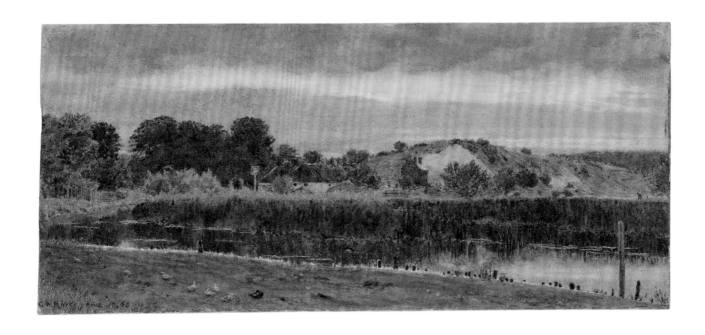

94

ALBERT MOORE (1841–1893)
Study of an Ash Trunk, 1857

Watercolour and bodycolour on paper, 30.3 × 22.9 cm
Signed in monogram and dated: *AM 1857*
Purchased, 1959; WA1959.59
LITERATURE: Staley and Newall (2004) no.14; Harrison (2015) no.59

Albert Moore was the youngest son in a family of artists based in York. He followed his older brother Henry (who became a very successful sea painter) to London in 1855 and entered the Royal Academy Schools in 1858. In this extraordinary study Moore examines a tree trunk and its accompanying foliage in great detail. The work is a remarkable achievement for an artist aged only 16.

It has often been pointed out that Moore probably knew Ruskin's manual, *The Elements of Drawing* (1857), which encouraged artists to draw ivy around the base of a tree as an exercise in painting from nature. In the *Elements* Ruskin recommended the subject highly:

> In woods, one or two trunks, with the flowery ground below, are at once the richest and easiest kind of study: a not very thick trunk, say nine inches or a foot in diameter, with ivy running up it sparingly, is an easy and always a rewarding subject.[131]

It should be noted, however, that this passage mentions flowers, which Moore does not include in his watercolour, and makes no mention of ferns, which feature strongly in the work. Ferns were very popular in the 1850s: Charles Kingsley coined the term 'pteridomania' to describe the passion for collecting and classifying ferns that began in the 1840s. Amateur naturalists collected dried ferns for their albums, displayed them in Wardian cases in the home and established whole gardens of them – called ferneries – outside.

There were a number of visual sources which may have had as much impact on Moore as Ruskin's words. At exhibitions Moore would have seen works by Pre-Raphaelite painters such as John William Inchbold which featured detailed treatments of tree trunks and foreground foliage (fig.64). He would also have been aware of the work of contemporary photographers who enjoyed taking close-up images of ferns and ivy, such as Henry White's photograph *Ferns and Brambles* (1856).[132] Given the technical limitations of early photography, such subjects were easier to photograph than more distant landscape views. However, photographs of this period could not rival the subtle variations of colour that painting could achieve, and often gave a false impression even of the degrees of light and shade.

Moore's first exhibits at the Royal Academy, in 1857, were two studies of dead birds, followed by this watercolour in 1858. In the 1860s he worked as a decorative artist, designing tiles, wallpaper and stained glass for Morris, Marshall, Faulkner and Co. He became famous as a painter, not of landscape, but of classically draped female figures. This watercolour already shows a feeling for the patterns and harmonies created by carefully selected colours, which laid the basis for his mature work.

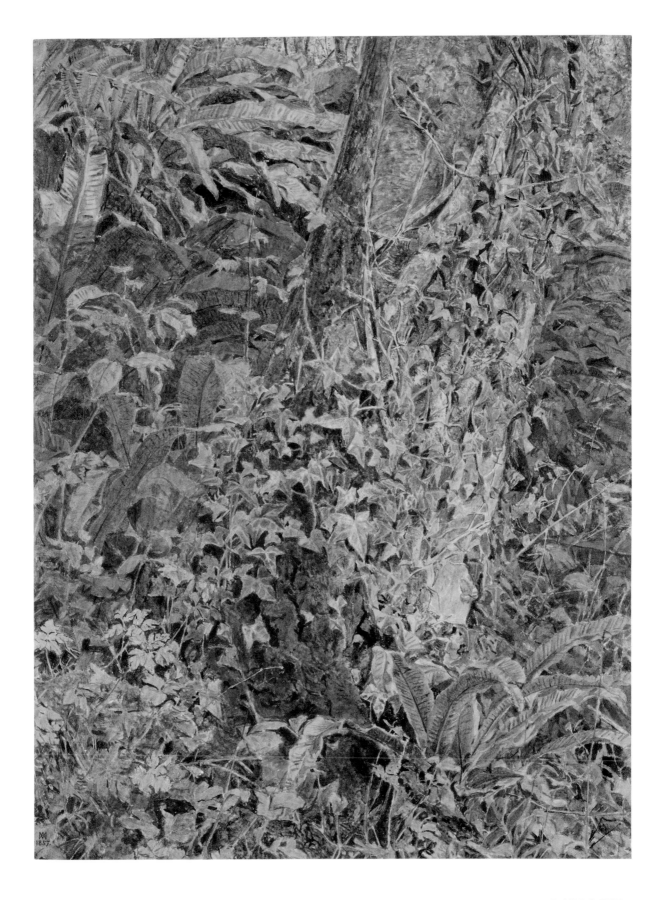

95

JOHN WILLIAM INCHBOLD (1830–1888)
Wooded Slope with Four Figures, c.1881

Watercolour and bodycolour on paper, 35.5 × 25.1 cm
Signed and dated: *I. W. INCHBOLD / VEVEY / 8.4.188-[?]*
Presented by Miss Mary Tyrwhitt, 1945; WA1945.96
LITERATURE: Newall (1993) no.49

John William Inchbold was born in Leeds. He moved to London in the late 1840s
and began exhibiting landscape paintings in 1849. In 1852 he exhibited a painting
of a leaf-strewn foreground at the Royal Academy, entitled simply *A Study*. The
work was noted by William Michael Rossetti in his review of the exhibition as
evidence that 'in landscape art ... Pre-Raphaelitism is visibly making its way'.[133]
By 1854 Inchbold was on friendly terms with Brown, Hunt and Rossetti, while
Millais admired his painting *Anstey's Cove*,[134] which he had submitted to the Royal
Academy exhibition. Millais was shocked when *Anstey's Cove* was rejected and he
exhibited it in his own studio, where it was seen by George Price Boyce.[135]

In 1855, in the first of his exhibition reviews, *Academy Notes*, Ruskin described a
small painting by Inchbold, *A Study in March*, as 'exceedingly beautiful'.[136] This has
been identified with the painting in the Ashmolean now known as *In Early Spring*
(fig.64). It was exhibited with lines from the poet William Wordsworth, drawing
the viewer's attention to the flowers in the foreground: 'When the primrose
flower peeped forth to give an earnest of the spring'. The hillside and leafless trees
are painted with extraordinary precision, the strong sunshine and the sheep and
lambs evoking one of those warm days that mark the end of winter and the joyous
birth of a new season.

Ruskin and Inchbold spent time together in the Alps in 1856 and 1858. Ruskin
was dissatisfied with Inchbold's painting, however, which may have led to a
loss of self-confidence on the artist's part.[137] For the rest of his career Inchbold
travelled widely, finding subjects for his art in Devon, the Isle of Wight, his
native Yorkshire, Venice, Spain and north Africa. From 1879 he spent much of his
time in Switzerland, on the shores of Lake Geneva. He remained in touch with
members of the Pre-Raphaelite circle, who continued to express their admiration
for his work, but his paintings were repeatedly rejected by the Royal Academy and
he was often hard up.

Much of Inchbold's later work is poetic in approach, aiming at atmosphere
rather than fine detail. However in this watercolour, which shows a wooded
hillside at Vevey, on the north shore of Lake Geneva, the artist returns to the
meticulous study of nature evident in his earlier work. The effect shown is very
similar to *In Early Spring*: the leafless trees cast long shadows across the hillside,
but the sun has enough warmth to encourage the girls to sit on the grass and enjoy
the prospect of the coming spring.

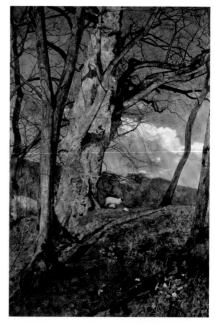

Fig.64 John William Inchbold (1830–1888),
In Early Spring, or *A Study, in March*,
1855. Oil on canvas. Ashmolean Museum.
WA1962.4.2.

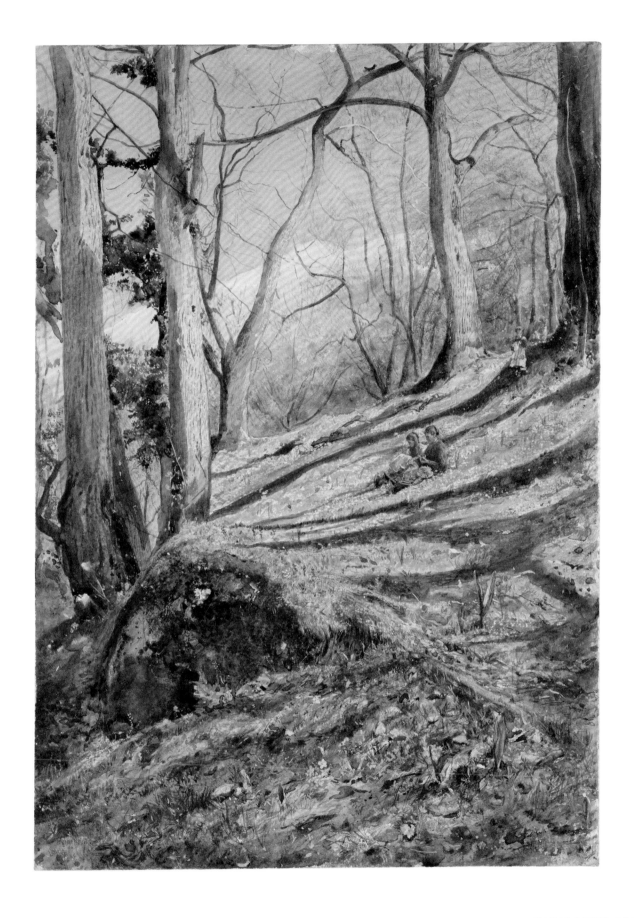

96

JOHN WILLIAM INCHBOLD (1830–1888)
View of a Lake with Trees, 1857

Watercolour and bodycolour on paper, 25.2 × 35.4 cm
Signed and dated: *20 July /57 / J. W. Inchbold*
Presented by Lady Mary Murray, 1942; WA1942.79

Inchbold deploys a range of different techniques in this charming study of a simple corner of nature. He has used transparent watercolour for the sky and the blue hills in the distance, complemented by more opaque bodycolour for the highlights on the trees and ripples on the lake. He has also varied his brushstrokes, using broad cursive strokes in the trees and thin straight lines for the reeds at the water's edge. Dragged washes in the foreground create the effect of sparkling light. The watercolour was made in the summer of 1857, the year in which William Michael Rossetti described Inchbold as 'perhaps highest of the strictly Pre-Raphaelite landscape painters'.[138]

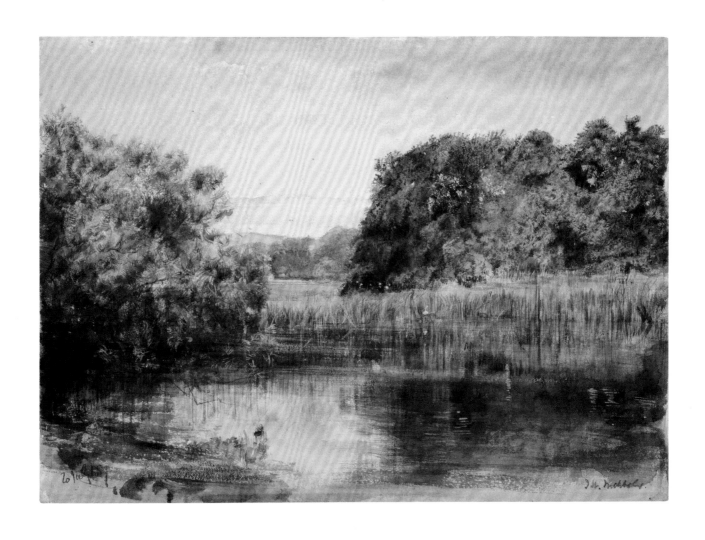

97

JOHN WILLIAM INCHBOLD (1830–1888)
A Stream with a Large Standing Stone, c.1870

Watercolour and bodycolour on paper, 36.5 × 26.4 cm
Presented by Mrs Ursula Tyrwhitt, 1964; WA1964.84.11

Little is known about this watercolour, which is undated. It is similar in composition to a watercolour by Inchbold of Malham Cove, Yorkshire, dated 1876,[139] which also shows a stream bordered by trees, with a figure glimpsed on the edge of the view.

The large stone in the foreground is suggestive of a pagan monument. The rising sun just breaking over the hillside evokes the role of the Heel Stone at Stonehenge in marking the place where the summer solstice sunrise appears. In this case the stone perhaps marks the winter solstice. Inchbold was interested in prehistoric remains: he painted a large oil of Stonehenge, but suffered further disappointment when it was rejected by the Royal Academy in 1869.[140]

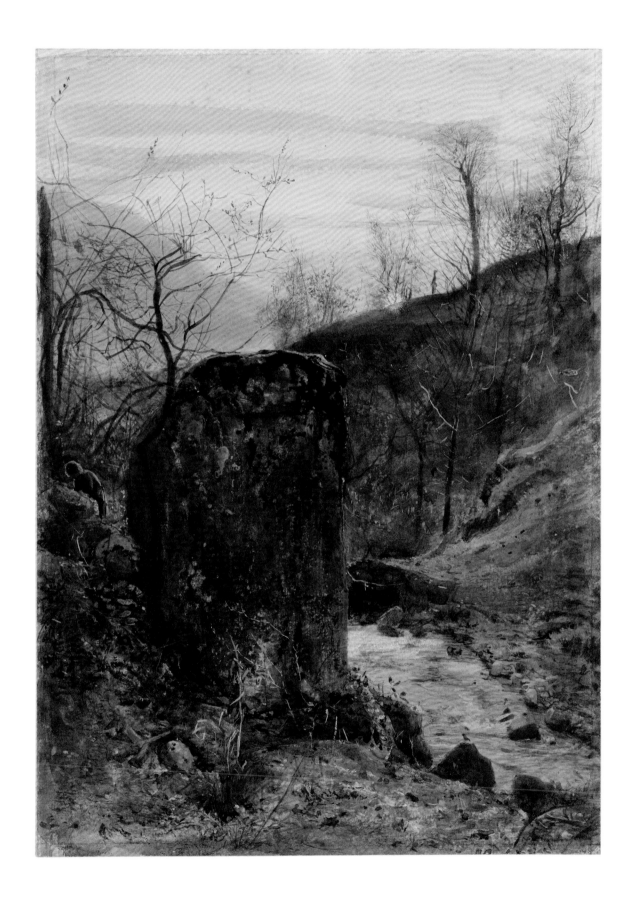

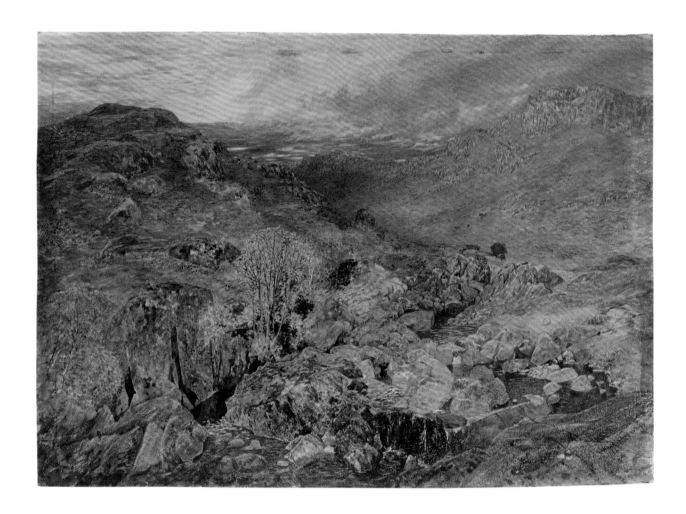

98

ALFRED WILLIAM HUNT (1830–1896)
Easedale, near Grasmere, 1853

Watercolour on paper, 27.5 × 38.5 cm
Bequeathed by R. S. Newall, F. S. A., 1978; WA1978.15

Alfred William Hunt, the son of a landscape painter, was born and educated in
Liverpool before going to Oxford to read Classics in 1848. He began his artistic career
working in the sketchy style of David Cox (1783–1859), a friend of his father, but in
the mid-1850s he underwent a conversion to Pre-Raphaelitism and began to paint in
a tighter, more finished manner. He also met Ruskin, who gave him encouragement
tempered by criticism; Hunt's interest in geological features of the landscape was an
obvious point of affinity between the two men. Easedale is a well-known beauty spot in
the Lake District, close to the cottage where the poet William Wordsworth lived from
1799 to 1808.

99

ALFRED WILLIAM HUNT (1830–1896)
Welsh Landscape, 1858

Watercolour on paper, 25 × 36.2 cm
Presented by Miss Mary Tyrwhitt, 1945; WA 1945.91

Hunt's interest in geology also comes to the fore in this watercolour of a (so far unidentified)
Welsh mountain hillside. By this date he would have read Ruskin's fourth volume of *Modern
Painters* (1856), which was on mountain beauty, and encouraged several artists to make detailed
studies of rocky features. Here conventional ideas of composition have been abandoned in
favour of a direct view that implies careful study in the open air.

 Hunt was offered a fellowship at Oxford. He vacillated between an academic and an artistic
career, finally deciding on the latter in 1857. In 1858, however, his submissions to the Royal
Academy were rejected. Ruskin warned him against badly chosen subjects, the use of tiny
stippled strokes and insufficient differentiation between areas of light and shadow. He also
advised Hunt to paint small, easily saleable pictures.[141]

Bibliography

Unpublished sources

BURNE-JONES: Edward Burne-Jones, Autograph Work Record ('A List of my Designs, Drawings and Pictures, from 1856 when I began to draw'), *Edward Burne-Jones Papers*, Fitzwilliam Museum Archives, Cambridge. GBR/0280/BURNE-JONES.

ROBERSON archive ledgers for Dante Gabriel Rossetti and Edward Burne-Jones, Hamilton Kerr Institute, Fitzwilliam Museum, University of Cambridge: HKI MS 245-1993, p. 63; HKI MS 103-1993, p. 338; HKI MSHKI MS 104-1993, pp. 33 and 317; HKI MS 105-1993, p. 52; HKI MS 106-1993, p. 119a: HKI MA 247-1993, p. 96; HKI MS 313-1993, pp. 258 and 259.

WILKES 2019: Robert Wilkes, 'The Hidden Pre-Raphaelite: The Art and Writings of Frederic George Stephens from 1848–70', PhD thesis, 2 vols., Oxford Brookes University 2019.

Published sources

BARRINGER 2012: Tim Barringer, Jason Rosenfeld and Alison Smith, *Pre-Raphaelites: Victorian Avant-Garde*, exh. cat., Tate Britain, London 2012.

BENNETT 2010: Mary Bennett, *Ford Madox Brown: A Catalogue Raisonné*, 2 vols., New Haven and London 2010.

BRADBURY 2019: Sue Bradbury (ed.), *The Boyce Papers: The Letters and Diaries of Joanna Boyce, Henry Wells and George P. Boyce*, 2 vols., Woodbridge 2019.

BRADLEY 1860: J. W. Bradley, *A Manual of Illumination on Paper and Vellum*, London 1860.

BRONKHURST 2006: Judith Bronkhurst, *William Holman Hunt: A Catalogue Raisonné*, 2 vols., New Haven and London 2006.

BROWN 1978: David Brown, 'Pre-Raphaelite Drawings in the Bryson Bequest to the Ashmolean Museum', *Master Drawings*, 16:3 (Autumn 1978), pp. 287–358.

BURNE-JONES 1904: G. B.-J. [Georgiana Burne-Jones], *Memorials of Edward Burne-Jones*, 2 vols., London 1904.

CENNINI 1954: Cennino Cennini, *The Craftsman's Handbook 'Il Libro dell'Arte'*, translated by Daniel V. Thompson, Jr, Dover Publications, New York 1954.

CHRISTIAN 2007: John Christian, Elisa Korb and Tessa Sidey, *Hidden Burne-Jones: Works on Paper by Edward Burne-Jones*, exh. cat., Birmingham Museums and Art Gallery, London 2007.

COHN 1977: Marjorie B. Cohn, *Wash and Gouache: A Study of the Development of the Materials of Watercolor*, exh. cat., Fogg Art Museum, Cambridge, Mass. 1977.

CROOK 1981: J. Mordaunt Crook, *William Burges and the High Victorian Dream*, London 1981.

CRUISE 2005: Colin Cruise et al., *Love Revealed: Simeon Solomon and the Pre-Raphaelites*, London and New York 2005.

CRUISE 2011: Colin Cruise, *Pre-Raphaelite Drawing*, exh. cat., Birmingham Museums and Art Gallery 2011.

DIMBLEBY 2005: Josceline Dimbleby, *A Profound Secret*, London 2005.

DOUGHTY AND WAHL 1965–7: Oswald Doughty and J. R. Wahl, *The Letters of Dante Gabriel Rossetti*, 4 vols., Oxford 1965–7.

ELEMENTS: Elements of Drawing website, http://ruskin.ashmolean.org.

ELZEA 2001: Betty Elzea, *Frederick Sandys 1829–1904: A Catalogue Raisonné*, Woodbridge 2001.

EVANS AND WHITEHOUSE 1958: Joan Evans and John Howard Whitehouse (eds.), *The Diaries of John Ruskin*, Vol. II 1848–1873, Oxford 1958.

FREDEMAN 1975: William E. Fredeman (ed.), *The P. R. B. Journal: William Michael Rossetti's Dairy of the Pre-Raphaelite Brotherhood 1849–53*, Oxford 1975.

FREDEMAN 1989: William E. Fredeman, 'A Rossetti Cabinet', *Journal of Pre-Raphaelite and Aesthetic Studies* 2 (1989).

FREDEMAN 1991: William E. Fredeman, 'A Rossetti Cabinet: A Portfolio of Drawings by Dante Gabriel Rossetti', *Journal of Pre-Raphaelite and Aesthetic Studies Special Issue*, II: 2 (1991).

FREDEMAN 2002: William E. Fredeman (ed.), *The Correspondence of Dante Gabriel Rossetti*, 10 vols., Cambridge 2002–10.

FREDERICK AND MARSH 2015: Margaretta Frederick and Jan Marsh, *Poetry in Beauty: The Pre-Raphaelite Art of Marie Spartali Stillman*, exh. cat., Delaware Art Museum, Wilmington, Delaware 2015.

FUNNELL 1999: Peter Funnell et al., *Millais: Portraits*, exh. cat., National Portrait Gallery, London 1999.

GILCHRIST 1973: Alexander Gilchrist, *Life of William Blake*, 2 vols. (reprint of 1880 edition), Wakefield, Yorkshire 1973.

GOLDMAN 1996: Paul Goldman, *Victorian Illustration: The Pre-Raphaelites, the Idyllic School and the High Victorians*, Aldershot 1996.

GRIEVE 1973: Alastair Grieve, 'The Applied Art of D. G. Rossetti—1. His Picture Frames', *The Burlington Magazine*, 115:838 (January 1973), pp. 16–24.

HAMILTON 1882: Walter Hamilton, *The Aesthetic Movement in England*, London 1882.

HARRISON 2010: Colin Harrison and Christopher Newall, *The Pre-Raphaelites and Italy*, exh. cat., Ashmolean Museum, Oxford 2010.

HARRISON 2015: Colin Harrison, Caroline Palmer, Katherine Wodehouse et al., *Great British Drawings*, exh. cat., Ashmolean Museum, Oxford 2015.

HAUPTMAN 2007: Jodie Hauptman, *Georges Seurat: the Drawings*, New York 2007.

HEWISON 2000: Robert Hewison, Ian Warrell and Stephen Wildman, *Ruskin, Turner and the Pre-Raphaelites*, exh. cat., Tate Britain, London 2000.

HILL 1897: George Birkbeck Hill (ed.), *Letters of Dante Gabriel Rossetti to William Allingham 1854–1870*, London 1897.

HUNT 1905: William Holman Hunt, *Pre-Raphaelitism and the Pre-Raphaelite Brotherhood*, 2 vols., London and New York 1905.

JEFFREY 1984: Rebecca A. Jeffrey, 'A Rediscovered Study for Walter H. Deverell's Lost Painting, "The Banishment of Hamlet"', *The Burlington Magazine*, 126:974 (May 1984), pp. 282–4.

KOOISTRA 1999: Lorraine Janzen Kooistra, 'The Dialogue of Image and Text in Christina Rossetti's "Sing-Song"', *Victorian Poetry*, 37:4 (Winter 1999), pp. 465–92.

LAGO 1982: Mary Lago (ed.), *Burne-Jones Talking: His Conversations 1895–1898 Preserved by his Studio Assistant Thomas Rooke,* London 1982.

LESLIE 1888: G. D. Leslie, *Our River: Personal Reminiscences Or An Artist's Life on the River Thames* (2nd edition), Bradbury 1888.

LOVETT 2017: Patricia Lovett, *The Art and History of Calligraphy,* London 2017.

LUTYENS 1984: Mary Lutyens, 'Walter Howell Deverell (1827–1854)', in Leslie Parris (ed.), *Pre-Raphaelite Papers*, London 1984, pp. 79–96.

MACCARTHY 2010: Fiona MacCarthy, *William Morris: A Life for Our Time,* London 2010.

MACCARTHY 2011: Fiona MacCarthy, *The Last Pre-Raphaelite: Edward Burne-Jones and the Victorian Imagination*, London 2011.

MANN 2005: Fiona Mann, 'Rossetti's Watercolours: Materials and Techniques', *Review of the Pre-Raphaelite Society*, 13:3 (Autumn 2005), pp. 19–29.

MANN 2014: Fiona Mann, 'A "Born Rebel": Edward Burne-Jones and Watercolour Painting 1857-80', *Burlington Magazine*, 156:1339 (October 2014), pp. 657–64.

MANN 2019: Fiona Mann, '"Opaque with a Vengeance": Burne-Jones's Later Watercolours 1880–98', *Burlington Magazine*, 161:1391 (February 2019), pp. 128–39.

MARILLIER, 1904: H. C. Marillier, *Dante Gabriel Rossetti* (3rd edition), London 1904.

MARSH 1991: Jan Marsh, *Elizabeth Siddal 1829–1862, Pre-Raphaelite Artist*, exh. cat., Ruskin Gallery, Sheffield 1991.

MARSH 2019: Jan Marsh et al., *Pre-Raphaelite Sisters*, exh. cat., National Portrait Gallery, London 2019.

MARSH AND NUNN 1997: Jan Marsh and Pamela Gerrish Nunn, *Pre-Raphaelite Women Artists*, exh. cat., Manchester City Art Galleries 1997.

MELVILLE 2006: Jennifer Melville (ed.), *William Dyce and the Pre-Raphaelite Vision*, exh. cat., Aberdeen Art Gallery, Aberdeen 2006.

MILLAIS 1899: John Guille Millais, *The Life and Letters of Sir John Everett Millais*, 2 vols., London 1899.

MILLS 1912: Ernestine Mills, *The Life and Letters of Frederic Shields 1833–1911*, London, New York, Bombay and Calcutta 1912.

MORRIS AND KELVIN 1984: William Morris and Norman Kelvin (eds.), *The Collected Letters of William Morris, Vol. 1 1848–1880*, Princeton and Guildford, Surrey, 1984.

MURRAY 1878: Henry Murray, *The Art of Painting and Drawing in Coloured Crayons*, London 1878.

NEWALL 1993: Christopher Newall, *John William Inchbold: Pre-Raphaelite Landscape Artist*, exh. cat., Leeds City Art Galleries 1993.

NEWALL AND EGERTON 1987: Christopher Newall and Judy Egerton, *George Price Boyce*, exh. cat., Tate Gallery, London 1987.

NEWMAN AND WATKINSON 1991: Teresa Newman and Ray Watkinson, *Ford Madox Brown and the Pre-Raphaelite Circle*, London 1991.

PAYNE 1993: Christiana Payne, *Toil and Plenty: Images of the Agricultural Landscape in England, c.1780–1890*, exh. cat., Yale Center for British Art, New Haven 1993.

PAYNE 2017: Christiana Payne, *Silent Witnesses: Trees in British Art, 1760–1870*, Bristol 2017.

PAYNE AND SUMNER 2010: Christiana Payne and Ann Sumner, *Objects of Affection: Pre-Raphaelite Portraits by John Brett*, exh. cat., Barber Institute of Fine Arts, Birmingham 2010.

PETROSKI 1990: Henry Petroski, *The Pencil: A History,* London 1990.

ROBERTS AND WILDMAN 1997: Leonard Roberts and Stephen Wildman, *Arthur Hughes: His Life and Works*, Woodbridge, Suffolk 1997.

ROSE 1981: Andrea Rose, *Pre-Raphaelite Portraits*, Yeovil 1981.

ROSENFELD AND SMITH 2007: Jason Rosenthal and Alison Smith, *Millais*, exh. cat., Tate Britain, London 2007.

ROSSETTI 1850: Dante Gabriel Rossetti, 'The Blessed Damozel', *The Germ: Thoughts Towards Nature in Poetry, Literature, and Art*, 2 (February 1850), pp. 80–3.

ROSSETTI 1895: William M. Rossetti (ed.), *Dante Gabriel Rossetti: His Family-Letters with a Memoir*, 2 vols., London 1895.

ROSSETTI 1903: William Michael Rossetti, 'Dante Rossetti and Elizabeth Siddal', *The Burlington Magazine*, 1:3 (May 1903), pp. 273–95.

SEDDON 1858: [John Pollard Seddon], *A Memoir and Letters of the Late Thomas Seddon, Artist, By his Brother*, London 1858.

SEWTER 1975: A. C. Sewter, *The Stained Glass of William Morris and his Circle*, 2 vols., New Haven and London 1975.

SHARP 1882: William Sharp, *Dante Gabriel Rossetti: A Record and a Study*, London 1882.

STALEY 2001: Allen Staley, *The Pre-Raphaelite Landscape* (first publ. 1973; 2nd edition), New Haven and London 2001.

STALEY AND NEWALL 2004: Allen Staley and Christopher Newall, *Pre-Raphaelite Vision: Truth to Nature*, exh. cat., Tate Britain, London 2004.

SURTEES 1971: Virginia Surtees, *The Paintings and Drawings of Dante Gabriel Rossetti (1828–1882): A Catalogue Raisonné*, 2 vols., Oxford 1971.

SURTEES 1980: Virginia Surtees (ed.), *The Diaries of George Price Boyce*, Norwich 1980.

SURTEES 1981: Virginia Surtees, *The Diary of Ford Madox Brown*, New Haven and London 1981.

SURTEES 1991: Virginia Surtees, *Rossetti's Portraits of Elizabeth Siddal: A Catalogue of the Drawings and Watercolours*, Aldershot 1991.

TATE 1984: *The Pre-Raphaelites*, exh. cat., Tate Gallery, London 1984.

WARNER 1979: Malcom Warner, *The Drawings of John Everett Millais*, exh. cat., Arts Council of Great Britain, London 1979.

WATERS AND CAREW-COX 2012: Bill Waters and Alastair Carew-Cox, *Angels and Icons: Pre-Raphaelite Stained Glass 1850–1870*, Worcester 2012.

WILDMAN AND CHRISTIAN 1998: Stephen Wildman and John Christian, *Edward Burne-Jones: Victorian Artist-Dreamer*, exh. cat., Metropolitan Museum of Art, New York 1998.

WILKES 2017/18: Robert Wilkes, 'The 1860s Watercolours of Dante Gabriel Rossetti', *British Art Journal*, 18:3 (Winter 2017/18), pp. 48–55.

WILKES 2020: Robert Wilkes, '"Of chivalry and deeds of might": Reviving F. G. Stephens's "lost" Arthurian poem', in Heather Bozant Witcher and Amy Kahrmann Huseby (eds.), *Defining Pre-Raphaelite Poetics*, London 2020.

WODEHOUSE 2017: Katherine Wodehouse, 'Josephine Butler (1828–1906): The Face of Feminism', *The Ashmolean*, no.73 (Spring 2017), pp. 3–5.

WOODCOCK 1995: Sally Woodcock, 'The Roberson Archive: Content and Significance', in Arie Wallert, Erma Hermens and Marja Peek (eds.), *Historical Painting Techniques, Materials, and Studio Practice: preprints of a symposium [held at] University of Leiden, The Netherlands, 26–29 June 1995*, California (Getty Conservation Institute), 1995, pp. 30–7.

WORKS: E. T. Cook and Alexander Wedderburn (eds.), *The Works of John Ruskin*, 39 vols., London 1903–12.

Notes

Introduction: 'Pre-Raphaelites on Paper' (pp. 11–28)

1 Cruise (2010), pp. 15, 20.
2 Fredeman (1975), p. 3.
3 See Wilkes (2021).
4 Hunt (1905), I, pp. 89, 101–2.
5 Millais (1899), I, pp. 91–3; Hunt (1905), I, p. 311.
6 Tate, London.
7 Hunt (1905), I, pp. 194–5.
8 *The Times*, 13 May 1851, *Works* 12: 319–23.
9 *Works*, 12: 339 and 3: 623–4.
10 1846, letter to George Richmond, *Works* 36: 64, cited Hewison (2000), p. 147.
11 *Works*, 15: xvii.
12 *Works*, 22: 330.
13 Letter, 9 January 1853. http://www.victorianweb.org/painting/whh/HRLet/letters.html, accessed 27 July 2020 (no.2).
14 Burne-Jones (1904), I, p. 77.
15 Burne-Jones (1904), I, p. 110.
16 Brown (1978), p. 292.
17 Burne-Jones (1904), I, p. 176.
18 Burne-Jones (1904), I, p. 169.
19 Cruise (2011), p. 197, citing Harry Quilter, *Preferences in Art, Life and Literature* (London 1892), p. 208.
20 Surtees (1981), p. 148, entry for 6 August 1855.
21 Fredeman (2002), II, no.57.12, p. 171. Letter from DGR to William Bell Scott, 7 February 1857.
22 Christian (2007), p. 7.
23 Burne-Jones (1904), I, p. 38.
24 Burne-Jones (1904), II, pp. 5–6, 56.
25 Christian (2007), p. 15.
26 Tate, London; Manchester Art Gallery.
27 Roberts and Wildman (1997), p. 140.

Navigating the 'many botherations of a picture' (pp. 29–49)

1 *The Art Journal*, 'The Society of Painters in Water Colours: the Sixtieth Exhibition', 1 June 1864, p. 169.
2 For a full account of Roberson, see Woodcock (1995). The Roberson Archive, held at the Hamilton Kerr Institute, Cambridge, consists of handwritten ledgers containing the personal accounts of over 9000 individual customers and covers a period from 1820 to 1944.
3 For further details of my research, see Mann (2014) and Mann (2019).
4 Bradbury (2019), vol.2: George Price Boyce diary, 5 August 1851, p. 986.
5 Bradbury (2019), vol.2: George Price Boyce diary, entry for 10 August 1851, p. 986.
6 Bradbury (2019), vol.2: George Price Boyce diary, entry for 21 April 1854, p. 1009.
7 Bradbury (2019), vol.2: George Price Boyce diary, entry 14 April 1862, p. 1063.
8 Bradbury (2019), vol.2: George Price Boyce diary, entry 30 October 1860, pp. 1044–5.
9 Leslie (1888), pp. 10–11.
10 Bradbury (2019), vol.2: George Price Boyce diary, entry 8 April 1856, p. 1014.
11 Bradbury (2019), vol.2: George Price Boyce diary, entries 16 and 23 April 1864, pp. 1070–1.
12 Birmingham Museums and Art Gallery.
13 Lago (1982), p. 107.
14 Fredeman (2002), II, p. 269, 59.35: Letter to G. P. Boyce, Monday 5 September 1859.
15 Museum of Fine Arts, Boston.
16 Bradbury (2019), vol.1: Letter from H. T. Wells to J. M. Boyce, 19 July 1855, p. 231.
17 Tullie House Museum and Art Gallery, Carlisle.
18 National Gallery of Victoria, Australia.
19 Tate, London.
20 Tate, London. Bradbury (2019), vol.2: George Price Boyce diary, entry 5 March 1865, p. 1073.
21 Fredeman (2002), II, p. 265, 59.30: Letter DGR to James Leathart, Monday 8 August 1859.
22 Fredeman (2002), II, p. 214, 58.6: To William Bell Scott [c.21 June 1858].
23 Newman and Watkinson (1991), p. 126: Madox Brown's letter in 'The Journal of the Working Men's College', 1934.]
24 Fredeman (2002), II, p. 251: Letter to Charlotte Lydia Polidori,

Thursday [February] 1859, p. 251.

25 Surtees (1971), I, no.109, pp. 62–5.

26 Thomas Sulman, 'A Memorable Art Class', *Good Words*, August 1897, p. 549.

27 Winsor & Newton, catalogue attached to Murray (1878), p. 23.

28 Surtees (1971), I, p. 23.

29 Gilchrist (1973), Vol.I: Chapter XXXIX by Dante Gabriel Rossetti, p. 392.

30 Lago (1982), p. 142.

31 Fredeman (2002), II, p. 242, 59.1: Letter to Ford Madox Brown, Thursday 6 January 1859.

32 Thomas Sulman, 'A Memorable Art Class', *Good Words*, August 1897, pp. 547–51.

33 Lago (1982), p. 107.

34 Roberson Archive, Hamilton Kerr Institute, Cambridge: HKI MS 245–1993, p. 63; HKI MS 104–1993, p. 33; HKI MS 105–1993, p. 52; HKI MS 106–1993, p. 119a.

35 Roberson Archive: HKI MS 245–1993, p. 63.

36 'Bistre' refers to a pigment of a warm, brown colour, prepared from the soot of wood; 'sanguine' refers to a deep reddish-brown colour, resembling the colour of blood.

37 For more details about conté crayons see Hauptman (2007), pp. 33–6.

38 Walker Art Gallery, Liverpool. The sketches are in the Tate, London.

39 Cennini (1954), p. 9.

40 Murray (1878), p. 46. First published in 1856.

41 Mills (1912), pp. 145–6.

42 Winsor & Newton, catalogue attached to the back of Murray (1878), p. 37.

43 Mills (1912), letter DGR to Frederic Shields, 27 August 1869, p. 129. For further details see the National Portrait Gallery *British Artists' Suppliers, 1650–1950 – B* at https://www.npg.org.uk/research/programmes/directory-of-suppliers/b/.

44 Art Institute of Chicago.

45 Harvard Art Museums/Fogg Museum.

46 Mills (1912), letter from DGR to Frederic Shields, 27 August 1869, p. 128.

47 Private collection.

48 Marillier (1904), p. 140 and note 1.

49 Doughty and Wahl (1965), Vol. II, 1861–1870, p. 899: No.1066 Letter to Ford Madox Brown, August (1870). For F. G. Stephens' contribution to Rossetti's improvement in understanding perspective, see Robert Wilkes's blogspot: https://robertwilkes.blogspot.com. Accessed 13 June 2020.

50 Tate, London.

51 British Museum website, 'Lynn Blatchford has pointed out that Hamlet's head and the area around it, including the arches behind him, appears to have been drawn on a separate piece of paper and attached to the main sheet' (see M.A. thesis, Royal Holloway and Bedford New College, University of London, 1995). https://www.britishmuseum.org/collection/object/P_1910-1210-8. Accessed 15 May 2020.

52 *Works*, 15: 109.

53 Birmingham Museums and Art Gallery.

54 Lovett (2017), p. 41.

55 Bradley (1860), pp. 24 and 34.

56 Crook (1981), p. 56.

57 Bradbury (2019), vol.2: George Price Boyce diary, entry 29 May 1858, p. 1023.

58 Private collection.

59 Metropolitan Museum of Art, New York.

60 Harvard Art Museums/Fogg Museum.

61 Fitzwilliam Museum, Cambridge.

62 Harrison (2015), p. 198.

63 Lovett (2017), p. 39.

64 See Morris and Kelvin (1984), pp. 219: 231: WM letter to Charles Fairfax Murray, 26 March 1874.

65 MacCarthy (2010), p. 267.

66 Roberson Archive: HKI MS 247–1993, p. 96.

67 Roberson Archive: HKI MS 313–1993, p. 259. Entry for 31 March 1897.

68 W&N catalogue attached to the back of J. W. Bradley and Goodwin, 8th edition revised by J. J. Laing, *A Manual of Illumination on Paper and Vellum*, London, 1860, p. 13.

69 Roberson Archive: HKI MS 103–1993, p. 338 and HKI MS 104–1993, p. 317.

70 Cohn (1977), p. 47.

71 Lovett (2017), pp. 144–7.

72 Tate, London.

73 Ashmolean Museum, Oxford.

74 Harvard Art Museums/Fogg Museum.

75 Fitzwilliam Museum, Cambridge; Burne-Jones Autograph Work record, *Burne-Jones Papers*. See also Roberson Archive: HKI MS 250–1993, p. 282 (1893) and 313–1993, p. 258 (1895 and 1896). I am very grateful to Dr Joyce H. Townsend (Tate, London) for her advice on metallic paints.

76 Dunedin Art Gallery, New Zealand.

77 Museum of Fine Arts, Boston.

78 Ashmolean Museum, Oxford.

79 National Museum of Wales, Cardiff.

80 Lago (1982), p. 143. Entry for 22 April 1897.

81 Waters and Carew-Cox (2012), p. 248.and p284.

82 Tate, London.

83 Dimbleby (2005), p. 257.

84 *Athenaeum*, 5 December 1891, p. 767.

85 www.faber-castell.co.uk > A-brief-history-of-the-pencil. Accessed 26 June 2020. Also available on: https://issuu.com/faber-castell/docs/a_brief_history_of_the_pencil. Accessed 24 August 2020.

86 Petroski (1990), p. 132.

87 Lago (1982), p. 84. Entry for 18 January 1896.

88 Fredeman (2002), II, p. 276, 59.43 Letter DGR to William Bell Scott, 13 November 1859.

Reading and Drawing (pp. 51–66)

1 Hamilton (1882), p. 8.

2 Hunt (1905), I, p. 159.

3 Fredeman (1975), pp. 108–12.

4 Harrison and Newall (2010), pp. 22–35.

5 Brown (1978), p. 288; Wilkes (2019), I, pp. 77–8.

6 Wilkes (2019), p. 212 (Appendix 1, no.2). I am very grateful to Rupert Maas for presenting these sketches to me as a gift in 2019. The sketches were found tucked inside the Maas Gallery's copy of Stephens's pamphlet 'William Holman Hunt and His Works' (1860), which once belonged to Stephens himself and is annotated by him.

7 Rossetti gifted two drawings to Stephens: *Torello's First Sight of Fortune* (c.1849) and *Hesterna Rosa* (1853), both now in the Tate collection.

8 Cruise (2011), p. 46.

9 Frederic George Stephens, *The Proposal (The Marquis and Griselda)* (1850–1; Tate, London).

10 Dante Gabriel Rossetti, *The Damsel of the Sanct Grael* (1857; Tate, London).

11 Burne-Jones (1904), I, pp. 97–8.

12 John Everett Millais, *Mariana* (1851; Tate, London); William Holman Hunt, *Claudio and Isabella* (1850–3; Tate, London) and *Valentine Rescuing Sylvia from Proteus* (1850–1; Birmingham Museums and Art Gallery).

13 *Twelfth Night, Act II, Scene IV* (1849–50; private collection); *Rosalind Tutoring Orlando in the Ceremony of Marriage (As You Like It)* (1845–50; Birmingham Museums and Art Gallery); *Scene from 'As You Like It'* (Shipley Art Gallery, Gateshead). Deverell also produced an etching depicting Viola and Olivia from *Twelfth Night* for the fourth issue of *The Germ* (May 1850). He is also recorded as working on a design of 'the converse of Laertes and Ophelia [from *Hamlet*]' in October 1850; Fredeman (1975), p. 72.

14 Jeffrey (1984), pp. 282–4. When exactly the painting was lost is not known; Lutyens (1984), pp. 79–96 states that the painting was destroyed in a gas explosion while still in the possession of the Deverell family.

15 Fredeman (1975), p. 72.

16 Brown (1978), p. 291, records the inscription in Deverell's own hand on the drawing's old mount: 'Walter H. Deverell to Dante G. Rossetti'.

17 Jeffrey (1984), p. 284.

18 John Everett Millais, *Isabella* (1848–9; Walker Art Gallery, Liverpool).

19 *The Athenaeum*, no.1225 (19 April 1851), p. 435.

20 Marsh (2019), p. 22.

21 Marsh (2019), p. 27; email from Jan Marsh to the author, 19 June 2020.

22 Mann (2005), pp. 7–8.

23 Wilkes (2017/18), pp. 48–55.

24 For more on Rossetti's picture frame designs, see Grieve (1973), pp. 16–24.

25 Surtees (1971), I, p. 23. The watercolour is dated 'Carlisle / 1853', although this does not necessarily mean that it was made in Carlisle.

26 The sketch is in Birmingham Museums and Art Gallery (1904P305), titled *Battlements of Wetheral (Sketch of a Castle)*. Letter from Rossetti to William Michael Rossetti, 1 July 1853: 'Yesterday and the day before [William Bell] Scott and I made an excursion to Wetheral, Carlisle, and Hexham'; Rossetti (1895), II, pp. 104–5.

27 Sharp (1882), p. 150.

28 Dante Gabriel Rossetti, *Paolo and Francesca da Rimini* (1855; Tate, London), *The Wedding of St George and Princess Sabra* (1857; Tate), *Ruth and Boaz* (1855; private collection).

29 Letter from Rossetti to Ford Madox Brown, 23 May 1854, in Fredeman (2002), I, letter no.54.49.

30 William Holman Hunt, *The Flight of Madeline and Porphyro* (1848; Guildhall Art Gallery, London).

31 Many of the Siddal drawings in the Ashmolean have inscriptions by W. M. Rossetti on the versos, confirming her authorship and/ or identifying the subject of each picture: Jephta's Daughter, Sister Helen, 'St Agnes' Eve'.

32 Rossetti (1850), p. 80. Rossetti extensively revised the poem for later publications, so the version quoted here differs from the better-known version published in Rossetti's *Poems* (1870) that has been widely anthologised.

33 I am grateful to Glenda Youde for bringing this to my attention; email to the author, 10 June 2020.

34 The sketch is reproduced online: 'The Blessed Damozel; sketch, Dante Gabriel Rossetti, 1869 (circa)', *The Rossetti Archive*, www. rossettiarchive.org/docs/f14.s244.rap.html; see also Fredeman (1989), plate 14.

35 Dante Gabriel Rossetti, *The Blessed Damozel* (1871–8; Harvard Art Museums, USA).

36 Letter from Rossetti to William Allingham, 8 January 1856, in Hill (1897), pp. 161–2.

37 It is not known whether the Ashmolean sheet is the same version of *Pippa Passes* that was owned by Ruskin.

38 Letter from Rossetti to Allingham, 18 March 1855, in Hill (1897), p. 110.

39 See Goldman (1996).

40 Harrison (2014), p. 184.

41 Letter from Rossetti to Allingham, 23 January 1855, in Hill (1897), p. 97.

42 This anecdote evidently originated from Arthur Hughes; Rossetti (1903), pp. 273–95.

43 The drawing is inscribed on the reverse in W. M. Rossetti's hand 'By Lizzie R / Tennyson's St Agnes' Eve'.

44 Rossetti (1903), p. 295: '[Siddal's drawing] certainly indicates the death of [St Cecilia] [...] I have no doubt it preceded Rossetti's design, and therefore this detail of invention properly belongs to Miss Siddal'.

45 Rossetti (1903), p. 283.

46 Rossetti (1903), p. 283.

47 See Kooistra (1999). The manuscript of *Sing-Song* with Rossetti's illustrations is in the British Library, Ashley MS 1371.

48 Wildman and Christian (1998), p. 119.

49 Wildman and Christian (1998), pp. 119–28.

50 See Florence S. Boos, '*A Dream of John Ball*: History as Fellowship', William Morris Archive, http://morrisedition.lib. uiowa.edu/DreamIntro.html.

51 Burne-Jones (1904), II, p. 139; MacCarthy (2011), p.xxii.

Catalogue (pp. 67–229)

1 Fredeman (1975), p. 78. 'Woolner ... fought the point savagely, being of opinion (in which I fully agree with him) that Collins has not established a claim to P.R.B.-hood, and that the connexion would not be likely to promote the intimate friendly relations necessary bet[ween] all P.R.B.s.'

2 Millais (1899), I, p. 103.

3 Hunt (1905), I, p. 271.

4 Millais (1899), I, pp. 221, 226.

5 Birmingham Museum and Art Gallery.

6 Surtees (1981), p. 76. Brown implied that Millais gave bad advice when he recommended that Brown paint the flesh in his oil

painting *Jesus Washing Peter's Feet* (1852–6, Tate, London) over a wet white ground.

7 Birmingham Museum and Art Gallery.
8 Tate, London.
9 Ruskin's second letter, dated 26 May 1851. *Works* 12: 322–7.
10 Burne-Jones (1904), I, p. 231.
11 Fredeman (2002), I, no.54.49, p. 184. Letter from DGR to Ford Madox Brown, 23 May 1854.
12 Surtees (1971), I, p. 190, citing William Michael Rossetti's diary, 5 July 1899.
13 Marsh (1991), p. 13, citing Parkes Papers, Girton College, Cambridge.
14 *Works*, 6: 61.
15 Funnell (1999), p. 93.
16 Ibid, p. 92.
17 Marsh (1991), p. 14.
18 Hunt (1905), I, pp. 312–13.
19 Ashmolean Museum, WA1894.1.
20 Manchester Art Gallery.
21 Funnell (1999), p. 108, citing Bowerswell Papers, Pierpont Morgan Library, New York City.
22 Tate, London.
23 Lady Lever Art Gallery, Port Sunlight.
24 Rose (1981), p. 119.
25 Birmingham Museum and Art Gallery.
26 Elements: Educational, manuscript 1878, R12.
27 Bowerswell Papers, cited Rosenfeld and Smith (2007), p. 90.
28 Bennett (2010), I, p. 144, citing Brown's catalogue for his one-man exhibition in 1865.
29 Millais (1899), I, p. 58.
30 British Museum.
31 Ashmolean Museum, WA1894.8.
32 Manchester Art Gallery.
33 Museum of Fine Arts, Boston.
34 Fitzwilliam Museum, Cambridge.
35 Payne and Sumner (2010), p. 16.
36 Tate, London.
37 Hunt (1905), I, p. 290.
38 Makins Collection.
39 Fitzwilliam Museum, Cambridge.
40 Fogg Art Museum, Harvard.
41 Collection of Lord Lloyd Webber.
42 Barringer (2012), p. 177.
43 Lago (1982), pp. 187–8.
44 Wildman and Christian (1998), pp. 217–21.
45 Elements: Educational, manuscript 1878, R12.
46 Private collection: Newall and Egerton (1987), no.52
47 First version 1864–70, Tate, London.
48 WA1977.80.
49 Arthur Ross Gallery, University of Pennsylvania, *Master Drawings (1800–1914) from the Ashmolean Museum, 2004.* http://www.arthistory.upenn.edu/ashmolean/Rossetti/Rossetti_entry.html. Accessed 27 May 2020.
50 Surtees (1971), I, p. 64.
51 Burne-Jones (1904), I, facing p. 186.
52 Now known only from a description by Georgiana Burne-Jones. Burne-Jones (1904), I, p. 187.
53 Fitzwilliam Museum, Cambridge.
54 Tate (1984), p. 225.
55 Surtees (1971), I, p. 154, citing a letter in the British Museum.
56 Delaware Art Museum.
57 Letter dated 15 February 1880, cited by Surtees (1971), I, p. 154.
58 Payne and Sumner (2010), p. 76, citing John Brett's Diary, 1 January 1860.
59 William Morris Gallery, Walthamstow.
60 First version, Tate, London, 1864–70.
61 Burne-Jones (1904), I, p. 97.
62 See Fredeman (1975), pp. 106–7, for Hunt's list.
63 Surtees (1971), I, p. 52, citing W. M. Rossetti, ed., *Ruskin, Rossetti: Pre-Raphaelitism*, London 1899, pp. 200–1.
64 Roberts and Wildman (1997), p. 146.
65 Marsh and Nunn (1997), p. 115, citing W. M. Rossetti, 'Dante Rossetti and Elizabeth Siddal', *The Burlington Magazine*, 1:3 (May 1903), p. 278.
66 Fredeman (2002), II, no.55.52, p. 70, letter from DGR to Robert Browning, 14 October 1855; ibid, no.55.58, p. 80, letters from DGR to William Allingham, 25 November 1855 and 8 January 1856.
67 Millais (1899), I, pp. 289–90.
68 Burne-Jones (1904), I, p. 157.
69 Surtees (1971), I, p. 48, citing William Michael Rossetti, 'Dante Rossetti and Elizabeth Siddal', *The Burlington Magazine*, 1:3 (May 1903), p. 295.
70 Surtees (1971), I, p. 61, citing a letter to George Eliot, 18 February 1870, coll. Duke University, Durham, North Carolina.
71 Pitti Place, Florence.
72 Museum of Fine Arts, Boston.
73 Tate, London.
74 Fredeman (1975), p. 13, entry for 29 August 1849.
75 Tate, London.
76 Tate (1984), p. 275.
77 Tate, London.
78 Birmingham Museum and Art Gallery.
79 Tate, London (1984), p. 88.
80 Tate, London.
81 Birmingham Museum and Art Gallery.
82 Hunt (1905), I, p. 292.
83 Tate, London.
84 Hunt (1905), I, p. 347.
85 Hunt (1905), I, pp. 289–90.
86 Bronkhurst (2006), p. 38, citing letter from Hunt to John Crossley, nephew of Thomas Combe, in 1894 (Manchester Art Gallery).
87 Tate, London archives, cited in Tate (1984), p. 197.
88 Lady Lever Art Gallery, Port Sunlight.
89 Makins Collection.
90 Ashmolean Museum, WA1948.32.
91 See catalogue for Sotheby's, Victorian and Edwardian Art, 9 December 2008, lot 101, where it is dated to the later 1880s.
92 Tate, London.
93 Burne-Jones (1904), I, pp. 266–7.
94 Ibid, pp. 267–9.
95 *Works*, 19:203–6.
96 Burne-Jones (1904), I, p. 268.
97 Victoria and Albert Museum.
98 Sewter (1975), I, pp. 16–17, repr.II, pl.412.

99 Collection of the William Morris Society.
100 Victoria and Albert Museum.
101 Harvard Art Museums.
102 *Works*, 12: 339 and 3: 623–4.
103 *Works*, 15: xii.
104 Hewison (2000), p. 162.
105 *Modern Painters* IV, 1856, *Works*, 6: 152.
106 *Praeterita, Works*, 35: 83.
107 *Works*, 13:524, cited Hewison (2000), p. 162.
108 *Works*, 35: 429.
109 Elements: Educational, manuscript, 1878.
110 Evans and Whitehouse (1958), p. 747.
111 *Works*, 21: 111.
112 Hewison (2000), p. 174.
113 *Works*, 27: 304.
114 *Works*, 23: 16–17.
115 *Works*, 13: 528.
116 Lady Lever Art Gallery, Port Sunlight.
117 Staley (2001), p. 205.
118 For the rejection of *Hayes Common* (Yale Center for British Art) see Payne (2017), p. 166.
119 Tate, London.

120 Melville (2006), p. 168.
121 Seddon (1858), p. 70.
122 Ibid, p. 85.
123 Ibid, pp. 93, 100.
124 Ibid, p. 149.
125 Ibid, p. 94.
126 Newall and Egerton (1987), p. 21.
127 3 December 1864, cited Newall and Egerton (1987), p. 55.
128 Ibid, p. 23.
129 Surtees (1980), p. 13, entry for 21 April 1854.
130 Staley (2001), pp. 145–6.
131 *Works*, 15: 109.
132 Private collection.
133 *Spectator*, 1852, p. 593, cited Newall (1993), p. 10.
134 Fitzwilliam Museum, Cambridge.
135 Newall (1993), p. 11.
136 *Works*, 14: 22.
137 Newall (1993), pp. 12–15.
138 Staley (2001), p. 157.
139 Private collection, Newall (1993), no.43.
140 Society of Antiquaries, London, Newall (1993), no.31.
141 Staley (2001), p. 196.

Index

This index is in alphabetical, word by word order. It does not cover the Contents List, Preface or Acknowledgements. Location references are to page number (in plain text), figure number (in italics) and catalogue number (in bold) and are given in that order. Abbreviations: fig.= figure.